Portraying Children

Dedicated to children everywhere
To everyone who has been a child and to those who still are.
Especially to children who, because of adults, are unable to
live the life of a child.
To all the children who will never become adults due to the
brutality or the indifference of yesterday's children.
To all the innocent children, both fragile and strong, who we can
imitate to better ourselves.

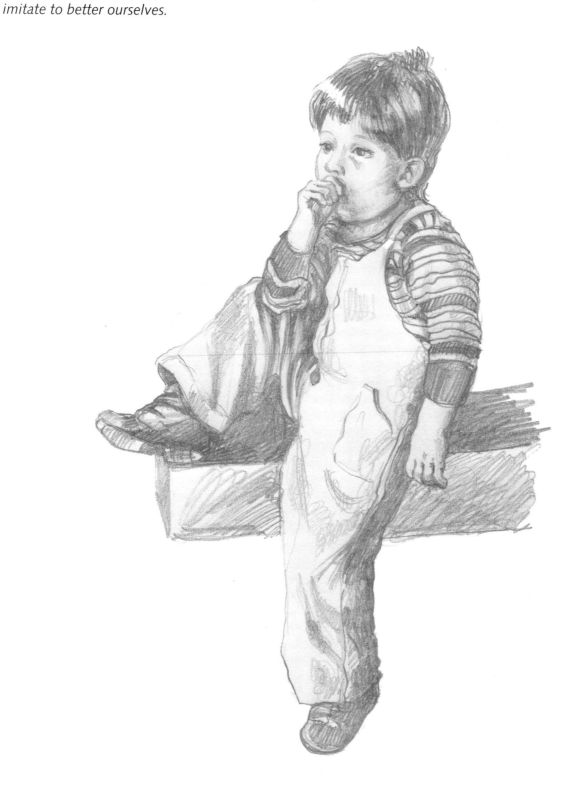

Dedicated to children everywhere
To everyone who has been a child and to those who still are.
Especially to children who, because of adults, are unable to
live the life of a child.

Portraying Children

Expressions, Proportions, Drawing and Painting techniques

Daniela Brambilla

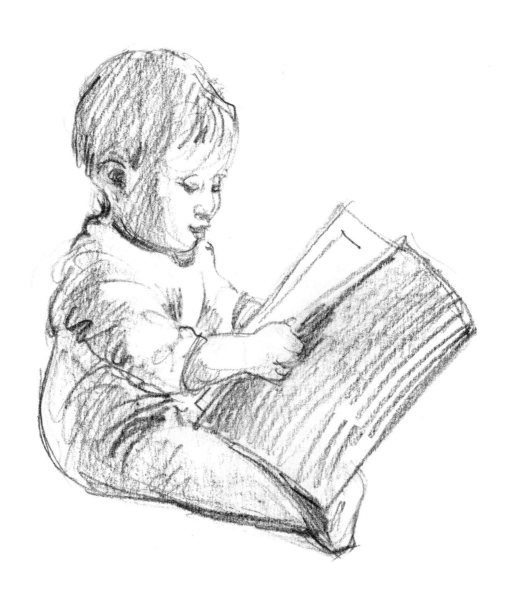

promopress

Daniela Brambilla

The studies and activities carried out by Ms Brambilla have always been focused on the study and production of images in the visual communications and arts fields.
With a degree in architecture followed by another qualification in art criticism from the Drama, Art and Music Studies programme at the University of Bologna, she has continued her study of life drawing and, in particular, of drawing the human body.
Starting in the 1980s, she began working in illustration, decoration, set design, and exhibition and trade fair staging with her own professional studio.
Since 1986, she has coordinated the Illustration and Animation course at the Istituto Europeo di Design in Milan, where she teaches figure drawing and painting techniques.
In the early 1990s, Ms Brambilla started focusing her professional activities mostly on art.
With Ikon Editrice, she has already published the popular educational text L'inquadratura-Strategia del racconto visivo (Framing: Strategies for Visual Storytelling) *and in 2009,* Vedere con la Matita, *translated and published in English* Human Figure Drawing *and Spanish* Dibujo de la figura humana *by Promopress in 2015.*
danielabruna.brambilla@gmail.com

Portraying Children
Expressions, Proportions, Drawing and Painting Techniques

Original title:
Disegnare Bambini
Espressioni, proporzioni, disegno e tecniche pittoriche

English Translation by Katherine Kirby

ISBN: 978-84-16851-55-3
D.L.: B 10016-2018

Copyright © 2018 Ikon Editrice srl
Copyright © 2018 Promopress for the English language edition

Promopress is a brand of:
Promotora de prensa internacional S.A.
C/ Ausiàs March 124
08013 Barcelona, Spain
Tel.: 0034 93 245 14 64
Fax: 0034 93 265 48 83
Email: info@promopress.es
www.promopresseditions.com
Facebook: Promopress Editions
Twitter: Promopress Editions @PromopressEd

First published in English: 2018

Cover design:
spread: David Lorente

Printed in China

A line, an area of tone, is not really important because it records what you have seen, but because of what it will lead you on to see...Another way of putting it would be to say that each mark you make on the paper is a stepping stone from which you proceed to the next, until you have crossed your subject as though it were a river, have put it behind you.

John Berger, *Drawing is Discovery*, *The New Statesman*, originally published 29 August 1953. Retrieved from https://www.newstatesman.com/culture/art-and-design/2013/05/john-berger-drawing-discovery on 24 January 2018.

There are numerous manuals about drawing the human figure which cover the topic from various points of view and with different types of in-depth analysis, but none of them focus exclusively on children. I began to wonder why dedicate an entire book to them. I found the answer only in the course of research that began with a certain scepticism and which I gradually became more enthusiastic about and intrigued by. Drawing children is undoubtedly more difficult than drawing adults and is certainly a subject which rarely appears with respect to the infinite production of images of the human figure. However, this topic has allowed me to explore a world that is still uncontaminated and full of nuances.

At this point, we'll try to lay the first stone to bridge the gap.

Drawing is the main way to learn to truly see and, as a result, to understand and to love. Through drawing, we are better able to 'read' the world around us, nature, animals, human beings and the environment overall. Learning to see by drawing is the best way to overcome the natural tendency to only see that which we expect or that which we choose to see.

There is more than one way to draw and different ways to learn, and the goal of this book is to capture one method of drawing, and of drawing children in particular.

The human form has been, without question, the most-represented subject in our culture since time immemorial, and thus the interest in drawing children is part of this more general attention to human beings.

Children appear in painting and sculpture relatively rarely. In the history of painting, starting from the Middle Ages up to today, the children that began to appear in sacred art were the baby Jesus, angels, St. John or cupids which are part of mythological scenes.

Pen drawing with red ink

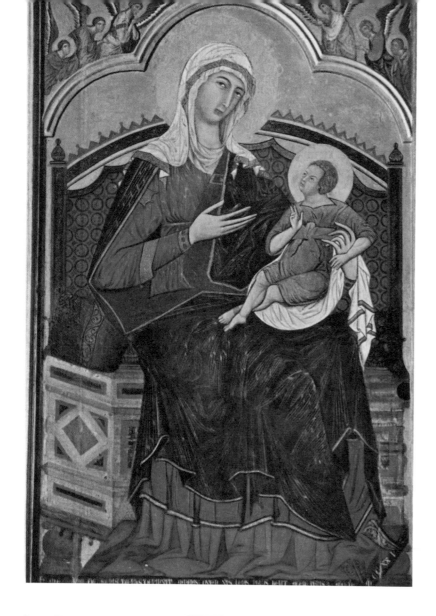

Guido of Siena, *Enthroned Madonna*, 1221, Palazzo Pubblico, Siena.

Rosso Fiorentino, *Sacred Conversation (Spedalingo Altarpiece)*, (angel detail), 1518, Uffizi Gallery, Florence.

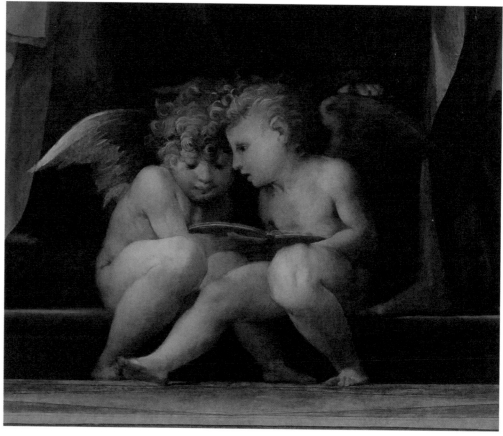

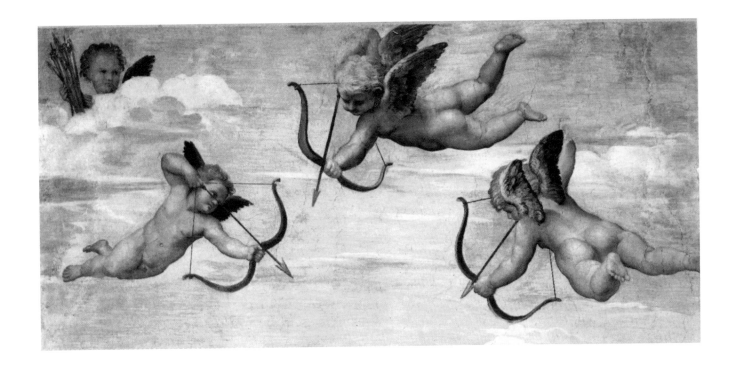

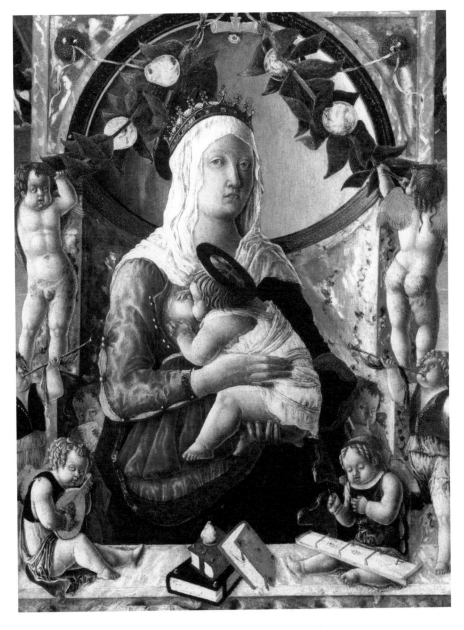

Above: Raphael, *Triumph of Galatea*, detail of the cupids, 1512, Villa Farnesina, Rome.

Below: Marco Zoppo, *Madonna and Child with Angels*, 1453-55, Louvre, Paris.

Normally, children do not appear on their own, but are part of images with a broader subject. They bring vivacity to the image and a sense of truth to the scene, or they appear alongside parents who commissioned the piece, or even on their own when they take on royal roles.

Paolo Veronese, *Head of a Child*, 1859, Ruskin Museum, Cumbria, England.

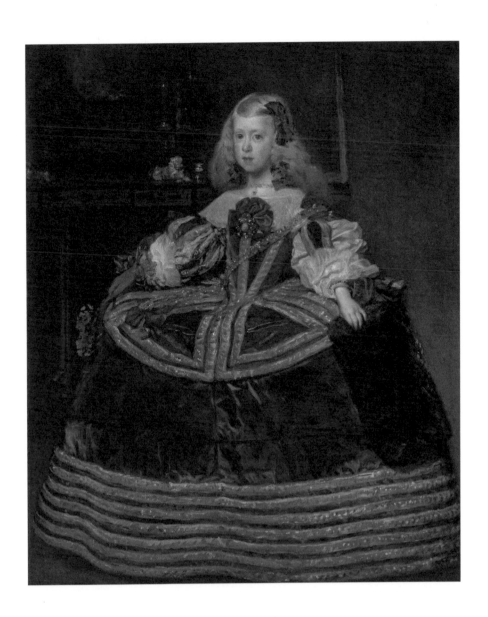

Velazquez, *Infanta Margarita*, 1659, Kunsthistorisches Museum, Vienna.

Below: Paolo Veronese, *Supper in Emmaus*, 1559-60, Louvre, Paris.

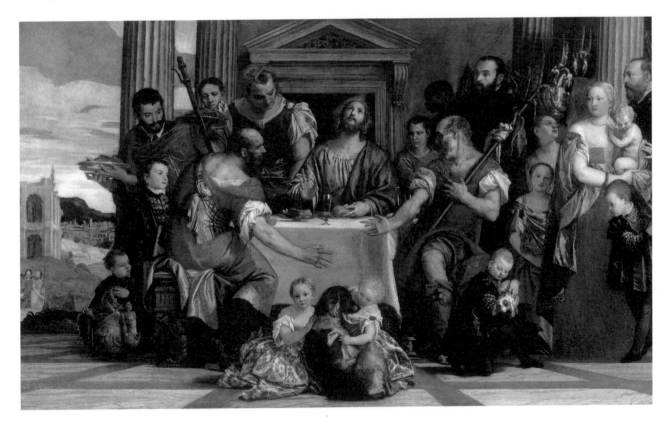

Starting at the end of the eighteenth century, children began to be the focus of genre paintings, and in the last two centuries they have appeared more frequently in both painting and sculpture. I'll mention just a few artists by way of example, but it was mainly in the last century that they began to regularly appear in illustrations and comic strips, taking on the role of protagonists.

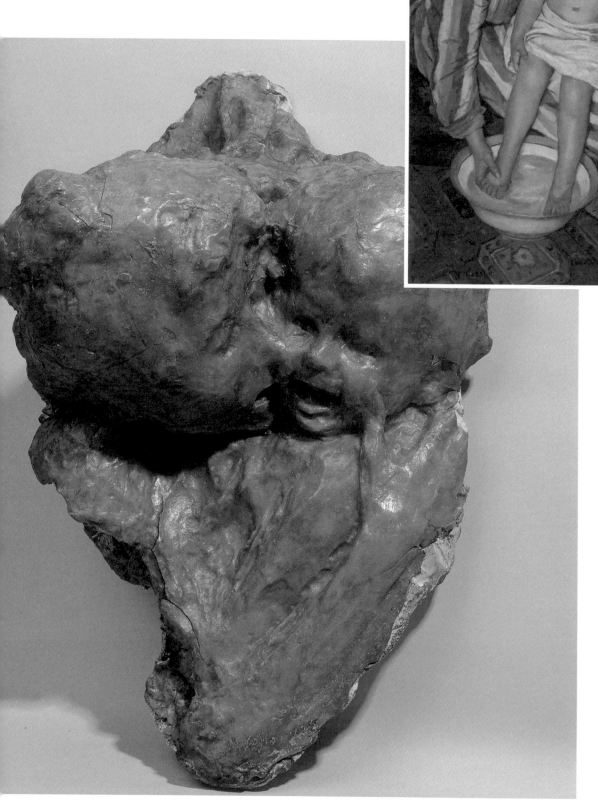

Above: Mary Cassatt, *The Child's Bath*, 1891-92, Art Institute, Chicago.

Below: Medardo Rosso, *Età dell'oro*, 1885, Municipal Gallery of Modern and Contemporary Art, Rome.

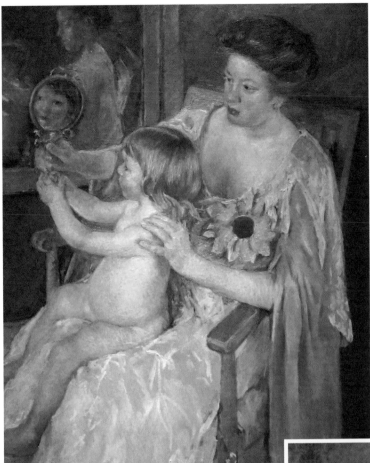

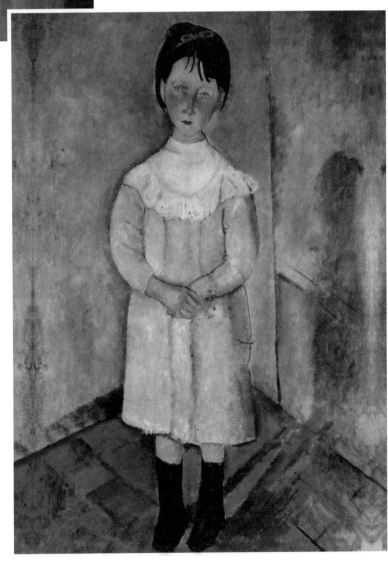

Drawing children, for those who have no experience with this subject and little experience drawing overall, is surely more difficult than drawing adults. In particular, their hard-to-read and difficult-to-understand proportions can be problematic.

It's important not to forget that we see only what we know.

In addition, children's small, round faces bear no mark of the life they've led. This offers very few characterising starting points and makes them all seem similar to one another.

In addition, it may so happen that, as with any other subject, people tend to place generalisations and stereotypes that at least in this case are based on the proportions of adult bodies and faces before a true visual understanding of the subject.

Also, when trying to portray a child from real life or from a photograph, the result is often a depiction which makes them seem older than they are. This depends both on the proportions of the body and head as well as the structure of the face. It's always helpful to consider that a child's eyes are very big, just as is true of all baby animals, and the eyes-nose-mouth triangle is smaller than that of an adult. In particular, a child's head is much larger in relation to his body.

Moreover, children's features and proportions change very quickly; they must be captured "on the fly". They undergo an extremely quick revolution in terms of their facial features and their expressions, which are quite variable and extraordinary, and which tend to lose their intensity or disappear completely over the years.

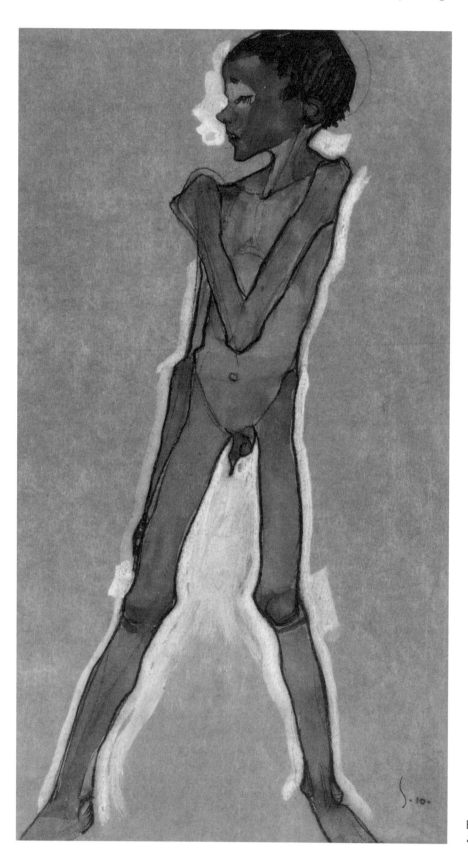

Egon Schiele, *Nude Boy Standing*, 1910, Vienna.

Who might use a manual on how to draw children?

First and foremost, those who love drawing and who wish to contend with every subject and, in particular, subjects which have particularities which are not easy to resolve.

It might also interest illustrators who are dedicated to children's illustrations or scholastic publishing, where drawing children is the main subject matter.

Parents, grandparents, and relatives who are all eager to immortalise the children in their lives.

Those who study or who teach drawing and also those who want to recreate, through photographic traces, physical and psychological transformations, emotions and thus the story of one's own childhood or that of one's kids.

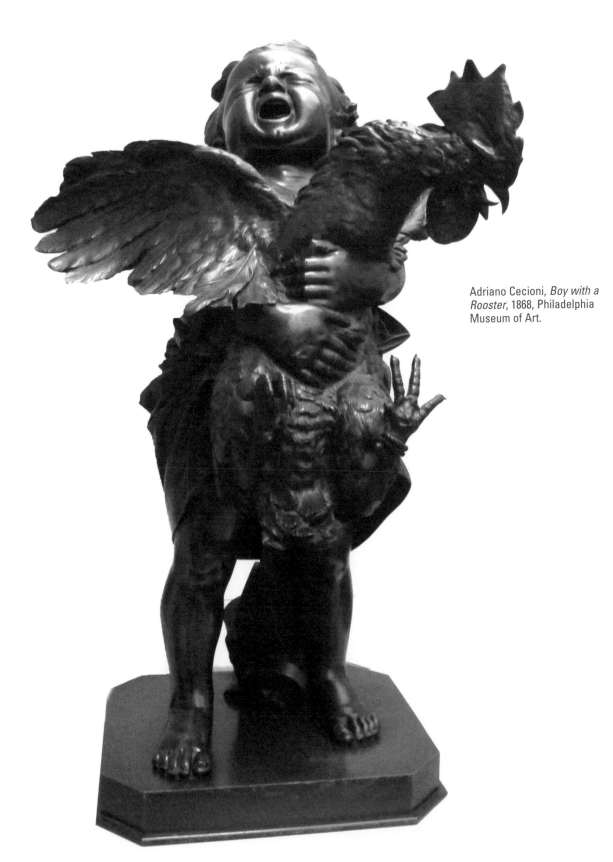

Adriano Cecioni, *Boy with a Rooster*, 1868, Philadelphia Museum of Art.

The proportions of the human body have been studied by artists, painters and sculptors of all eras.

The most well-known study of proportions is the famous drawing by Leonardo da Vinci, titled *The Vitruvian Man* from about 1490, which represents the archetype of the proportions of the human body. Da Vinci was dedicated to studying and measuring various parts of the body, analysing every part in relation to the others and each in relation to the whole.

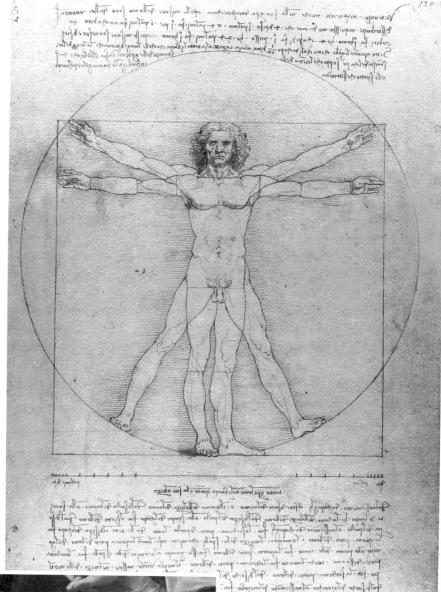

Top right: Leonardo da Vinci, *The Vitruvian Man: a study of the proportions of the human body according to Vitruvius*, c. 1490, Gallerie dell'Accademia, Venice.

Above and at right: Leonardo da Vinci, *Details from the Virgin of the Rocks featuring the baby Jesus and St. John the Baptist*, 1483-86, Louvre, Paris.

Referring to the theory of Vitruvius (Roman architect and author of *De Architectura*), Da Vinci demonstrated how the body of a man fits both into a circle and a rectangle, confirming it as a model of perfection and harmony. It's a model which is taken as the basis of architectural design and reflected in the classical ideal, celebrated in the Renaissance in buildings with a central floor plan. In addition, in this drawing, the representation of the human body contains the idea of movement, rendered by the passage from one position to the next, carried out in sequence, breaking with the static principle of proportions.

It is of course necessary to remember that throughout history, artists have proposed idealised beauty canons which change according to the culture of each era. As a consequence, the proportions and volumes of the body, especially for women, perfectly embody the tastes of the time, from "Steatopygian Venuses" onward.

In ancient paintings, the representation of children's bodies is generally characterised by roundness, even if a few artists such as Rubens painted particularly plump children who are in-line with the other depicted characters, while the children painted by Caravaggio, for example, tend to be a bit thinner.

In any case, roundness is the quality which sets the representation of children apart, be they cupids, angels or the baby Jesus.

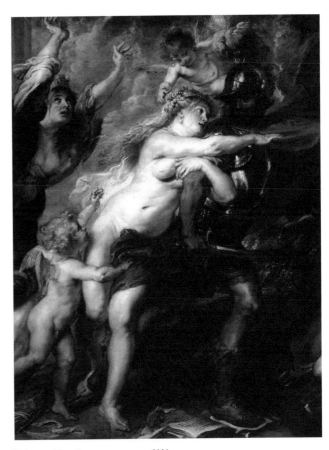

Rubens, *The Consequences of War*, 1638, Galleria Palatina, Florence.

Caravaggio, *Sleeping Cupid*, 1608, Palazzo Pitti, Florence.

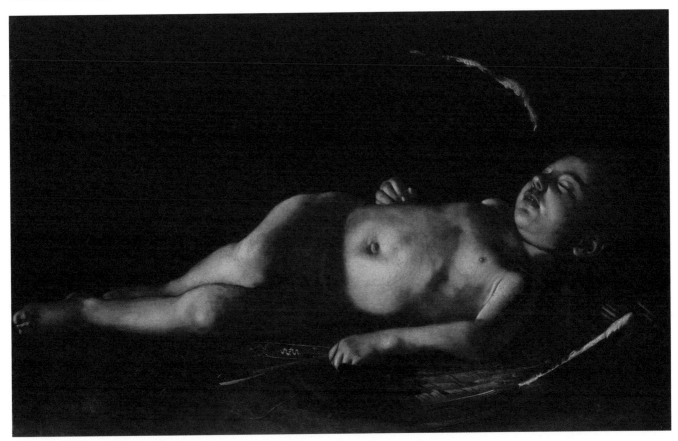

Anatomical drawing books or manuals which widely cover the study of the body's proportions in relation to a child's age and stage of development are rare. Usually, if at all, the topic is covered in a generalised, summarised way.

The development of little boys' and girls' bodies and personalities is concentrated in a time span of about 15 years, going from birth to maturity.

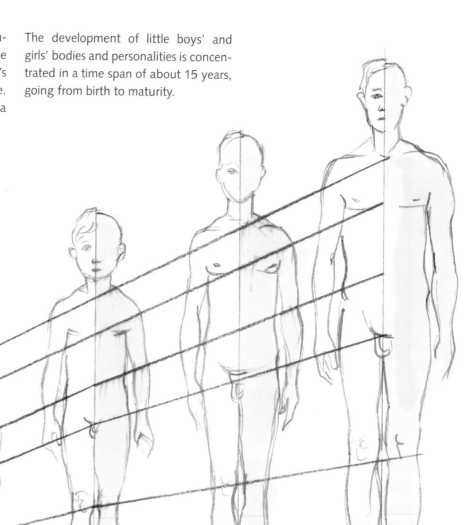

Illustration of the growth of the body's proportions, starting from age one, two, seven, fourteen and eighteen years old. The head goes from a quarter of the body to a fifth, sixth, seventh and an eighth.

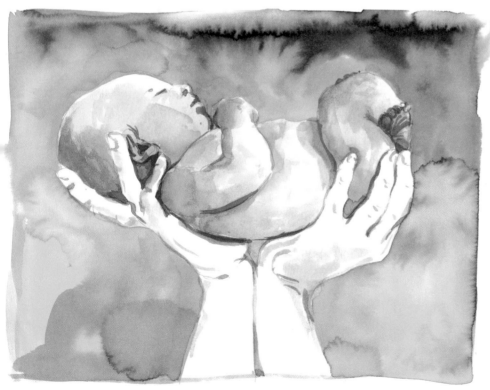

Young individuals don't grow in a constant, uniform manner, but rather in steps distinguished by lags and spurts. During the development process, the relationship between the various parts of the body - head, torso, arms and legs - isn't consistent. The growth of the head is quite gradual, while the legs and the torso grow approximately twice as fast.

At birth, a newborn measures about 50 cm. From that moment until reaching his definitive proportions, the size of the head doubles while that of the torso triples, the arms quadruple and the legs stretch to five times their length at birth.

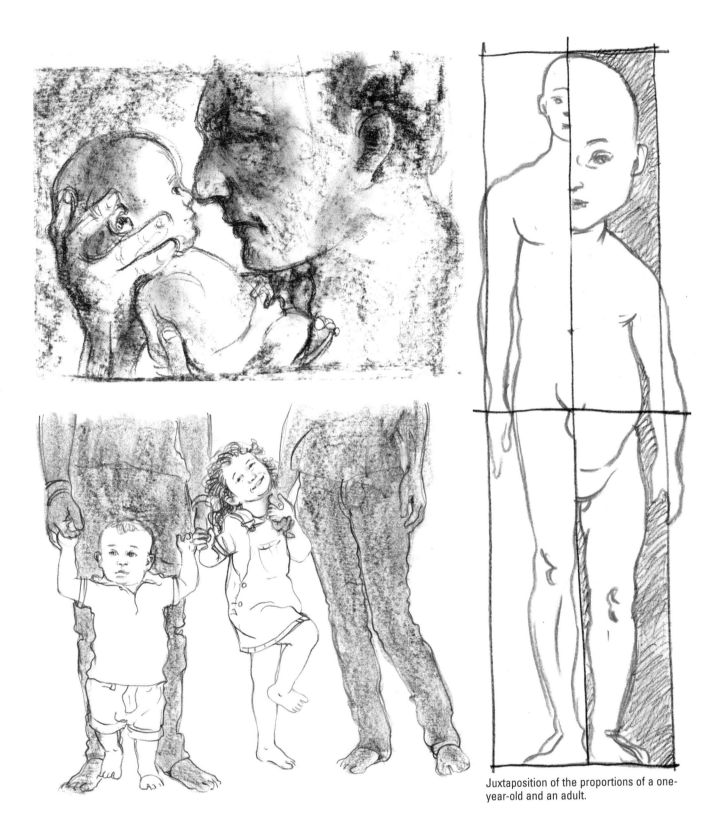

Juxtaposition of the proportions of a one-year-old and an adult.

The growth of the head in relationship to the other parts of the body is a specific determinant for age.

The main differences between newborns and adults are the ratios between the length of the head, the torso and the limbs in relation to the body as a whole.

Children's proportions (the relationship between the head, bust, arms and legs) vary greatly depending on their age. The head is the module of reference. From birth to one year of age, the head takes up a quarter of the body's total height. By three years old, the head is about a fifth of the body; at five, it's a sixth; and at ten, it's a seventh or a bit more. An adolescent's head is thus about a seventh of the body, while in adult men it's an eighth, and seven and one half for women.

The comparison of the head-body relationship for infants and adults is quite impressive. Such a large difference almost seems impossible, and, seeing the two images side by side, that of the child seems so disproportionate that it's almost monstrous.

Profile, front and top views. Growth of the cranium, comparing that of a newborn, a six-year-old and an adult. At six, when children loose their baby teeth, the skull grows longer, stretching downwards.

As kids grow, the eye line on the skeleton of infants and children is found below the horizontal median of the head.

The growth of the cranium, forehead and upper skullcap remain constant in proportion to the greatest width.

The status of the greatest width of the skull with respect to the halfway line remains constant from newborns to adults.

The vertical line marks half of the distance from the arch of the eyebrow and almost always coincides with the opening of the ear canal.

The proportions of newborns, six-year-olds and adults show the growth of the skull in relation to the horizontal line of the eyes and the vertical line with the subsequent development of the facial bones. In the last picture, the view from above highlights the development of the width-height ratio.

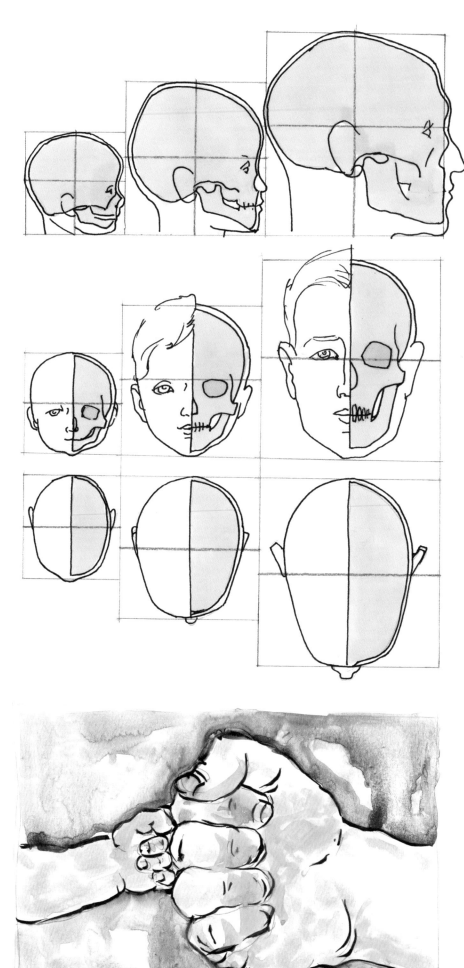

In the first year of life, nature provides for the infinite needs of little human beings, giving them an enormous brain and a chewing apparatus suitable to mostly liquid or semi-liquid food.

The proportions of a newborn's head change as teeth appear and solid food is introduced, with the result that the skull starts to develop downwards.

The first phase of growth concludes with the end of the change in baby teeth. The volume of the upper and lower jaw increases and the face elongates downwards.

Thus, during this growth period, the head's proportions vary between the skullcap, which contains the mass of the brain, and the facial skeleton as a whole.

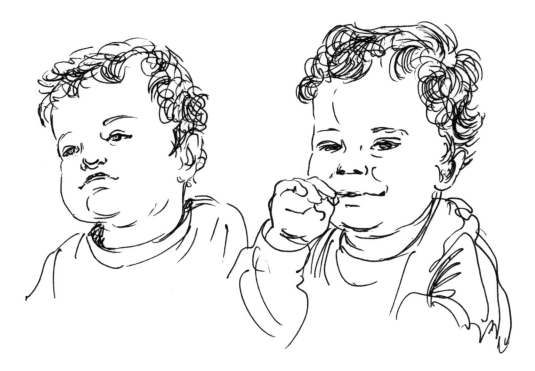

At the beginning of life, the brain works at a frenetic pace. This is exactly why it is so heavy compared to the rest of the body. In fact, it is the most significant part of the body's total volume.

This can easily be seen in all newborns up until the age of one or two; they often lose their balance due to the weight of their heads.

The torso and limbs are quite short and stocky during the transition from newborn to infant crawling about, then on to the child who takes his first steps.

Alessandro at four months, drawing in black pen.

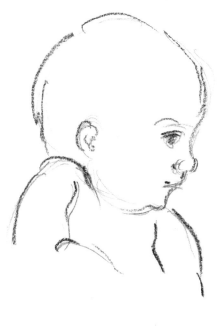

Body proportions, the head and the face at four months; pencil.

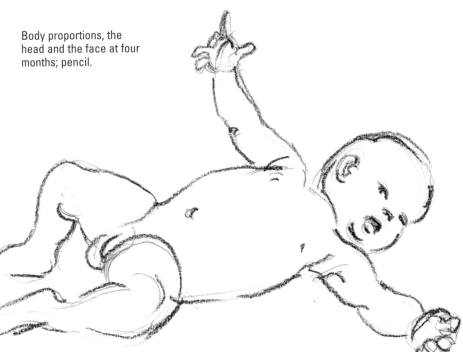

The characteristics of the forehead are quite important when portraying a given age. Newborns and babies have high foreheads, gradually transforming from convex to flat or even receding. The roundness of the forehead remains mostly only in girls.

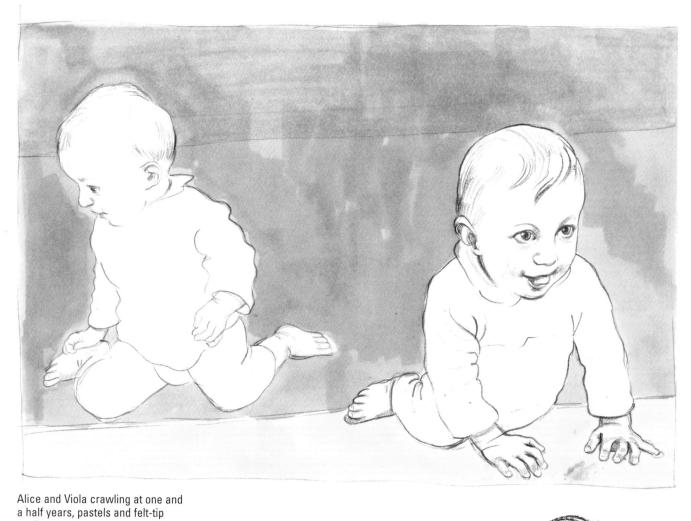

Alice and Viola crawling at one and
a half years, pastels and felt-tip
markers.

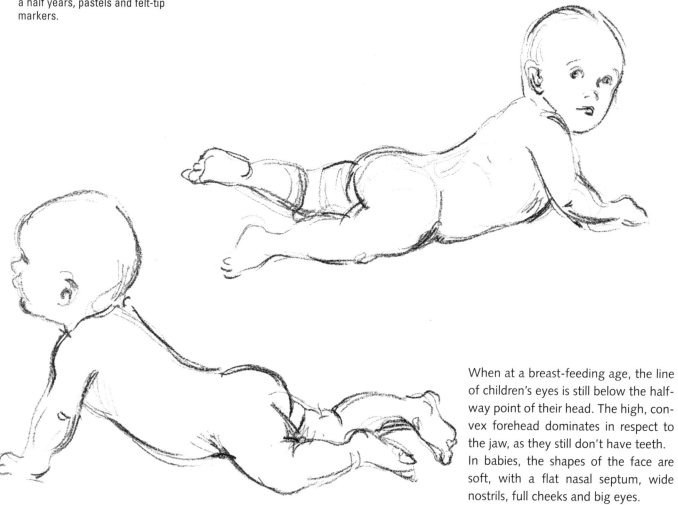

When at a breast-feeding age, the line
of children's eyes is still below the half-
way point of their head. The high, con-
vex forehead dominates in respect to
the jaw, as they still don't have teeth.
In babies, the shapes of the face are
soft, with a flat nasal septum, wide
nostrils, full cheeks and big eyes.

A 1 1/2-year-old boy
and 3-year-old girl.

Below: two boys, one at age
4.5, the other at 7: "neutral
age".

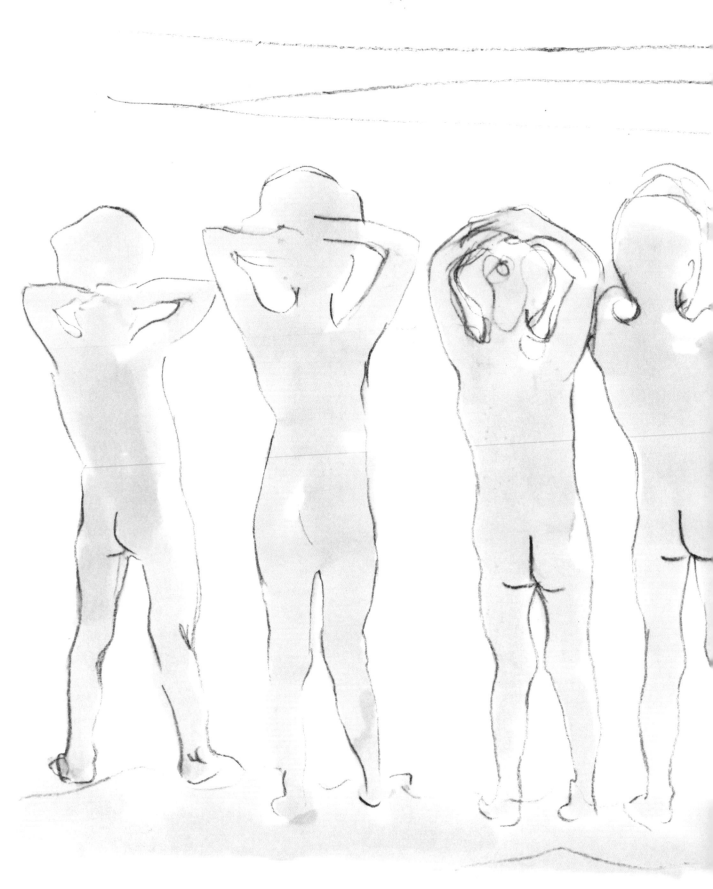

Boys and girls seen from behind on the beach in the "neutral age" phase. It is clear that the two sexes are indistinguishable. The first period (neutral age) spans from breast-feeding infants up to 10 1/2 years old for girls and 12 years old for boys. Up to that moment, the connotations of gender aren't evident; the term "neutral" indicates that, seen from behind, it is nearly impossible to tell a naked boy apart from a naked girl. Pencil and felt-tip marker.

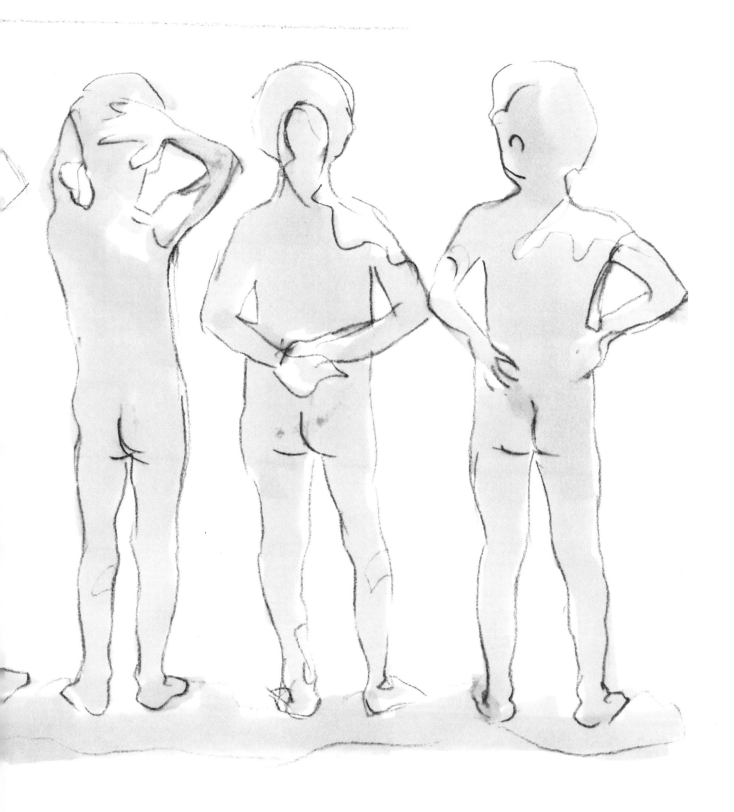

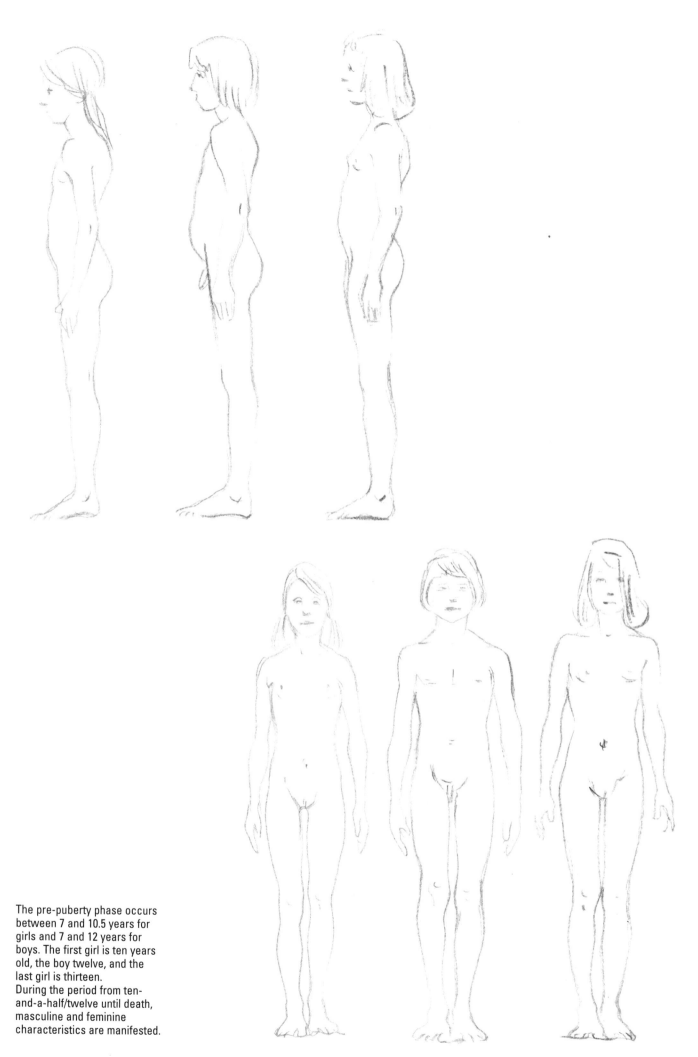

The pre-puberty phase occurs between 7 and 10.5 years for girls and 7 and 12 years for boys. The first girl is ten years old, the boy twelve, and the last girl is thirteen.
During the period from ten-and-a-half/twelve until death, masculine and feminine characteristics are manifested.

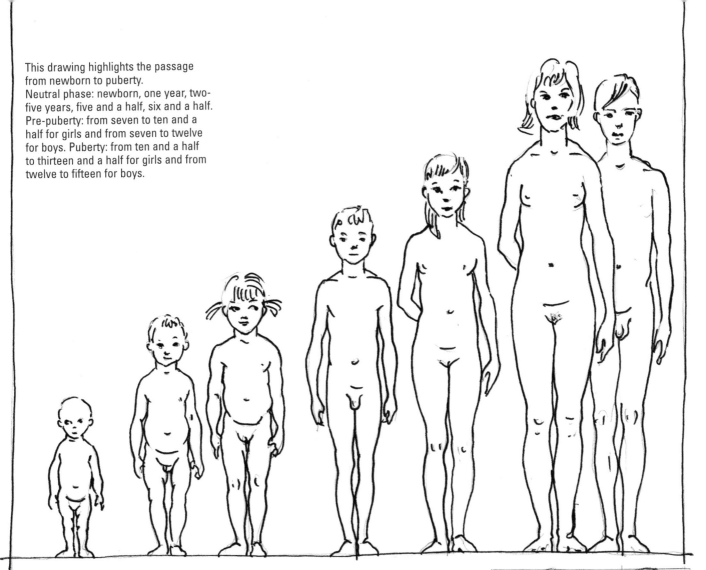

This drawing highlights the passage
from newborn to puberty.
Neutral phase: newborn, one year, two-
five years, five and a half, six and a half.
Pre-puberty: from seven to ten and a
half for girls and from seven to twelve
for boys. Puberty: from ten and a half
to thirteen and a half for girls and from
twelve to fifteen for boys.

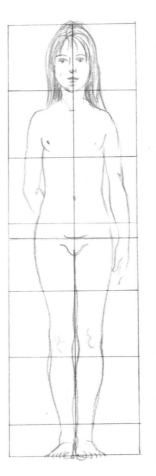

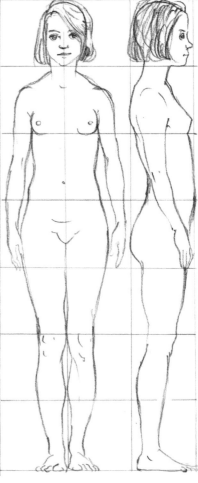

Proportions of a little girl
from four to ten years old.
A twelve-year-old girl seen
from the front and side.

**Illustrations by Giulio Peranzoni
for educational publishing**
Drawings of children of various ages,
between 9 and 13 years old, for a
cartoon-style character study, coloured
brush-stroke technique, intended for a
series of books on law for high school.
Publisher: Zanichelli. Digital technique.

Opposite: illustrated children's stories
in the painterly style of Ferenc Pintér,
a great Italian illustrator, for Lattes
Edizioni. Digital technique: photographs
are a starting point to understanding
and working out the morphological
characteristics of characters of
different ages.

As we've seen, curved lines and big eyes on an over-sized head are the elements that characterise drawings of children and infants. Those attributes are present and accented in all contemporary media, from comic strips to illustration and animated films.

Children under ten years old are generally drawn as shorter and chubbier in order to ensure a "child-like" effect.

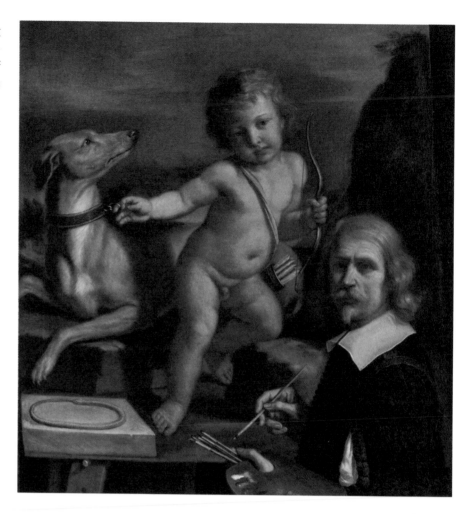

Right: Guercino, *Self Portrait Before a Painting of "Amore Fedele"*, 1655, National Gallery of Art, Washington D.C.

Below: Guercino, *The Madonna of the Sparrow*, 1615-16, detail, coll. of Denis Mahon, London.

Bottom right: Andrea Mantegna, *Camera degli Sposi*, Winged Cherubs Holding the Dedicatory Plaque, detail, 1464-75, fresco, Palazzo Ducale, Mantua.

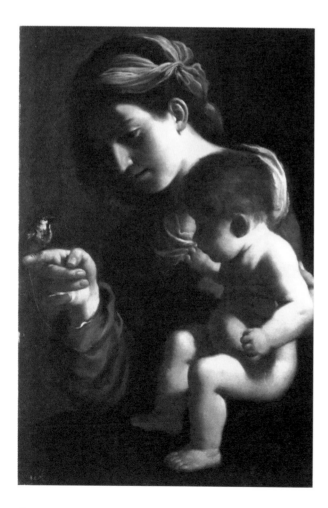

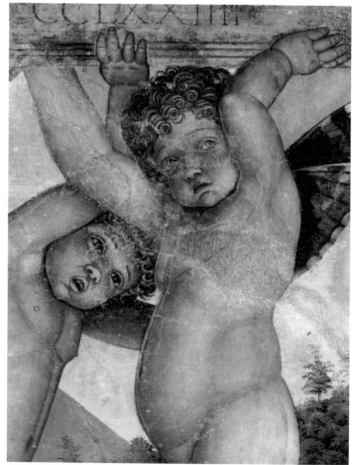

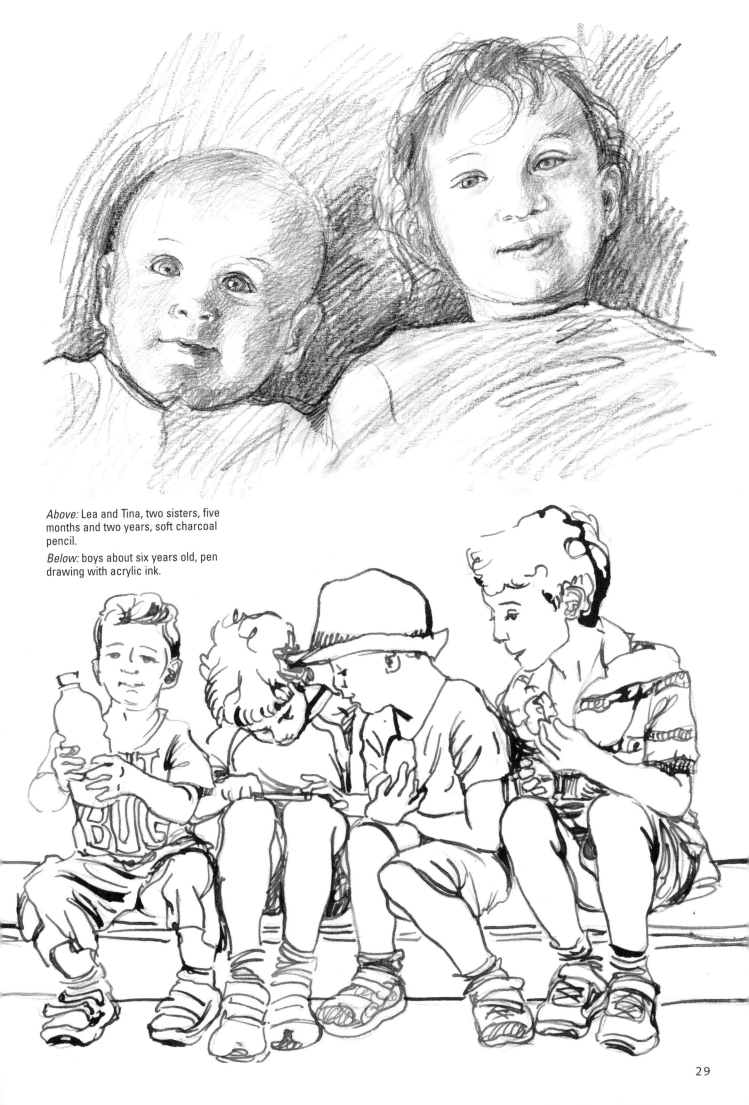

Above: Lea and Tina, two sisters, five months and two years, soft charcoal pencil.

Below: boys about six years old, pen drawing with acrylic ink.

29

CHILDREN IN FASHION

Even the fashion world studies children's proportions in various ages for the purpose of designing and illustrating clothing made just for them.

The sketches by Claudia Ausonia Palazio in *Fashion Sketching,* Promopress demonstrate the passage from fashion silhouettes, which are by nature brief, of children in various phases of development to a study of their dressed bodies.

Fashion academies teach students to create a silhouette, base, or figure to illustrate tailored garments in general, and this is just as valid for clothing for kids. Through the drawings on the book's pages, the author explains how, after having drawn the child's silhouette from photographs, one goes on to drawing the clothing by placing a blank piece of transparent paper over the base. The next step is to lighten the pencil marks with a rubber and proceed to draw and colour in the outfit.

Palazio confirms that: "There are various types of fashion drawings, but two main ones are: the sketch, which represents a stylised outfit, but one that is perfectly understandable in terms of a pattern, fundamental for a company when presenting an entire collection. The sketch is like a blueprint; and an illustration, which represents an already existing item of clothing and which often is seen in fashion magazines or decorating ateliers. They're flashes of a vision that demonstrate the essence of the look. *Fashion Sketching: Templates, Poses and Ideas for Fashion Design*, Promopress (Barcelona), p. 8. And for colouring, "...I recommend 80gr photocopy or printer paper in the A4 format. Start by drawing the clothing with a B or 2B, 0.5 or 0.7 mm micro-lead pencil for precise lines. After it's complete, erase the drawing with a rubber and colour it in with professional markers, then use soft pastels to create a chiaroscuro effect and special weaves. Finally, use a pen, Biro®, or the pencil again to recreate the characteristic immediacy of the drawing."

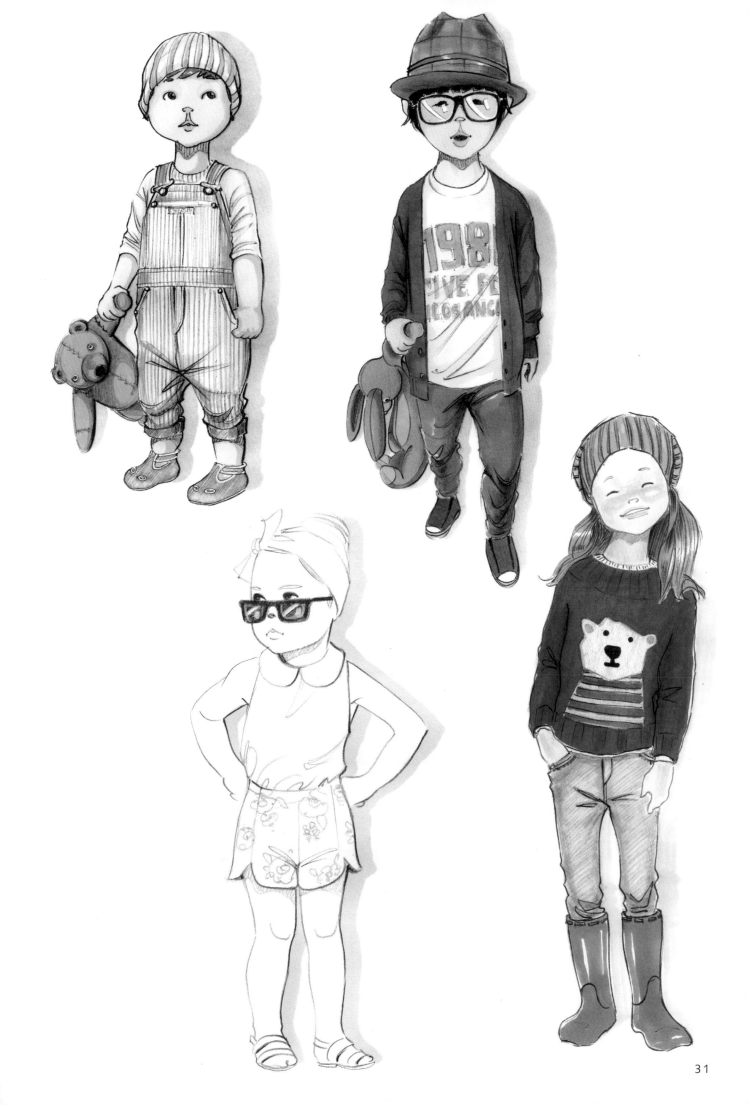

Children almost never sit still, which is, of course, one of the wonderful things about them. But anyone who wants draw them will find it difficult to get enough time to properly understand their proportions, movements facial characteristics and expressions.

When they're asked to pose, they take on stiff, artificial stances and often seem to imitate adults. Such postures are certainly not very expressive of their being children and surely do not match their personalities.

There are many examples of this, especially in official portraits of the past, though today it is mainly fashion photography or advertising that puts them in artificial poses.

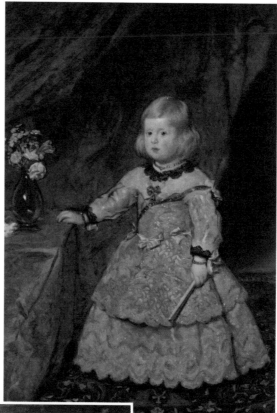

Velazquez, *Infanta Margherita*, 1655, Fundación Casa de Alba, Madrid.

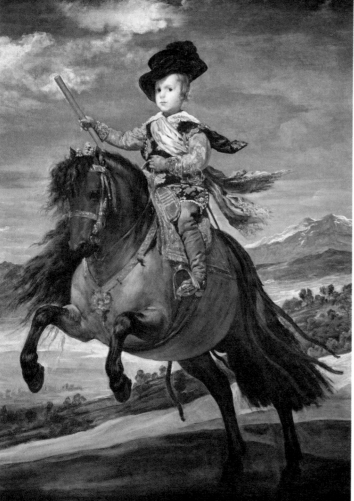

Left: Velazquez, *Equestrian Portrait of Prince Balthasar Charles*, 1635, Museo Nacional del Prado, Madrid.

Below: Van Dyck, *Portrait of Filippo Cattaneo, son of the marquise Elena Grimaldi*, 1623, National Gallery of Art, Washington D.C.

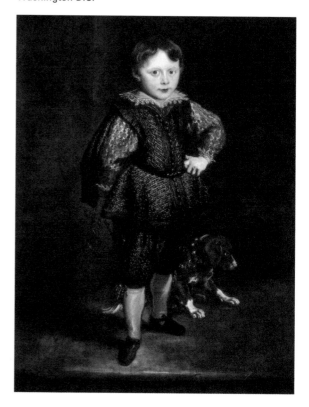

Van Dyck, *Portrait of Maddalena Cattaneo, daughter of the marquise Elena Grimaldi*, 1623, National Gallery of Art, Washington D.C.

Two print advertisements for children's clothing and accessories.

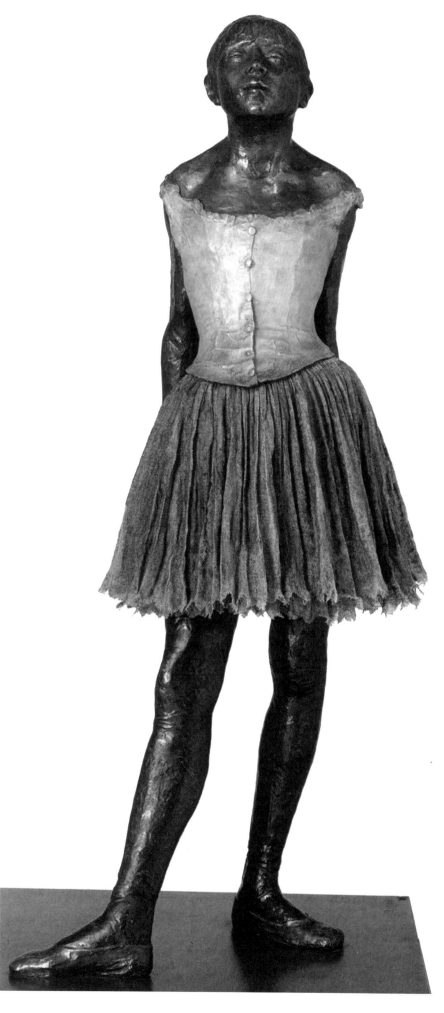

Edgar Degas, *Little Dancer of 14 Years*, 1881,
Musée d'Orsay, Paris.
The first signs of womanhood can be seen
in the little girl. Her hips are still narrow
and angular, but the roundness of the chest
is visible and, thanks to the ratio between
head and body, it's clear she has grown
taller.

Among the phases of growth which
have especially inspired artists are those
of the passage from one phase to an-
other, for example, the passage from
pre-puberty to puberty (between 11
and 14 years) where forms are still tak-
ing shape. Halfway between past and
future, these forms hint at the adult
who is yet to appear.

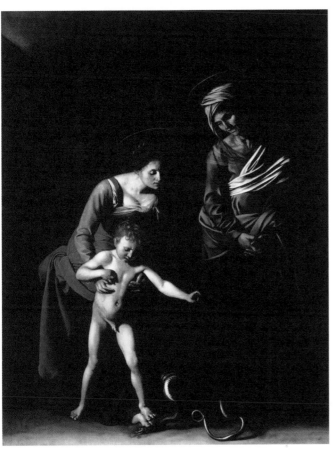

Caravaggio, *Madonna and Child with St Anne*, 1604-1606, Borghese Gallery, Rome.

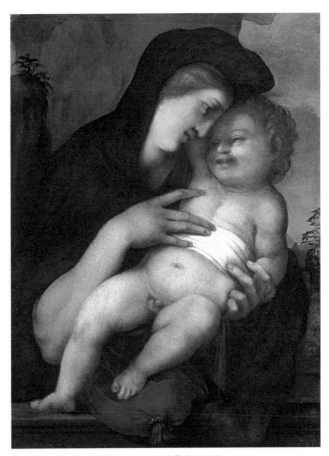

Alonso Berruguete, *Madonna and Child*, 1517, Uffizi Gallery, Florence.

In official poses as well as in the majority of advertising imagery, children often lose a large part of the vital freshness and spontaneity which characterise their world, so rich and unexpected that they are always amazed and enjoy themselves while inspiring tenderness in others.

Starting in the Renaissance, many great artists have managed to avoided stiffness and sought out poses that seem spontaneous, even when representing sacred, solemn scenes such as the Madonna and child. The baby Jesus isn't a posed baby, but a natural one, realistic

and lively in the loving, playful relationship he has with his mother. The solutions adopted by these artists bring religious representation closer to the reality lived through direct experience.

35

GESTURAL DRAWING

Life drawing, unlike photographs which stop time, moves with time and clearly shows the process of its appearance. In a certain sense, the drawing embodies time.

No matter what they are, drawing subjects in movement from real life requires very attentive, in-depth observation followed by quick, general sketching.

It might seem more difficult to draw quickly, in two or three minutes at most, instead of drawing slowly, taking your time. However, sketching with brevity, done without continuously double-checking and re-doing the image, makes it easier to capture the subject's entire gesture and, more importantly, the character of that gesture. At the same time, the dimensions and spatial relationships which exist within the composition of the entire drawing can be rendered.

When quickly sketching, the first lines (which may be quite light) are then joined by others which get closer to that being observed and which the artist wishes to capture. It is a continuous, progressive bringing into question, mark after mark.

Drawing is an incessant process of correction. It moves forward thanks to corrected mistakes.

Once a quick gestural sketch has been completed, the proportions can then be verified in a review. This step which is particularly necessary for representations of children because, as we have already seen, they have proportions which are entirely unlike those of adults. It's a verification which can improve the drawing and make it more effective and realistic.

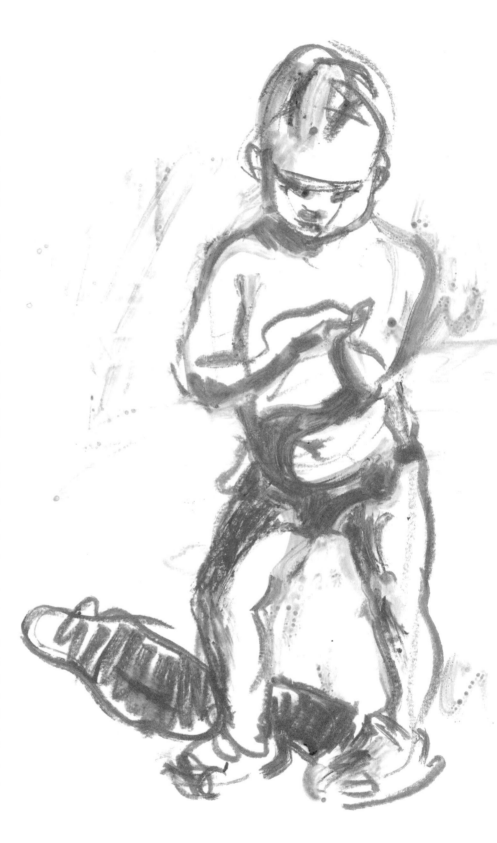

Above and on the following pages: children represented through life drawing with brush pen, wax pastels and soft graphite.

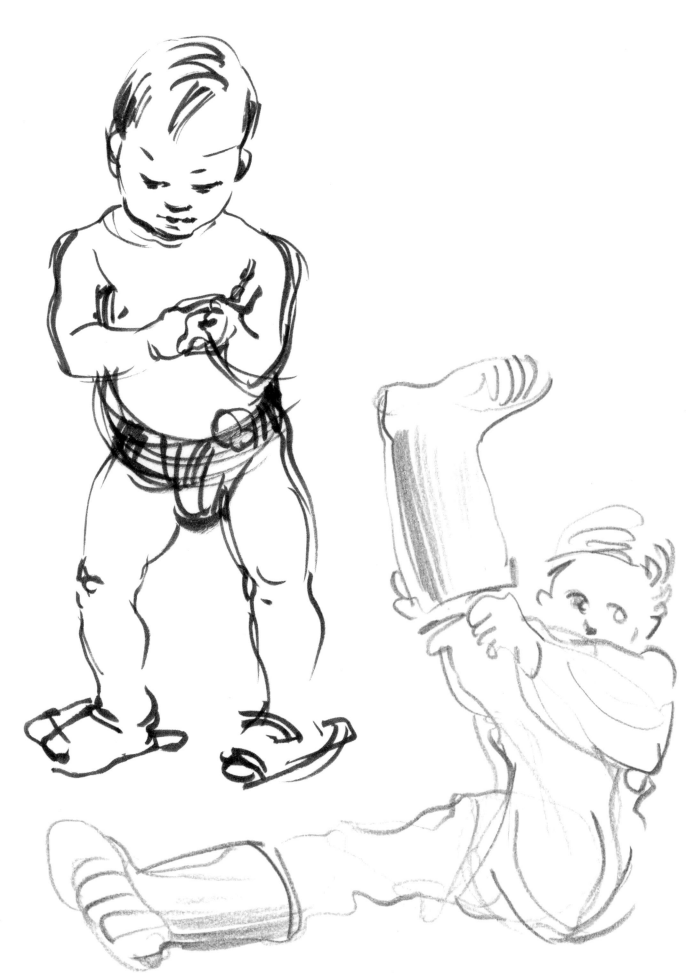

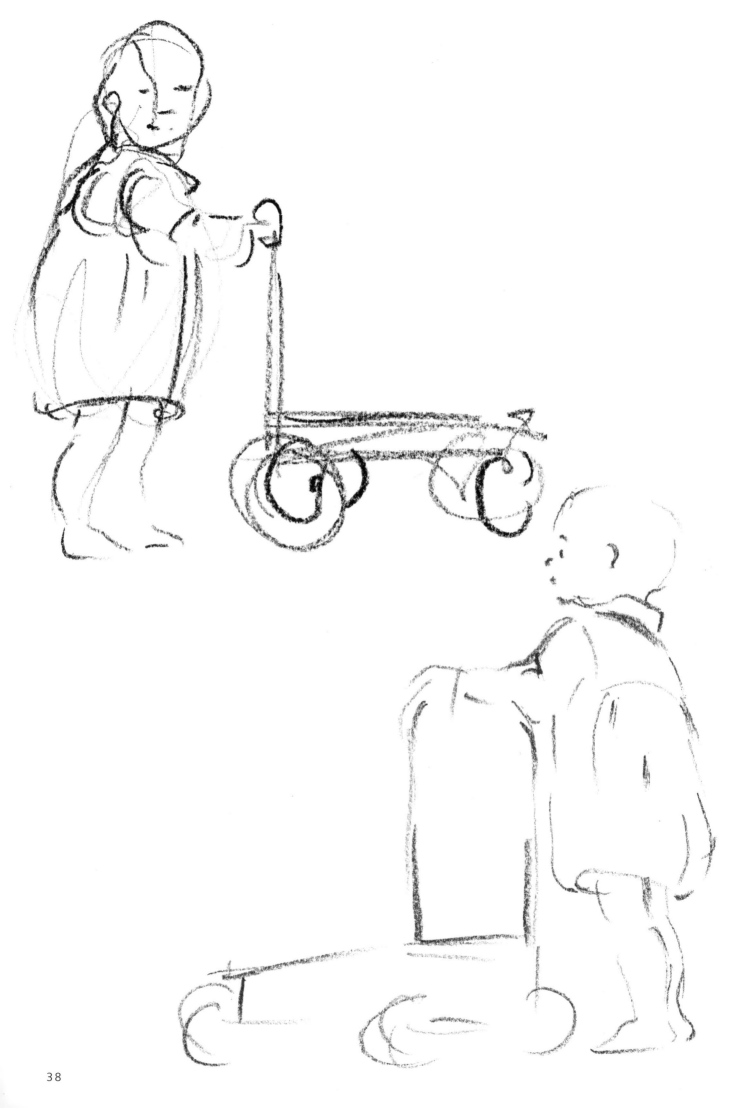

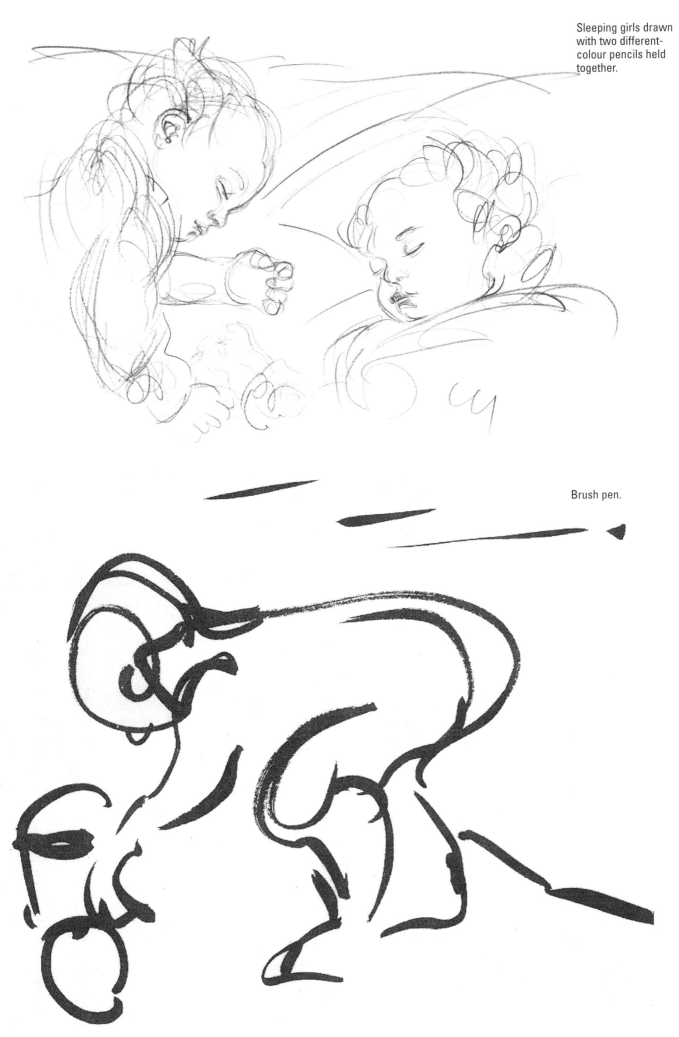

Sleeping girls drawn with two different-colour pencils held together.

Brush pen.

To capture children in their daily dynamic actions, it's best to identify the situations in which the repetition of a specific movement is handy. One occasion and great place of observation is the playground where children regularly engage in repeated movements such as that of going down the slide or swinging on the see-saw, etc, or the beach, with all the possible games they can play in and out of the water.

A simple sketchbook, a bench or a beach chair and something to draw with are more than enough to start observing and representing moving subjects.

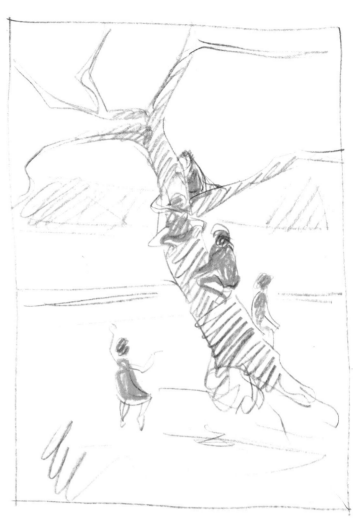

Children in the garden climbing a tree, quick sketches plus the subsequent addition of paint, pastels and watercolour pencils.

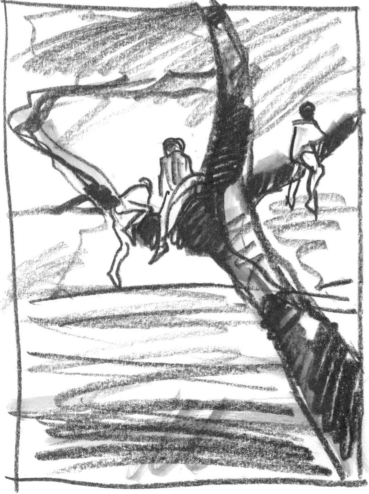

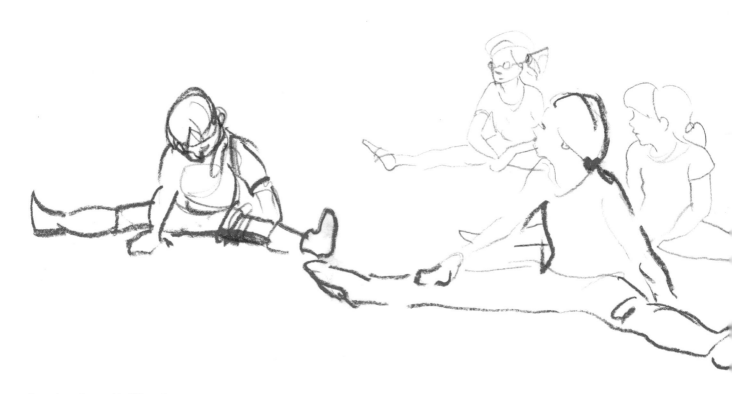

Exercises done with different
materials during a dance
lesson.

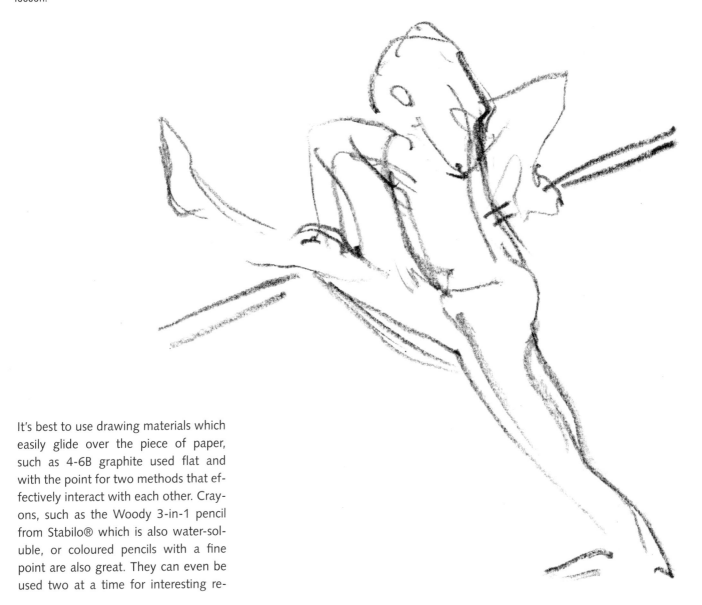

It's best to use drawing materials which
easily glide over the piece of paper,
such as 4-6B graphite used flat and
with the point for two methods that ef-
fectively interact with each other. Cray-
ons, such as the Woody 3-in-1 pencil
from Stabilo® which is also water-sol-
uble, or coloured pencils with a fine
point are also great. They can even be
used two at a time for interesting re-

sults. Even markers with a fine point are quite suitable for drawing quickly; the same is true for brush pens found on the market, with black and coloured ink. All these tools cannot be erased and that's fine. It's better to draw a lot and even make mistakes and repeated images instead of making only a few without confidence.

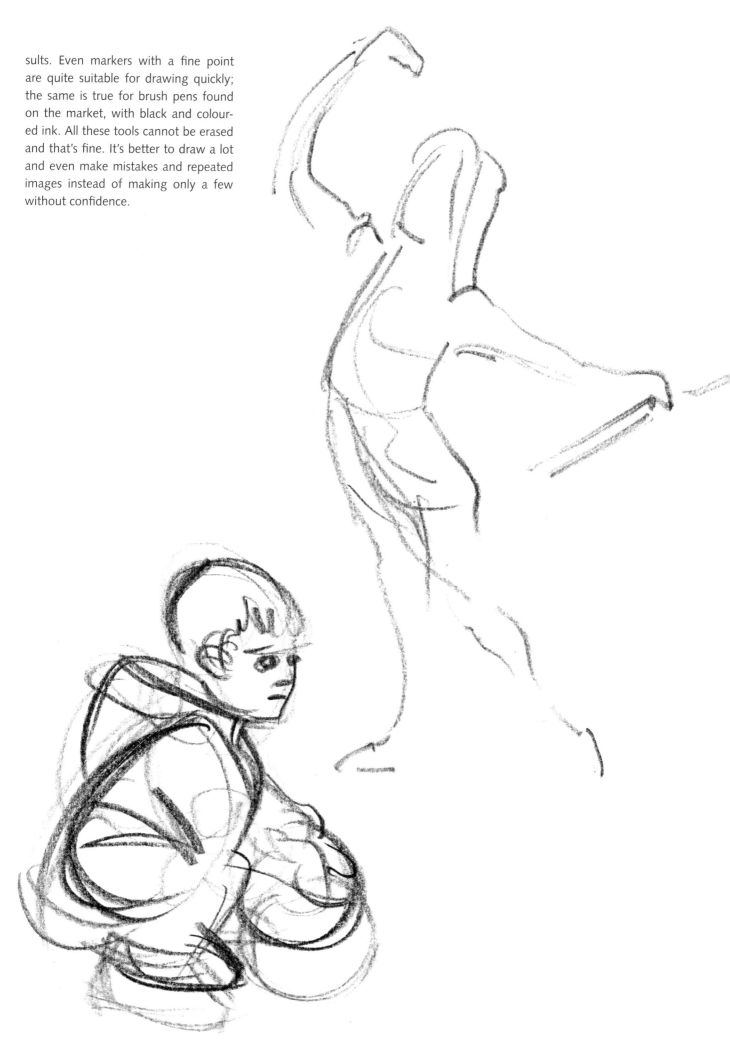

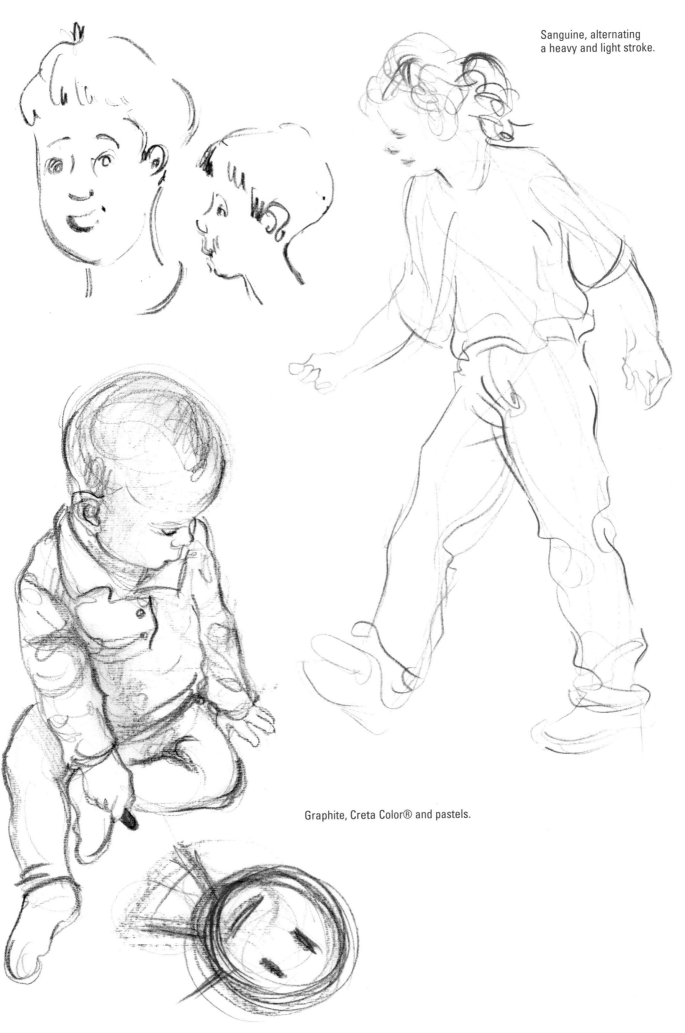

Sanguine, alternating
a heavy and light stroke.

Graphite, Creta Color® and pastels.

43

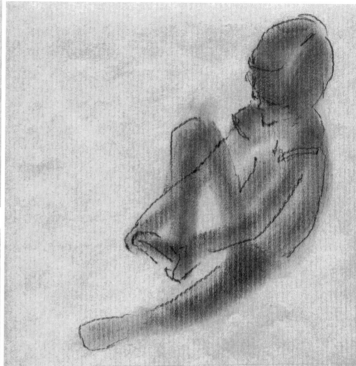

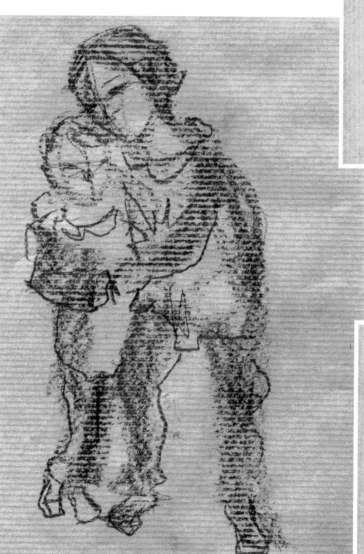

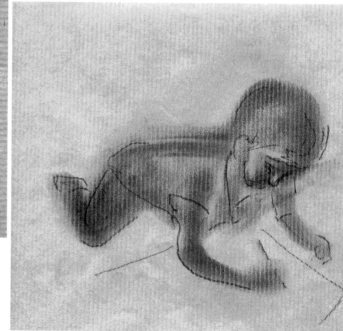

Rachele Santini, a student in
the illustration course at IED,
depicted her younger siblings
with a graphite stick, using the
point and side, then blending.

44

To capture figures in movement, they must be seen as a whole with a single gesture of the hand, trying not to lift the drawing material from the paper. The intention isn't to describe the movement itself, but to render the idea of that movement almost without looking at the sheet of paper, concentrating on the subject. Just a few seconds are necessary and sufficient to do so. When the action is repeated, it is possible to examine the drawing and correct or complete it. In any case, avoid illustrating the details until you've observed them for a long period of time and have truly understood them, perhaps creating separate drawings of specific details.

This exercise must be repeated multiple times so as to affix the observed movements in one's mind. Creating multiple drawings of the same action or of the same dynamic position makes it possible to really understand it and, as a consequence, identify the solution which can describe the subject in a truly efficient way.

In general, this method helps the artist understand proportions more by intuition than by reason, perhaps also because the brain doesn't have time to use the a priori tactics which tend to have a negative influence on our understanding of what we observe.

Tracing the soft lines and curves with light pressure creates results which can highlight the sense of movement. It's best to start drawing from the centre of the body and proceed outwards, leaving the head for last.

Open, repeated, light lines help avoid the stiff effects which deprive the subject of natural movements and create fake, abstract images, aside from the fact that the human body does not have a single straight, stiff line (if it did, bending one's joints and balancing would be nearly impossible).

Children playing on the beach, in a soft lead pencil using different levels of pressure.

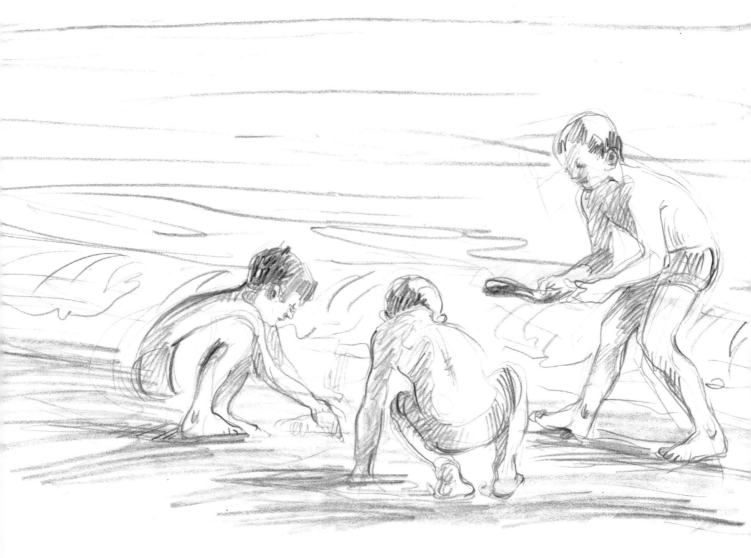

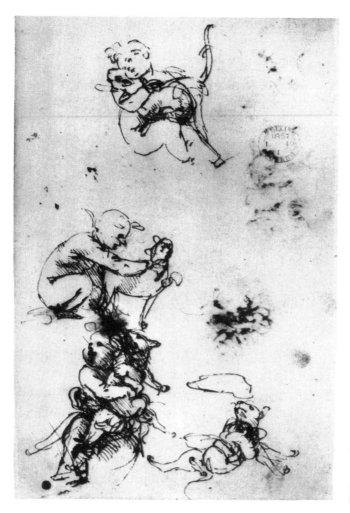

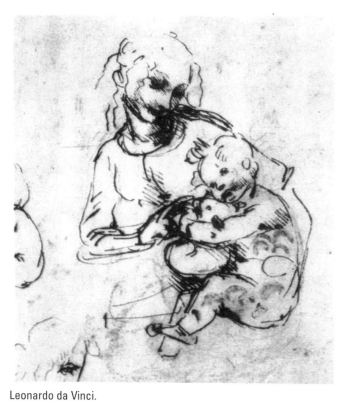

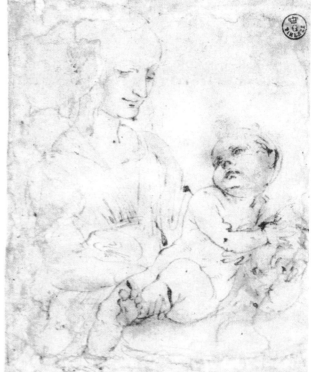

Leonardo da Vinci.

Above: two studies for the
Madonna del Gatto (1478-1480)
British Museum, London.

Below, at left: Study for the
Madonna del Gatto (1478-1480),
British Museum, London.

Below, at right: Life study
for the Madonna del Gatto
(1480-1483), Uffizi Gallery,
Department of Drawings and
Prints, Florence.

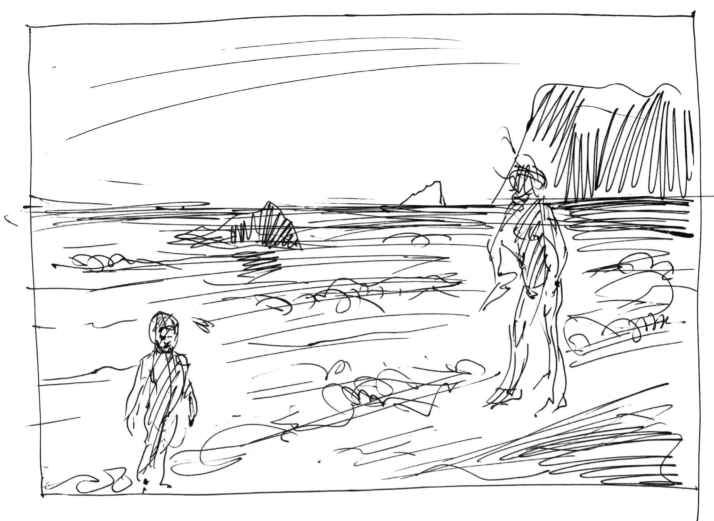

Little boys and girls playing on the beach
and at home, pencil and pen.
By drawing quickly from real life, it
is possible to capture not only the
personalities of individual children, but
also their proportions in relation to those
of other subjects such as adults, other
children, animals or other elements from
the environment where the action is taking
place.

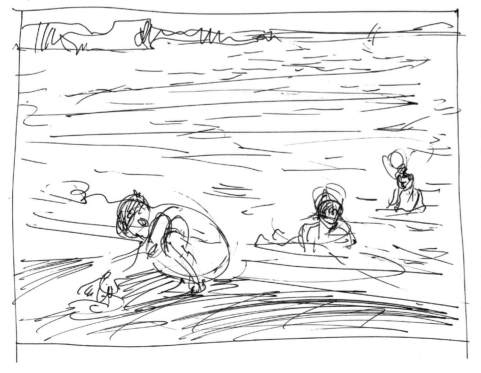

Again with a quick, summarising stroke,
it is possible to capture the entirety of a
scene with the related actions and char-
acters in it, drawing all the elements of
the image almost simultaneously. Start
drawing the "load-bearing" lines of the
whole, the lines within which the in-
dividual subjects are defined. Go from
that in the foreground to those far away
and the surroundings without worrying
about continuity.
We're accustomed to seeing people and
their surroundings as separate entities
when in reality they are all elements of
a single whole.

Two sisters play dress up and try on clothing, pencil and pen.

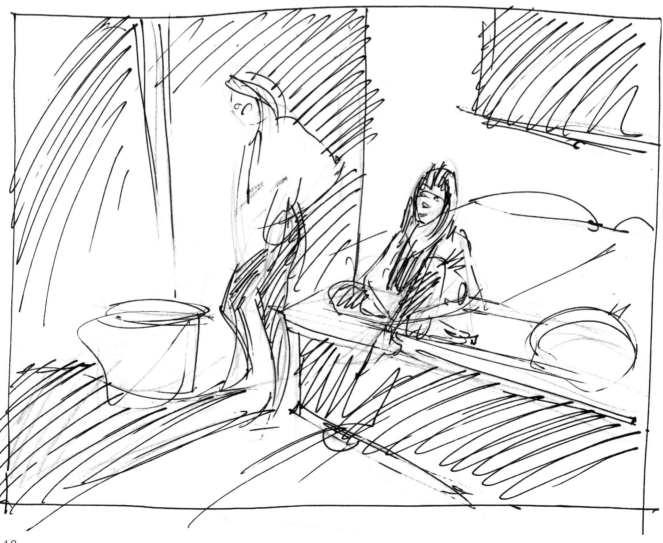

A composition study
of three paintings by
Federico Zandomeneghi,
*In Bed, Fishing on the
Seine, At the Opera*, 1877-
78, grease pencil.

To learn how to draw scenes, it's use-
ful to try to see in this way. You can use
photographs or, better yet, paintings
by great artists of the past which de-
pict complex scenes made up of people
in the foreground and background in an
internal or external setting.

With quick sketches, you can summa-
rise the overall composition, seeking
out the idea of the whole without stop-
ping to depict single elements, trying to
capture the general movement of the
piece.

Graphite is the perfect tool to shade and sculpt a scene using chiaroscuro. When used on its side, it quickly renders the impression of the whole, and with various tones of grey, it gives the sketch a sense of proximity or distance.

Depth is built upon a scale of luminosity and shadows, through chiaroscuro, give the elements volume. This produces a realistic effect with perspective.

Drawings by grand masters clearly show what the study and progressive steps leading to the final result were. The traces which the tool (graphite, charcoal or pen) leaves on the paper demonstrate how the initial idea gradually becomes precise, from the lighter marks to those which are more defined and stressed.

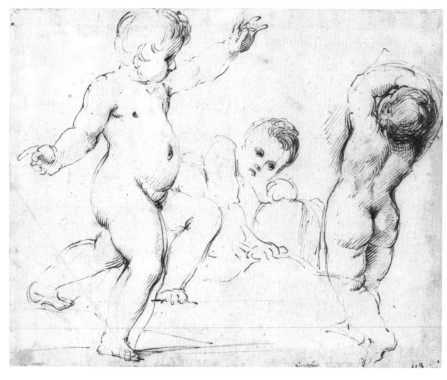

Guercino, *Study of Three Putti Playing*, private collection.

Below at left: Guercino, *Two Putti*, Los Angeles County Museum of Art.

Bottom right: Michelangelo, *Madonna with Child*, 1524, Casa Buonarroti, Florence.

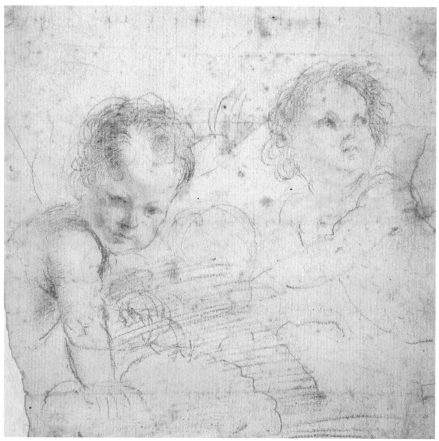

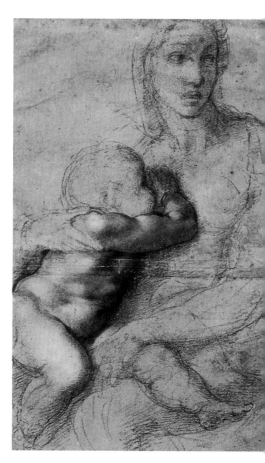

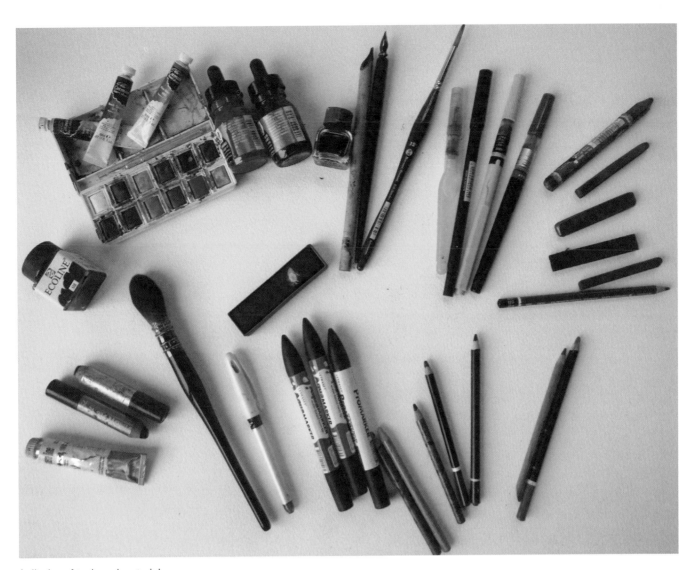

A display of tools and materials.

When drawing, it's always best to use inexpensive types of paper as it tends not to inhibit the artist as costly paper does. Drawing is a continual, infinite study. As such, it must flow freely and naturally without encountering obstacles of any sort, not even financial ones.

Photocopy paper is great: it comes in plentiful reams and costs relatively little. Other good options are translucent sketching paper, which is yellowish, relatively absorbent and well-suited to Conté or charcoal. All types of paper found at home can be re-purposed for art, including white or brown packing paper and wrapping paper, different types of cardboard and paperboard, scraps from cardboard boxes and any other material which might transform into a surface for drawing.

Many experiments will be disappointing, but if you persevere and continue to try, something good is sure to come of it.

It's incredibly important to try numerous different materials, graphics, pictorial devices, and scenes on different surfaces and experiment with different things to find the most interesting and pleasing solutions.

Try different tools on the same surface and different surfaces for the same tool. Surprising if continuous, this study method makes it possible to discover and strengthen one's hand to identify what will become your unique, personal expressive style.

With gestural drawing, you get used to seeing and representing movement, a fundamental element which characterises all living subjects. So, that's where we'll begin our path.

In my previous book, *Human Figure Drawing: Drawing Gestures, Postures and Movements* dedicated to drawing movement, a quotation of Bruno Munari explains: "Observe at length, understand deeply, create in an instant." This precise, succinct and admirable definition expresses the concept of drawing quickly from real life.

Dedicating oneself to drawing with pre-defined times, one or two minutes at most, helps one understand the gesture and develop the ability to see in order to draw.

It's best to trace the lines without lifting the instrument from the paper and without slowing one's rhythm, letting

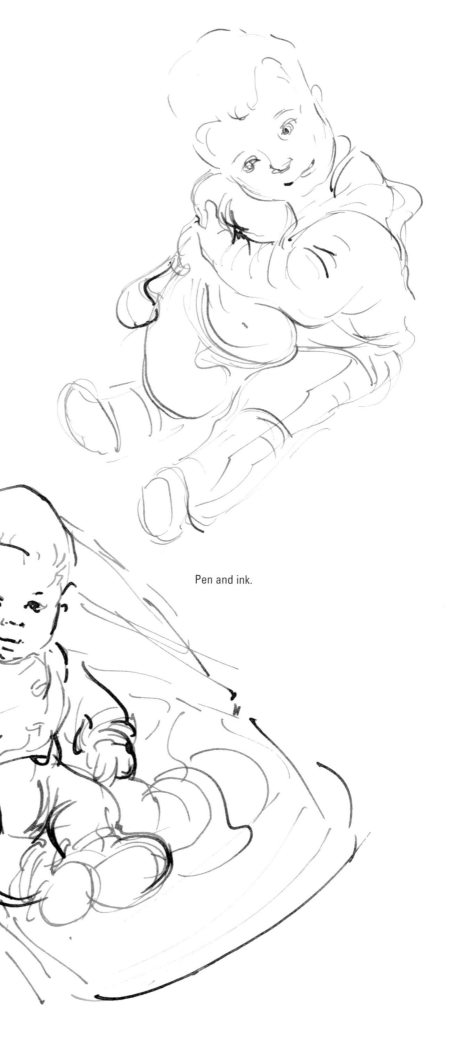

Pen and ink.

your hand move freely and without trying to follow the outlines of things. This exercise helps capture the dynamism of things, the change that characterises every living being.

In the first 5-10 seconds, after having observed attentively, draw the whole without worrying about making the subjects "legible". Even when the result is indecipherable and the drawing is to throw away, the exercise has produced a change. I recommend dating the sketches to see the transformation and thus gain awareness about the outcome of one's path.

In addition to living beings, even things have "gestures": a leaning curtain, the waves produced by the wind on the sheet hung out to dry, the growth of a blade of grass, a newspaper on the table. The gesture is the whole of all the forces which act within a subject.

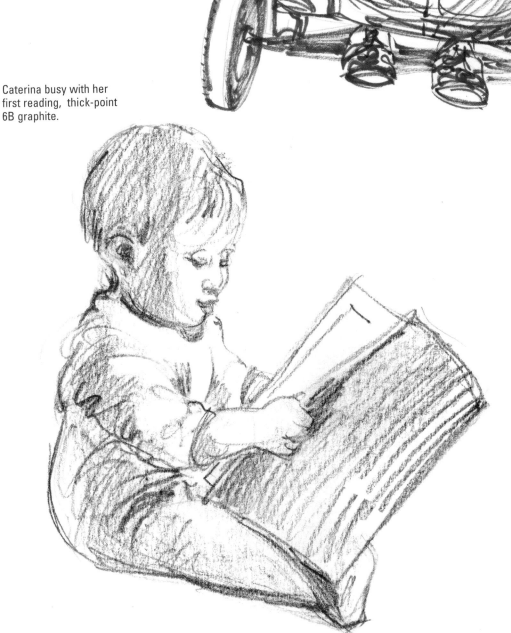

A promising driver, drawn with a brush pen.

Caterina busy with her first reading, thick-point 6B graphite.

Thick-point pastel pencils

Everyone's gesture is personal, like a signature: even if each one is never perfectly identical to the one before it, it can always be recognised thanks to the characteristic "hand" that sets it apart. Repeating the gesture of the person who wrote it, almost always makes it possible to understand a seemingly-illegible word. Even when trying a new Biro®, one tends to make new gestures and movements which are found in painting and drawing.

Recognising that you naturally have your own hand or gesture, and not criticising every single mark made by repeatedly erasing them, is the best way to study the representation of truth. One's hand is also relative to the tool used, which is why experimenting with different materials is important.

Drawing children from real life requires even more attention than drawing adults because, like puppies, they're always busy exploring the world with quick, rapid movements until they suddenly collapse, succumbing to sleep.

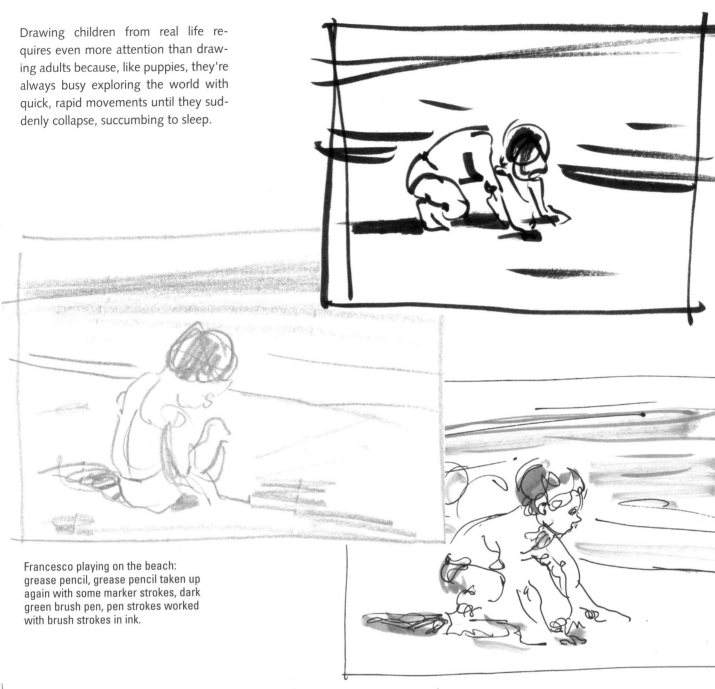

Francesco playing on the beach: grease pencil, grease pencil taken up again with some marker strokes, dark green brush pen, pen strokes worked with brush strokes in ink.

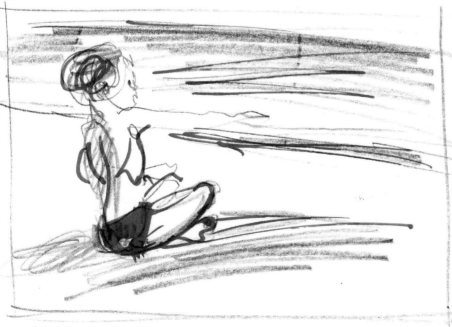

Observing kids as they play, in the home or out in the open, and paying the utmost attention in order to understand their repeated movements, drawing them quickly, is always a useful exercise. Life drawings can be taken up again later with additions or clarifications, or simply with colourful touches to highlight certain details, using various techniques, including water colours, oil pastels, pastel pencils or coloured pencils.

55

Paul Klee once said that "drawing is taking a line for a walk", and this is a bit of the spirit which animates draughtsmen. The final result is not and should not be what guides one's hand. Rather, it is the journey that the pencil or pen takes to represent a story, which is simultaneously the story of the subject portrayed as well as that of the artist.

One of the best materials for quick life drawing is graphite in its various forms. Graphite sticks and pencils in general quickly glide on the paper. All you need to do is increase or decrease the pressure for a wide range of greys.

To capture gestures and quick movements, refillable brush pens are another good tool. Refill the container with water and ink, subsequently adding just a few details, highlighting them with a pen.

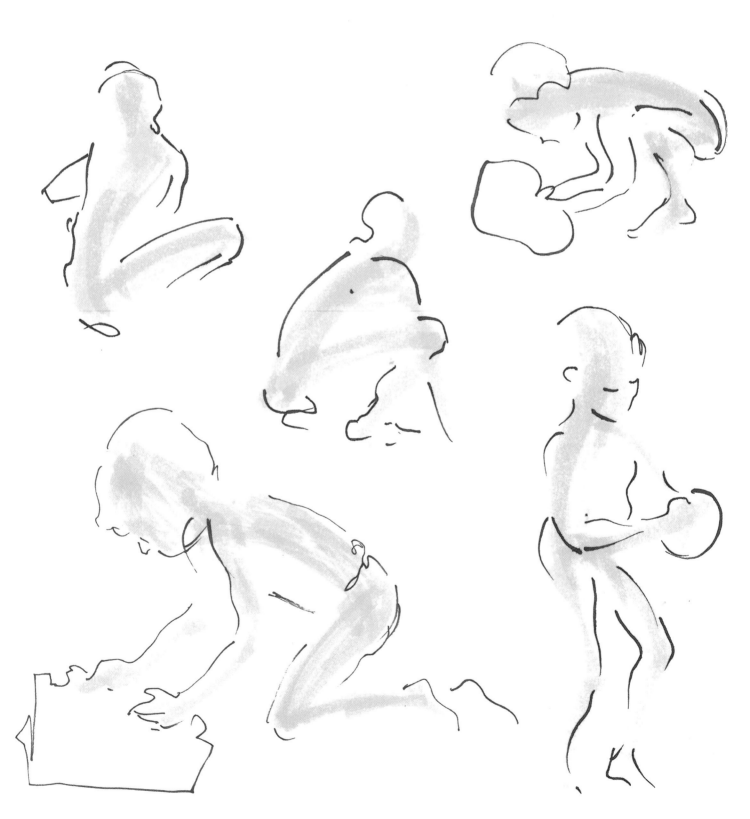

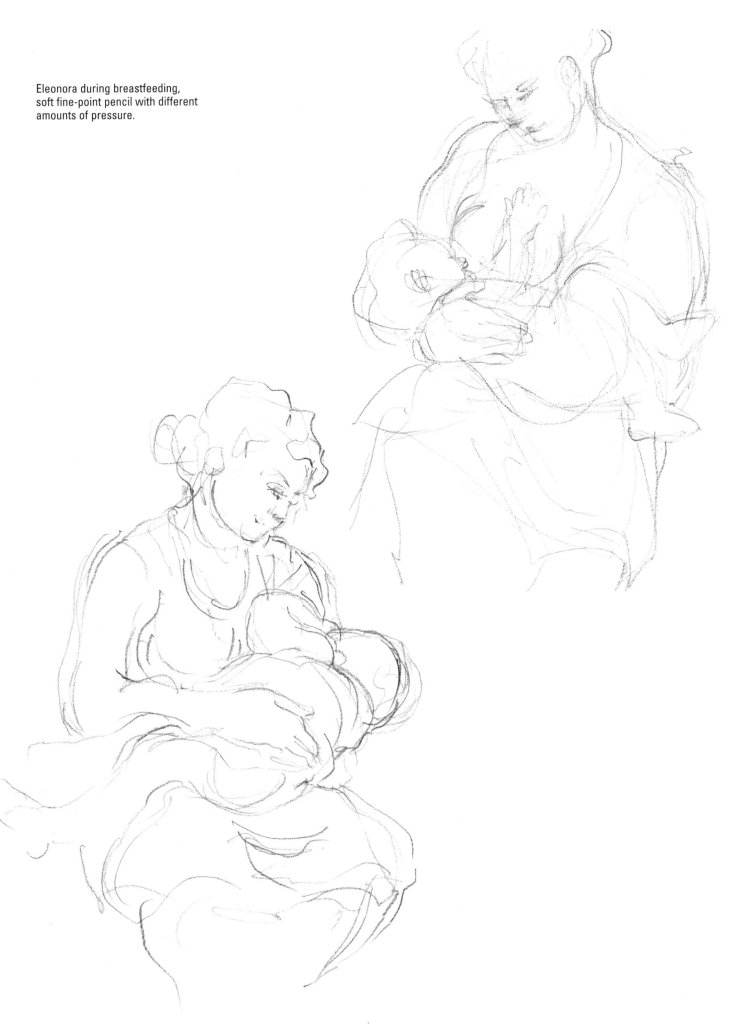

Eleonora during breastfeeding,
soft fine-point pencil with different
amounts of pressure.

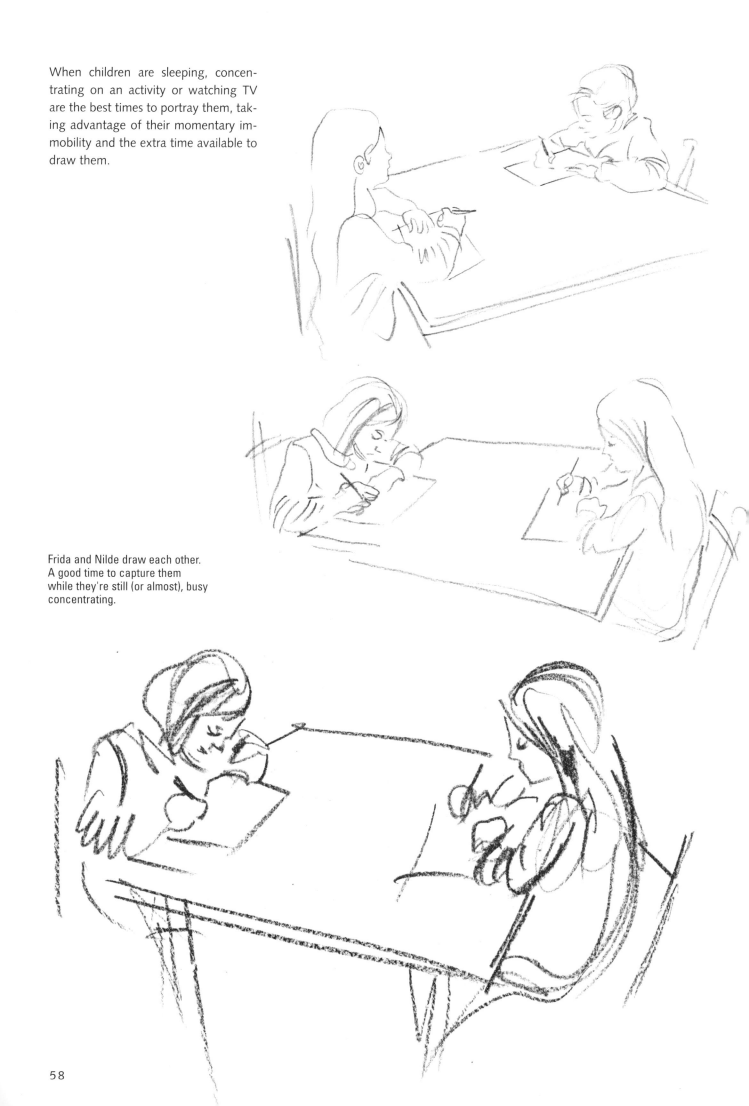

When children are sleeping, concentrating on an activity or watching TV are the best times to portray them, taking advantage of their momentary immobility and the extra time available to draw them.

Frida and Nilde draw each other. A good time to capture them while they're still (or almost), busy concentrating.

58

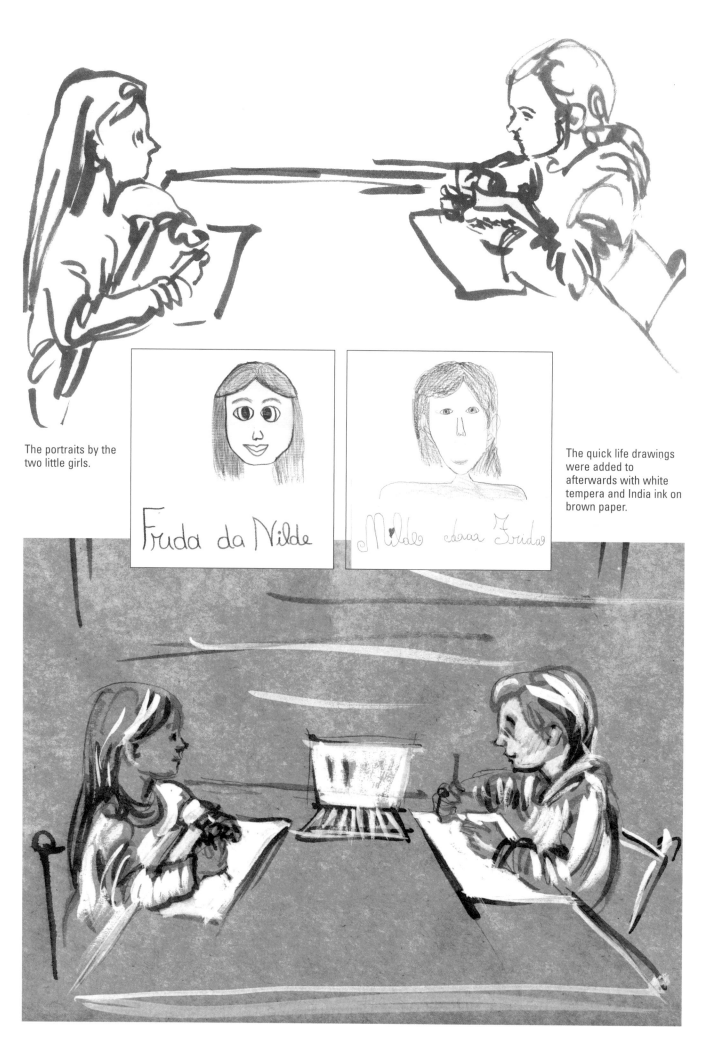

The portraits by the two little girls.

Fruda da Nilde

The quick life drawings were added to afterwards with white tempera and India ink on brown paper.

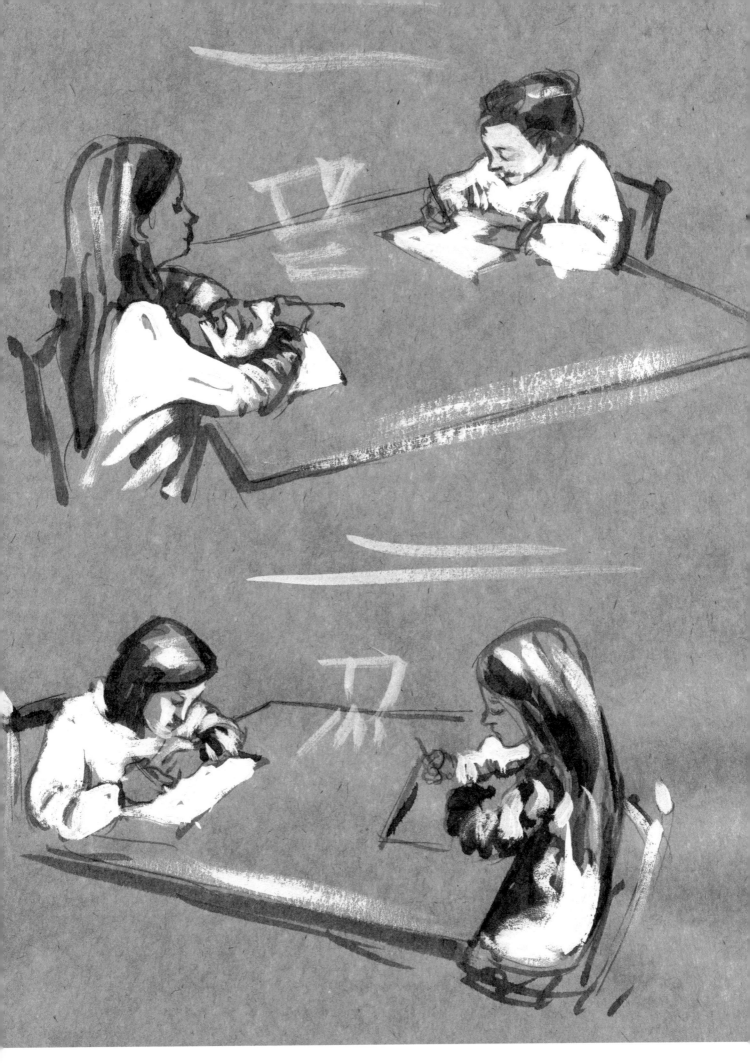

To conclude, drawing quickly teaches you first and foremost to see and, in particular, to understand a specific movement as well as the personality and character of that child and his or her way of interacting with space and others.

Character designers often start precisely from the qualities of movement to identify the morphological aspects, personality, emotions and stories of a character.

Alice and Viola sleeping, portrayed in pen with acrylic Liquitex® ink in Phtalocyanine green.

Below: life-drawn portrait of Fabio at twelve y.o. in pencil.

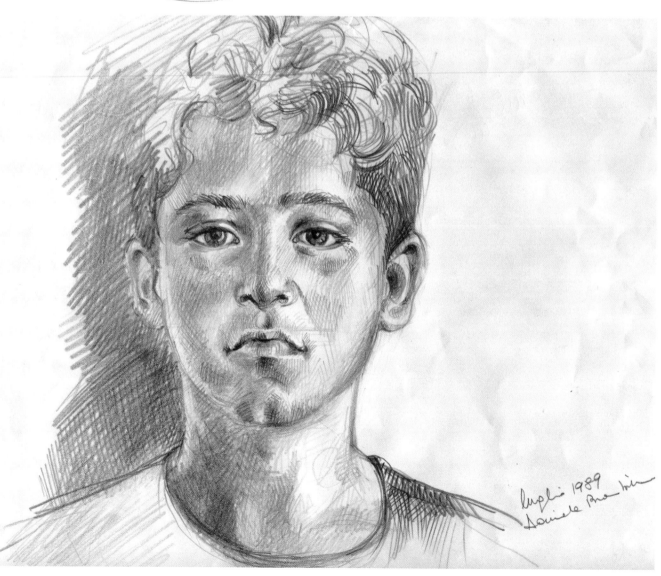

DRAWING FROM MEMORY

Even drawing from memory can benefit from quick sketching. You'll need to observe attentively and then try to quickly reconstruct the observed subject. Naturally, the goal won't be to create a meticulous description, but will be to practice your ability to capture the essential features of a subject and graphically render them.

Again, smoother materials which glide over the surface of the paper are preferable. Without overdoing it, and by working gradually, you'll reach an increasingly-defined level.

Exercising one's memory is also useful for life drawing. It teaches one to observe in the right way, to memorise shapes and spatial relationships as a whole, and to perceive the relationships between positive and negative space. In essence, it helps creates a special way of seeing: "seeing as an artist". It's like putting on a special pair of glasses which give you a rare talent for

paying attention, that which makes it possible to capture shapes through discovery, touching it to get proof that the world is solid and material. The drawing then becomes a sort of map, like that of a just-discovered island, never seen before.

Learning to draw is primarily based on learning to see, and memory is an always-present ingredient in drawing. Copying any subject from real life requires the continuous passage from observation to the gesture, from reality to its representation.

We observe and draw by always resorting to memory, except when blind contour drawing and tracing, though even then memory can play an important role.

Even using photographs is a simple way to start to exercise one's memory. After having looked at a picture for a relatively long time (until you feel like you've memorised it), create an initial sketch

without peeking at the photo. Once you're done, look at the photo and check for differences, correcting them as you go, perhaps in a different colour to highlight the discrepancies between the two versions.

These exercises are effective only when done frequently, practising on any subject, moving or not. We aren't very used to observing and memorising. For example, out of everyone who rides a bike daily, how many cyclists could draw one from memory? Try and you'll see it isn't easy.

Practising drawing from memory is an extremely useful method for learning how to draw in general. It's especially effective for exercising one's observation skills, the basis for representing the world. If done for just a few minutes a day, this sort of mental and visual training is sufficient enough to produce clear improvements in the way one sees and, as a result, the way one draws.

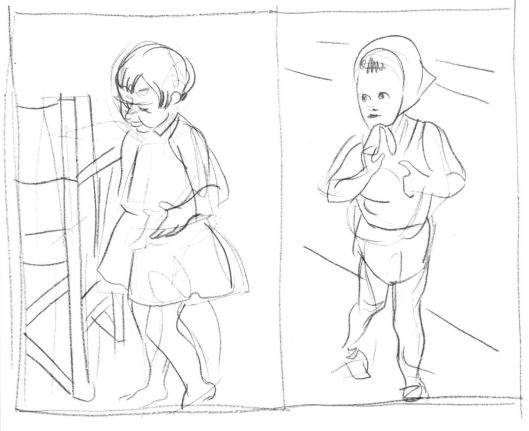

Pictures and drawings. A memory drawing (in blue) was corrected in red while looking at the photo.

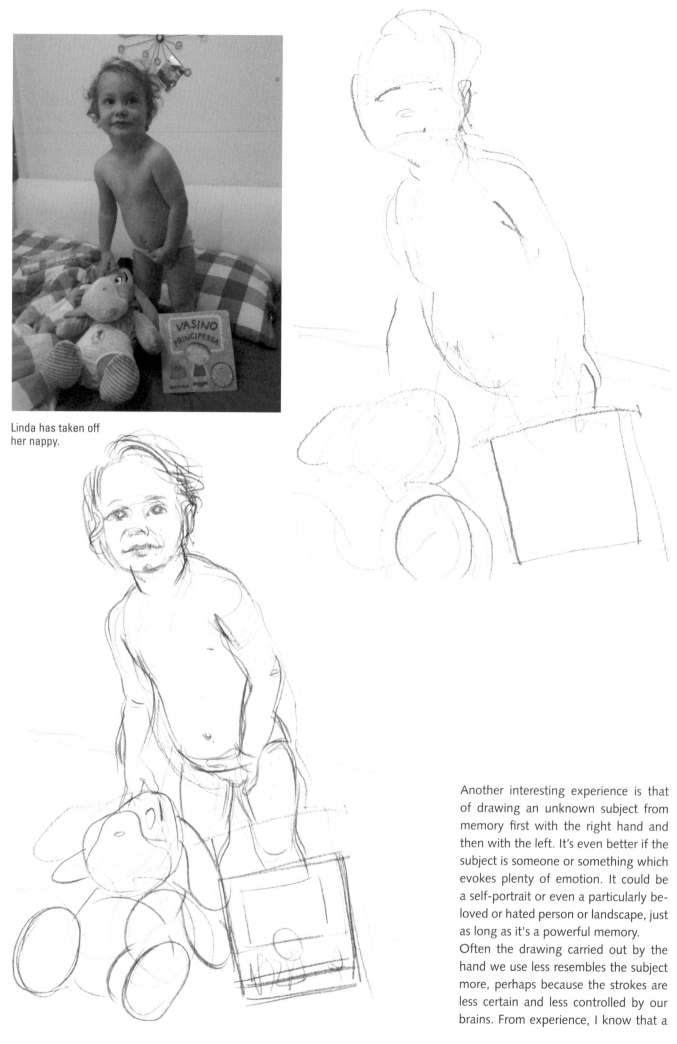

Linda has taken off her nappy.

Another interesting experience is that of drawing an unknown subject from memory first with the right hand and then with the left. It's even better if the subject is someone or something which evokes plenty of emotion. It could be a self-portrait or even a particularly beloved or hated person or landscape, just as long as it's a powerful memory.

Often the drawing carried out by the hand we use less resembles the subject more, perhaps because the strokes are less certain and less controlled by our brains. From experience, I know that a

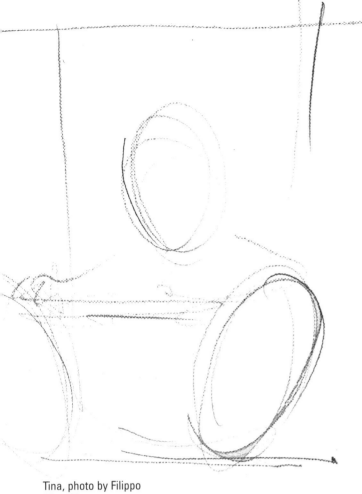

Tina, photo by Filippo
Bianchi

Tina having fun on a
swing.

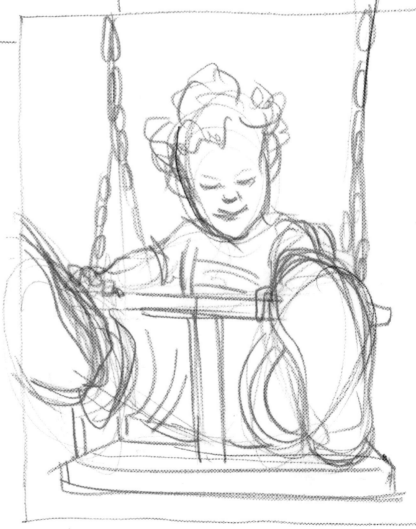

subject is often captured more effectively when the lines describing it are less assured and controlled.

An effective method for training one's memory is carefully observing a picture for a minute or two, turning it over and trying to draw what you remember without hesitating or over-thinking it. Once the drawing is finished, turn the picture over again and correct the parts of the drawing which weren't correctly recalled with a differently-coloured pencil.

METHODS AND TECHNIQUES

Drawing from photographs initially facilitates the work of the person drawing, yet at the same time it requires the artist to learn different skills and the ability to compose a new image with respect to the one in the picture. In short, it isn't a matter of simply transferring the photographic image to a painting or drawing. Even this procedure becomes interesting when going beyond an interpretive objective, developing elaborative abilities which are an entirely personal reading and rendering of the subject.

Faithfully reproducing a photograph as a whole is a useful exercise, but it's good not to limit it to a purely virtuosic one. Though it must be said that even virtuosity shouldn't be discounted: it can always lead somewhere else. From the time photography was invented, painters and then illustrators have managed to benefit from it, using it as a basis for distinctively original solutions.

Drawing from real life and from pictures are two entirely different methods. Photographs facilitate the work to be done because they provide an already-defined frame and a two-dimensional image that doesn't need to be "translated". But, for that very same reason, it's more difficult to break free and find personal ideas.

Yet digital pictures can capture children in special moments, quickly snapping unexpected expressions, small episodes that certainly couldn't be grasped by drawing from real life.

This happens especially with fickle subjects such as children, who offer infinite spurts of spontaneity, changing their own features with impressive speed.

Photographs and videos make it possible to capture unrepeatable moments on the fly, ones where spontaneity makes up the central charm of the person in the image. Seize moments of play and unique expressions, tenderness and anger, emotions and reactions, conflicts and expressions of affection between kids and stories of friendship between children and animals.

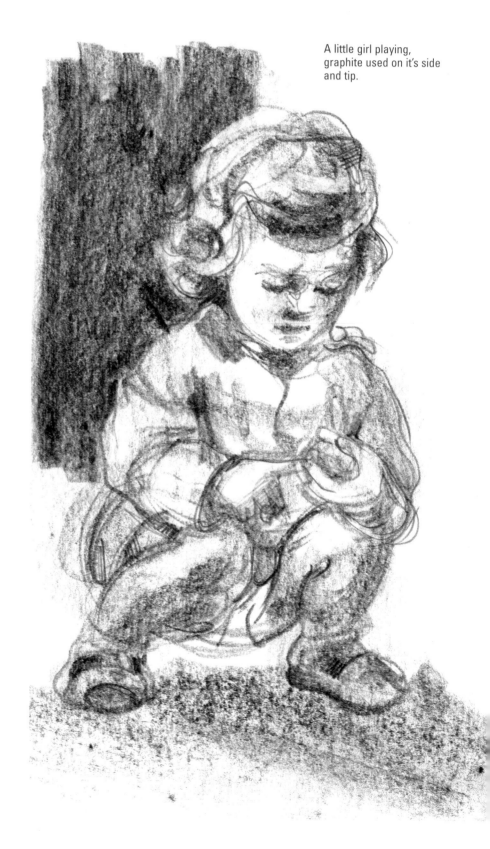

A little girl playing, graphite used on it's side and tip.

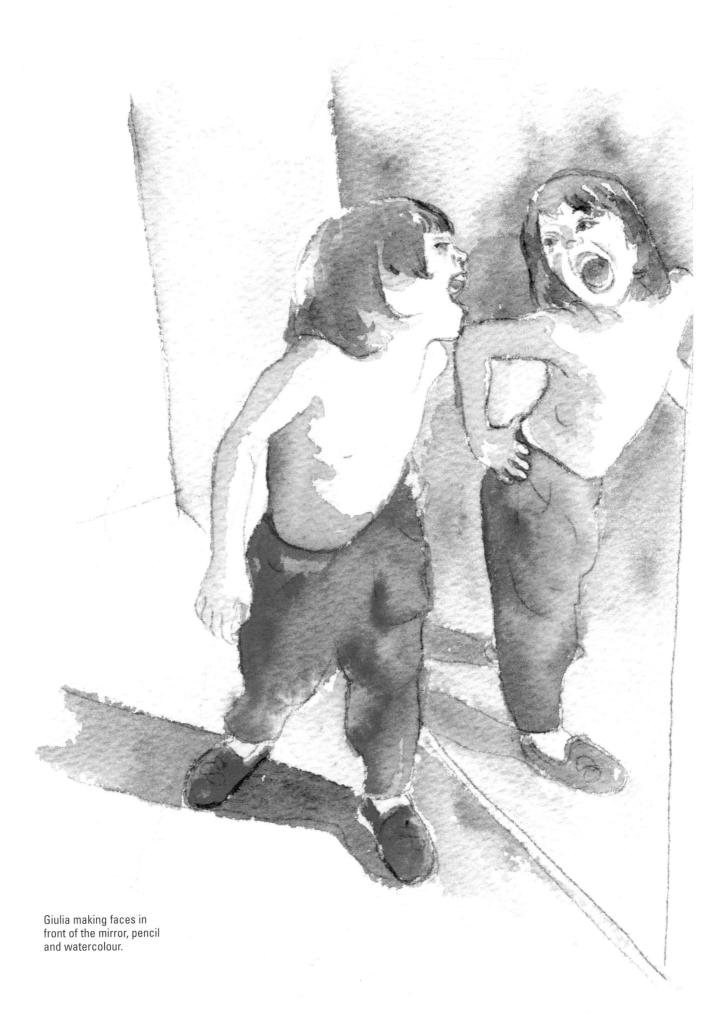

Giulia making faces in
front of the mirror, pencil
and watercolour.

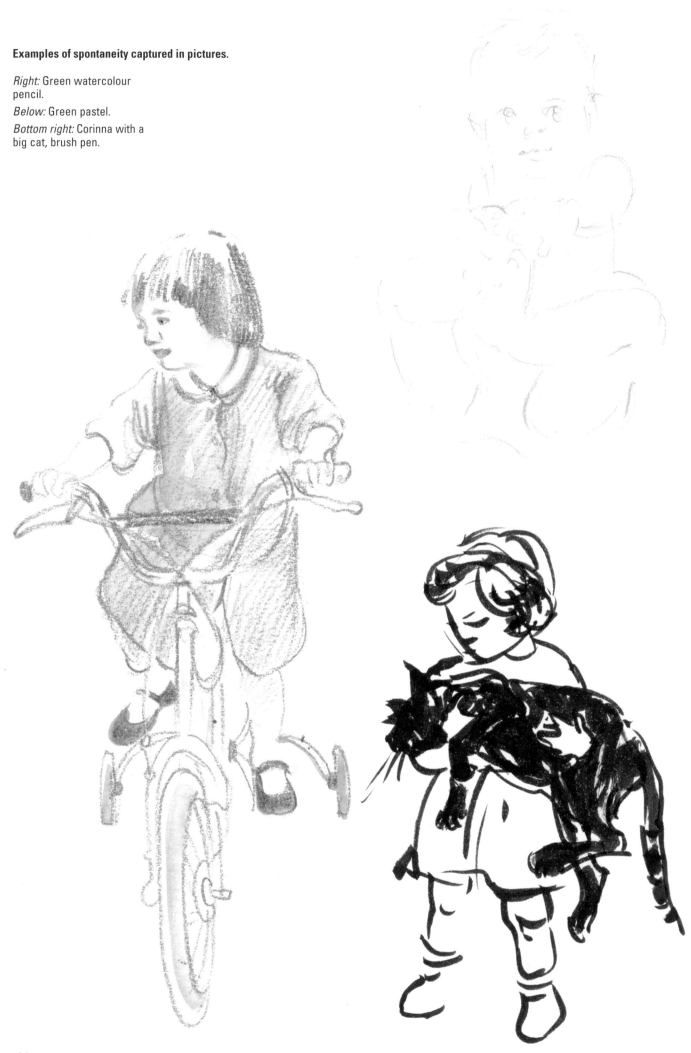

Examples of spontaneity captured in pictures.

Right: Green watercolour
pencil.

Below: Green pastel.

Bottom right: Corinna with a
big cat, brush pen.

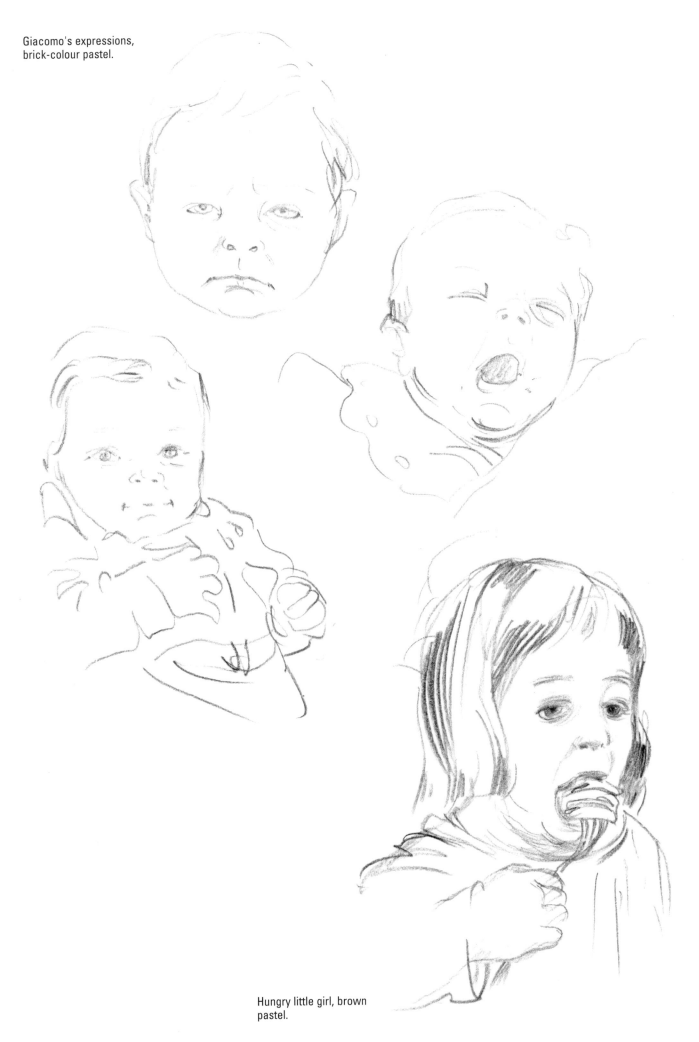

Giacomo's expressions,
brick-colour pastel.

Hungry little girl, brown
pastel.

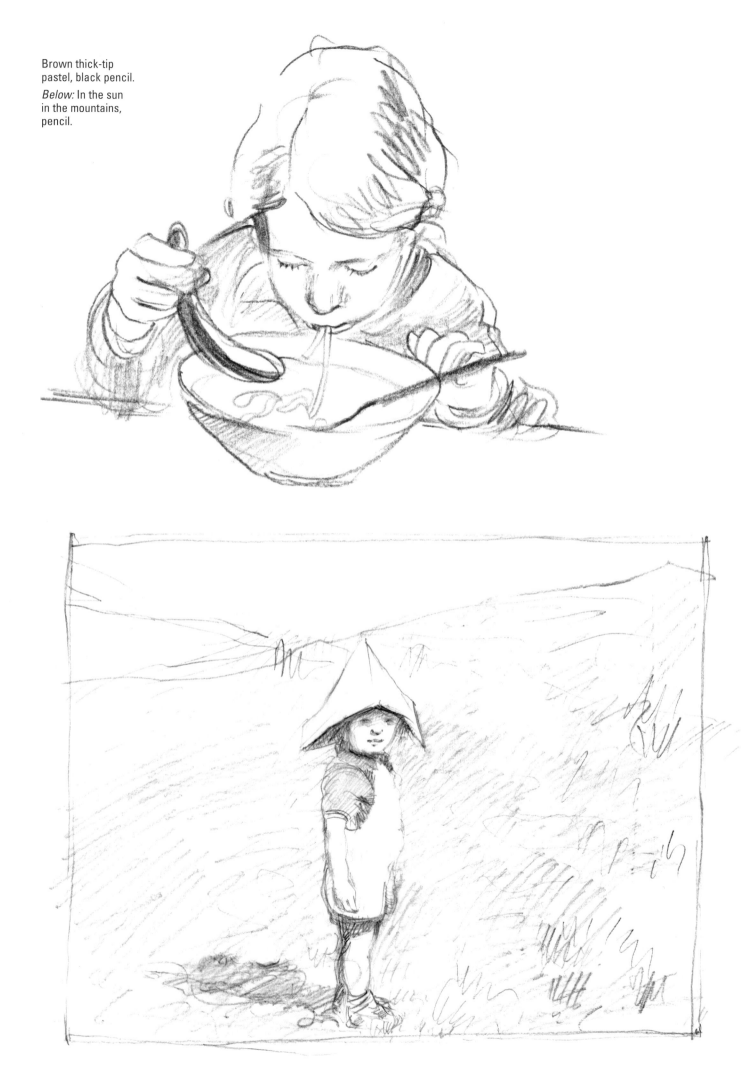

Brown thick-tip pastel, black pencil.

Below: In the sun in the mountains, pencil.

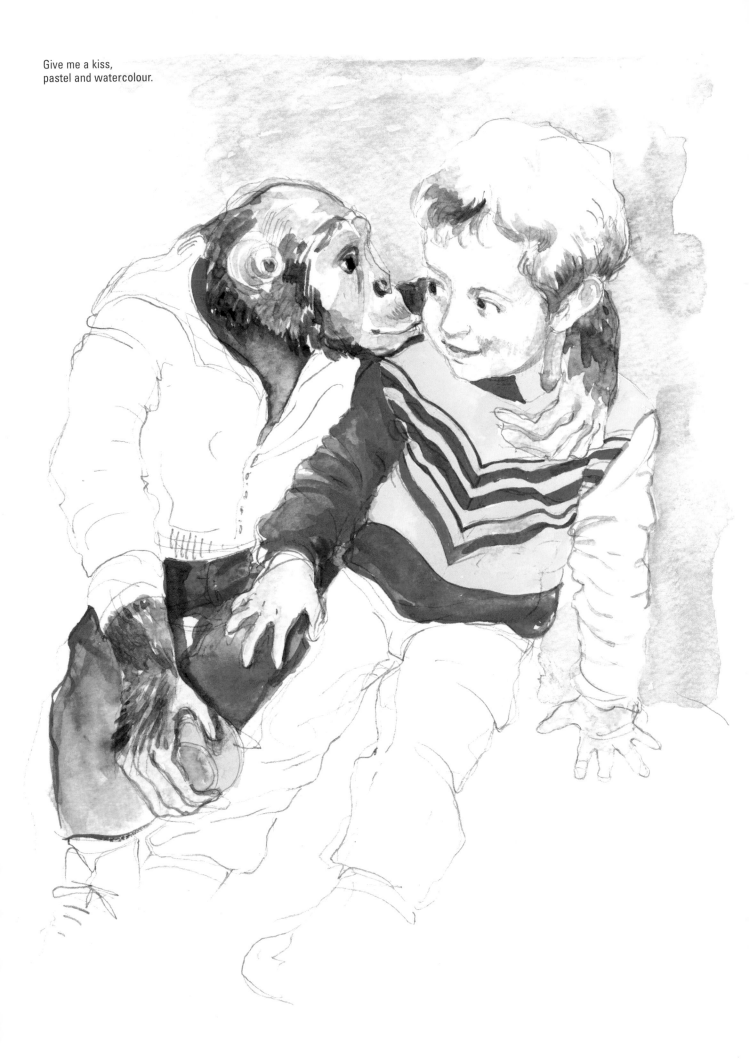

Give me a kiss,
pastel and watercolour.

From a children's footwear ad,
fine point graphite.

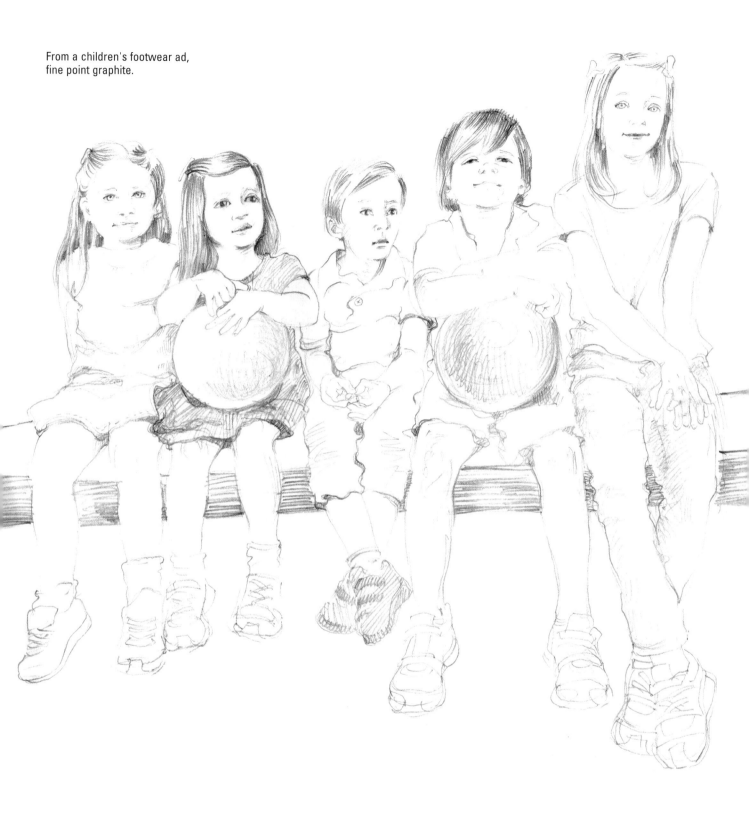

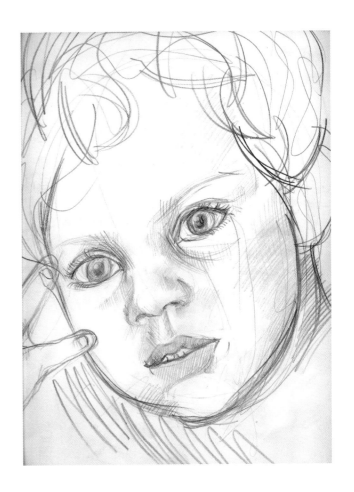

Pencil portraits from photos.

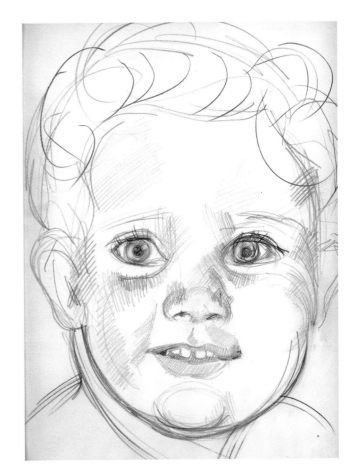

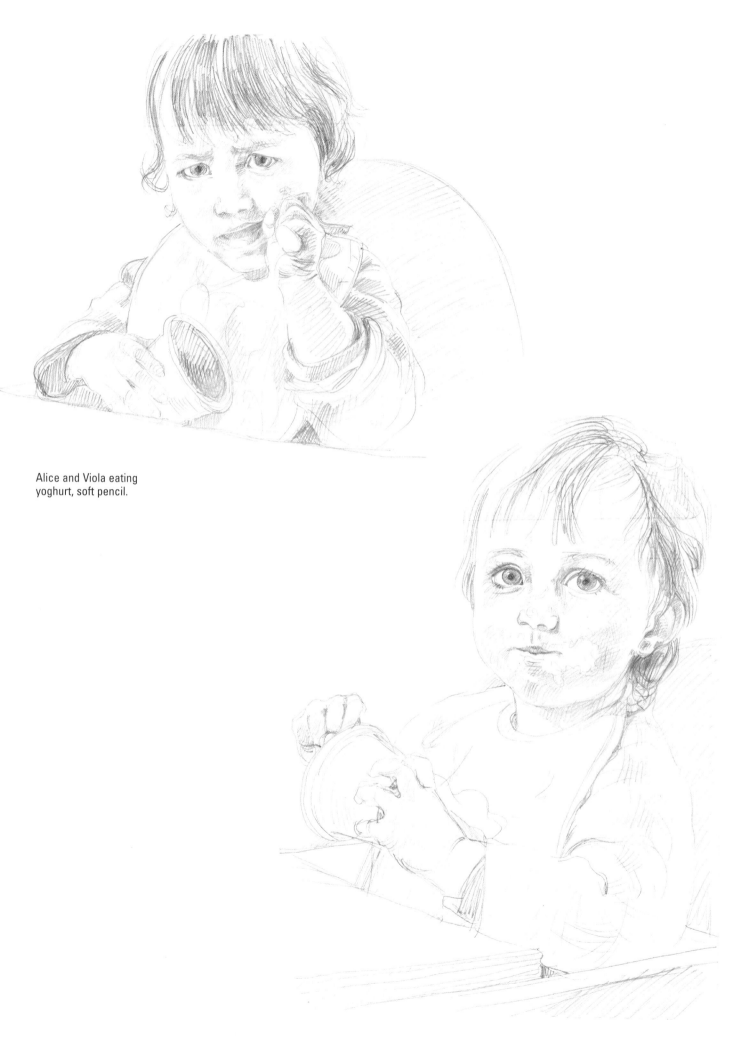

Alice and Viola eating
yoghurt, soft pencil.

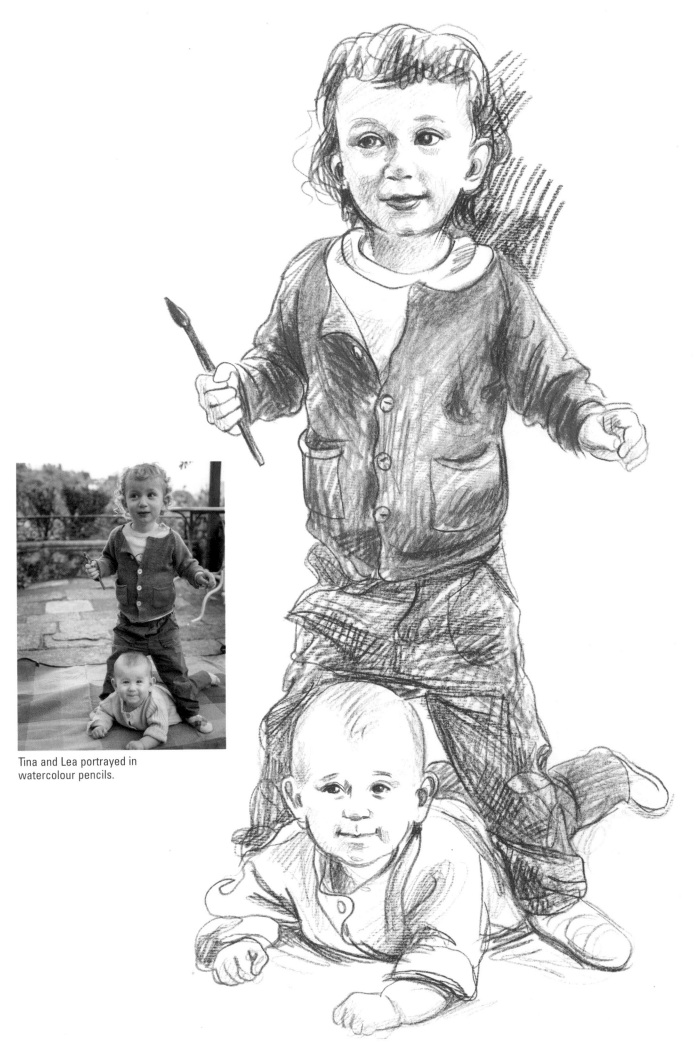

Tina and Lea portrayed in
watercolour pencils.

TRACING

There are various ways to work with photographs, and tracing is the one which may seem simplest. However, it is also the one which makes it difficult to distance oneself from a banal, stiff transposition.

And it just isn't true that tracing in an intelligent way is easy. Tracing is a method that shouldn't be practised mechanically; it should be done carefully, continuously comparing and checking the drawing against the original.

The procedure of continuously comparing and correcting the traced drawing against the original image, even if it doesn't seem like it, always requires the choice of which parts to trace and which to overlook through careful evaluation. It's best to identify the details which require more analytic, precise interpretation and which, on the other hand, are better summarised with less detail.

There are different types of tracing methods. Using a light box makes this exercise much easier, but it can still be done without one: just carry out the tracing with the paper placed against a window. Affix a photocopy or an image printed from a computer on the glass (a traditionally-printed picture generally won't work as the paper will be too thick and won't allow the light to pass through). Then overlap with a sheet of thin, transparent paper. If it's a sunny day out, that will be quite enough light to trace the image easily.

If, however, you want to use a thicker piece of paper to then paint with a water-based medium (i.e. one which light won't pass through), the simplest method is to first trace the image on a transparent sheet (such as tracing paper). Then transfer it to the desired support with graphite paper (also called transfer paper, a sort of carbon paper which allow for erasing) placed between the final destination and the tracing paper. Before proceeding with the final tracing, it's always best to check the intensity of the marks: avoid pressing too

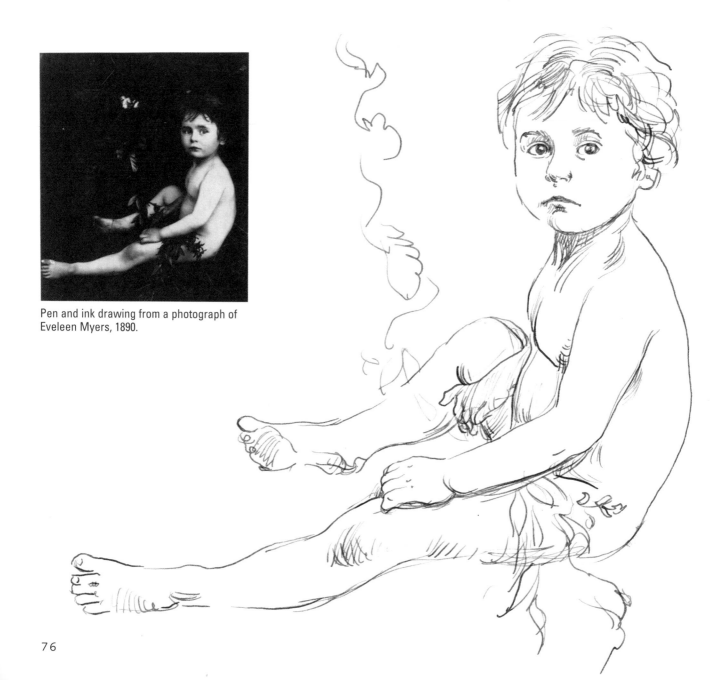

Pen and ink drawing from a photograph of Eveleen Myers, 1890.

The design traced on semi-transparent paper transferred via graphite paper to prepared canvas or paper.

hard, making it difficult to erase the drawing when you then move on to adding colour, but don't press too lightly, which will make the drawing hard to see. Check and adjust the pressure based on the first lines.

These procedures work if the size of the picture coincides with that of the copy. If not, the original can be enlarged or reduced easily with the help of Photoshop or a copier.

Once the drawing has been transferred to the paper suited to the medium/technique you want to use, proceed to the final stage, using paint, pastels, watercolour pencils or graphic techniques, pens of various types, markers, Conté crayons or any other type of medium you want to use. Further suggestions in this regard can be found in the dedicated chapter.

COPYING

Copying a photograph is an entirely different process than tracing.

To begin, choose the ratio between the picture and the copy: the same size, smaller or bigger.

The picture can be copied by looking at it from the right side, or by rotating it 180 degrees so it's upside-down, as Betty Edwards suggests in *Drawing on the Right Side of the Brain.*

Turning the image upside-down confuses the left side of the brain, which isn't prepared for that task. The right side of the brain then has the chance to temporarily take the lead, and it is exactly the right side of the brain which is engaged in "seeing like an artist". The paradox is that we draw better when

Example of a photo copied front-on, upside-down, with the left hand and with blind contour drawing.

we don't know what we're drawing, when we limit ourselves to seeing and drawing forms and lines without giving them a name or function.

If aliens landed on planet Earth and sat for a portrait, surely the resulting drawings would be even more efficient and more closely resemble those made of our fellow humans. This happens because it's easier to portray that which we don't know too well and which we haven't had time to create a stereotype about. In this case, drawing is a powerful way to get to know the subject.

You can copy a photo by freehand drawing, seeking out the movement of the whole, or by blind contour drawing, or even using the right hand one time

and the left the next and, depending on if you're right or left handed, verifying that they produce different, yet equally interesting, results.

I recommend conducting this exercise while keeping the same reference photograph to be able to compare the individual results, and understand which of these methods is best suited to your sensibilities and which you prefer.

They are all devices which are intended to shatter a way of seeing clouded by stereotypes, and to create drawings which open new expressive horizons.

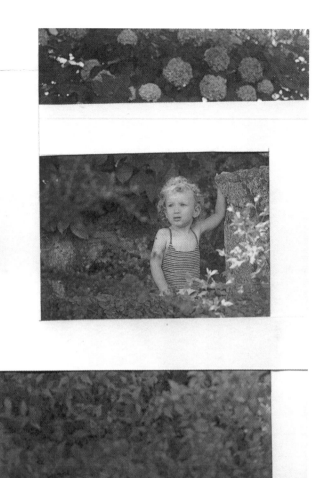

Framing within a picture is another way to interpret a given image. It creates different results and an entirely personal reading of the subject. It would also be possible to isolate a few subjects or details from the environment to highlight them and make them "perform" differently. These interpretations can produce surprisingly original results.

Photograph by Filippo Bianchi.
Examples of framing within framing.

Videos

If you have a way to film good-quality videos which can capture a particular moment in the life of a child, spontaneous gestures or a funny gag, you can extract a series of still images from it and draw them to tell a story through episodes. With subsequent technical elaboration, these drawings can then be used to produce a true graphic novel, a tale in images.

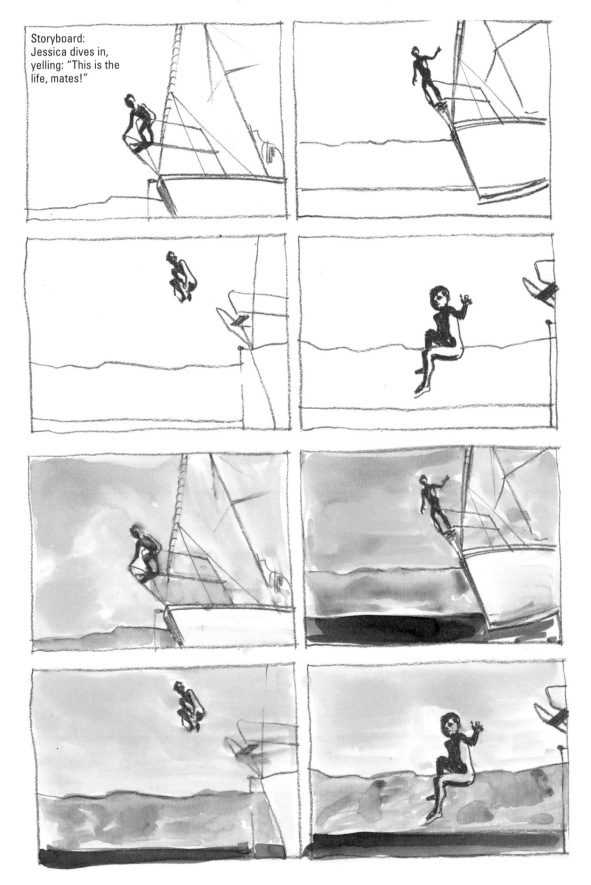

Storyboard:
Jessica dives in, yelling: "This is the life, mates!"

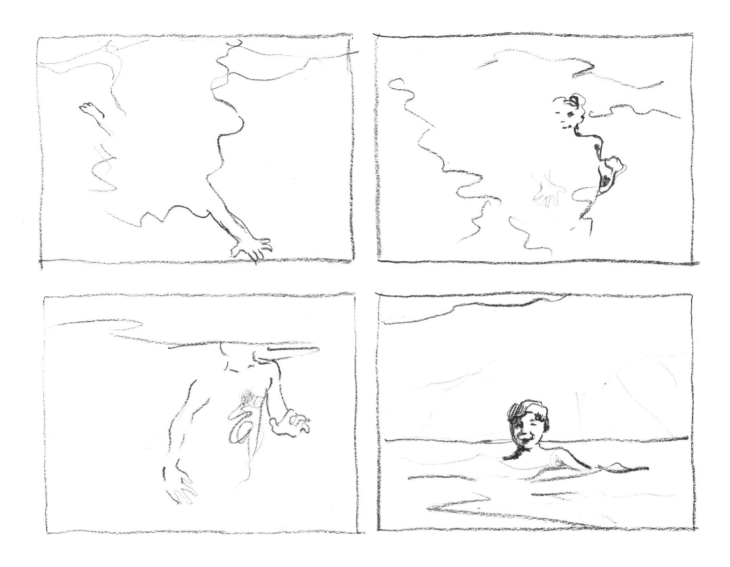

To tell a short story or a specific event, select the most meaningful scenes from a film or video. Proceed to printing the individual frames and copying them with the same methods used for photographs. The only relevant difference is that the multiple fixed images go in a sequence, adding the element of time to the drawing's dimensions. Remem-ber that each movement is made up of a before, during and after and that this breakdown contributes to understand-ing and, consequently, to describing a particular gesture or action.

The result may be equally real or imag-inary according to the tone one wishes to give the story and each person's ex-pressive methods. These elements form

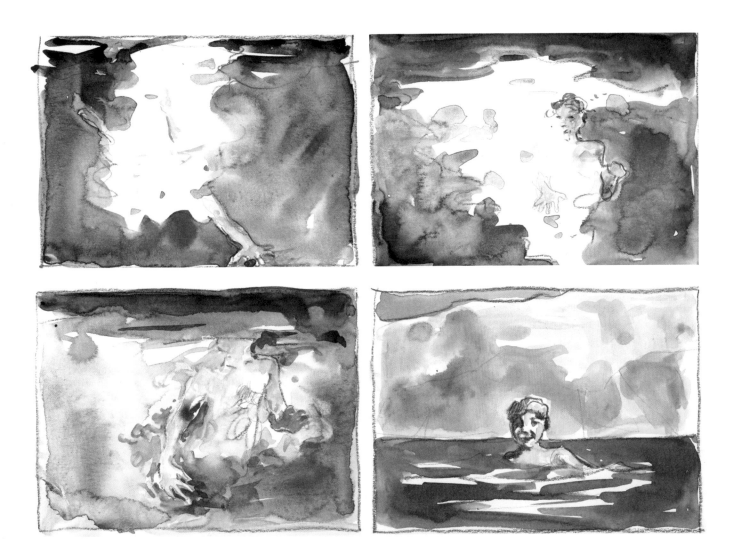

the basis for how one decides to use the photographic and video references available.

A basic rule for creating a sequence of coherent, easy-to-read - in a word, efficient - images is to maintain the same technique and format for all the images. When photographs or video stills are used, it can also be interesting to take advantage of the occasion to challenge oneself by working with different painting mediums: acrylics, oil-based paints, watercolours, or mixed media; even collage together with the other techniques can create engaging results.

BLIND AND MODELLED DRAWING

In this section of the manual, I'll provide a few suggestions for learning how to draw, and how to draw children in particular.

Drawing a figure is never just a question of pure and simple representation. Each and every human body evokes a sort of empathy in us. When drawing a human being, we always include a part of us, regardless of age or race, and there's always some part of the drawing that reveals it more or less clearly.

Children also have the power to evince a special feeling of tenderness and protection, and they often take on attitudes and poses that are so peculiar, taking on such funny expressions that they arouse the urge to affix them in some way, to enjoy them over a long time and in one's memory.

When drawing, sight isn't the only sense to tap into. On its own, it can deceive when it isn't combined with experiences derived from other senses.

The suggestions which are found in this book are valid for drawing in general and, in particular, for drawing the human body, which is an extraordinary mix of elements: muscles and bones certainly, but also character and soul.

Drawing is the foundation of all visual arts and an extraordinary means of expression. But in order to derive gratification from it, it's necessary to practice, even just a little bit, but often, ideally every day. There are no specific locations, complex equipment or expanded time lines required. Drawing can be done anywhere. All that's needed is a notepad, a pencil and ten minutes to

yourself. Talent and necessity proceed together; talent for an art form is accompanied by the need to practice it.

It's good to repeat the same subject often to gain awareness and get to know it better and better, despite and even because it's a different, unique and unrepeatable problem every time.

Drawing children may also be a way to learn, from them, how to throw oneself into discovering life with that precious curiosity, carefree attitude and the total lack of calculation and self-criticism that is the essential motor for overcoming the fear of making a mistake which is common among adults and which only creates restraints. For kids, drawing is a form of play; they aren't concerned about the end result. They make things simply to make them, not to have or possess them afterwards.

Proceeding with the specific intention to suspend judgement on what one is making is the first important step to learning how to draw - a truism when learning just about anything. At the end of a sketching session, it's a good idea to look over the sketches carefully to identify what's effective and what isn't, what type of stroke best embodies what one wants to capture and which don't work or are useless or repetitive. Often, out of many, only one design or a single detail in a sketch will demonstrate a new type of understanding, proof that one has heeded the right instinct. The satisfaction that derives from it becomes the flywheel to continue one's research and proceed with that type of endless journey.

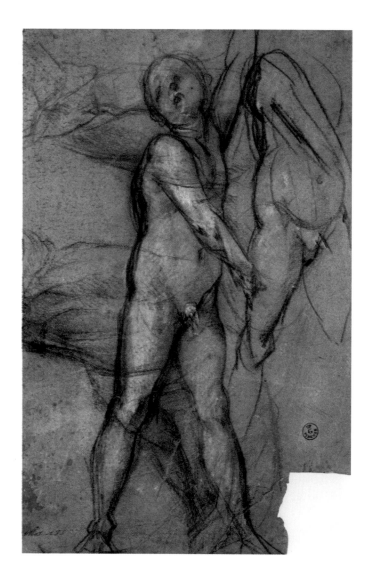

Pontormo, *Study for a cupid in the Pala Pucci*, 1517-18, Uffizi Gallery, Florence, black pencil and white lead.

Ductus

In writing just as with drawing, each of us subconsciously expresses a personality, a particular character which emerges from the manner, the speed and the determination with which strokes and lines are drawn.

"The ductus of a mark is that which makes one's particular way of experiencing it transparent, and the way in which it was drawn reveals not just the grip of the tool used, but also the soul, expressive quality and artistic personality of the artist. This is what makes up the inimitable uniqueness of freehand drawing", explained Giuseppe di Napoli in *Disegnare e conoscere. La mano, l'occhio e il segno* ("Drawing and Understanding: the hand, eye and mark"; Einaudi, Torino, 2004), perfectly stigmatising the concept of ductus. In Italian, *dotto* means 'duct' or 'passage' and often refers to anatomy. But the concept of a canal can be adapted just as easily to that of transmission, of the passage that occurs going from the hand to the mark.

Everyone has a unique manner of expression which must be tested and experienced in different ways to emerge through movements, tools and usage methods.

In this regard, the act of drawing is a complex whole, made up of various elements which interact and, combining in different ways, define the ductus of a freehand graphic mark.

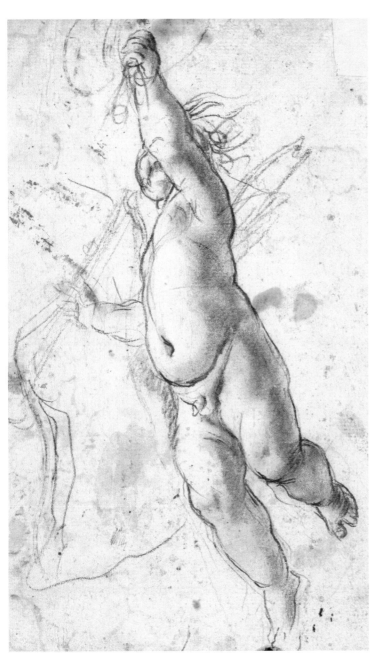

Annibale Caracci, *Flying Putto,* The Morgan Library & Museum, New York, black chalk, stumped.

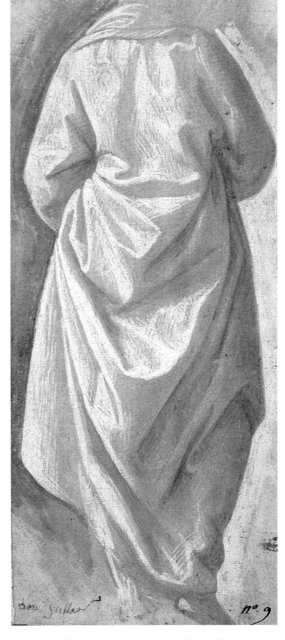

Domenico Ghirlandaio, *Drapery on a Figure Seen from Behind*, Musée des Beaux- Art, Rennes, silverpoint, brownish watercolour, white lead, paper with a pink wash, mounted.

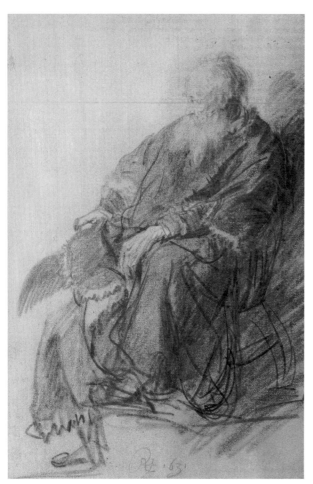

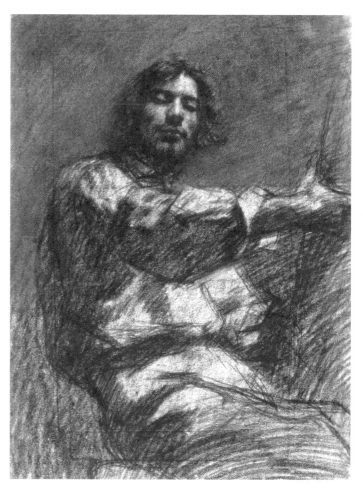

Rembrandt, *Bearded Old Man Seated in an Armchair*, 1631, coll. of A. Delon, Paris, red and black chalk on paper with a light yellow wash.

Gustave Courbet, *Young Man Sitting, Study*, self-portrait known as *At the Easel*, Musee d'Orsay, Paris, charcoal on paper.

These elements are: the type of tool and the way it's held; the way the arm and particularly the wrist move, being the source of movement for the hand, slow or quick; light or more intense pressure; rhythm which may be flowing or choppy; and a duration which can be continuous or fragmented.

The combination of these qualities is what gives rise to the personal expressive mark of an artist. Out of all the elements listed, the way a tool or medium is held plays a particularly important role, also able to produce a variety of strokes. In his books, the late "king of coun-terfeiting" Eric Hebborn explained the tricks and ways to create drawings in the style of different great artists. Once original materials and paper from the era are obtained, one must dive into the personality of that artist to create the drawing in the same hand, made of gestures, movements and speed, as the slightest hesitation will reveal the imitator. It's necessary to see the world through the eyes of the artist to familiarise oneself with his/her vision and way of expressing it.

Hebborn writes: "...it is possible to escape the influence of the period, place, and one's own personal mannerisms, and enter mentally into the timeless world of art from which the best artists draw their inspiration." *Drawn to Trouble: Confessions of a Master Forger*, Mainstream Pub. Projects, (Edinburgh), 1991, p. 360.

Of course I'm not trying to push anyone to copy the work of others. However, I do hope to encourage people to draw and to do so with the pleasure that comes from the progress and change that practice and passion are able to evoke.

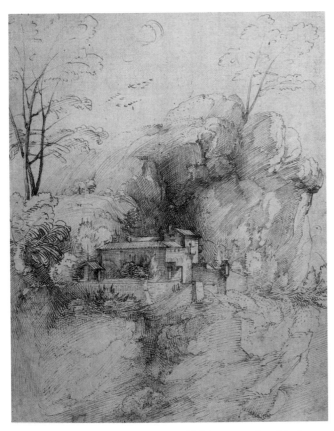

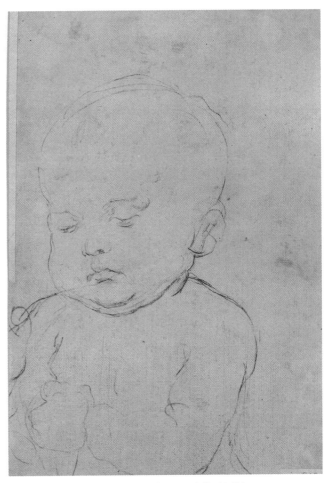

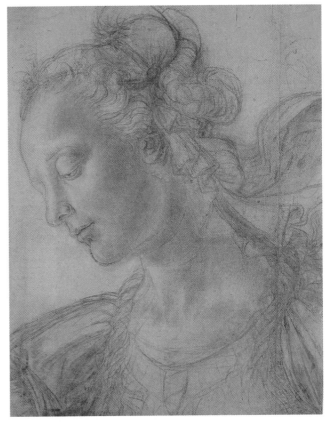

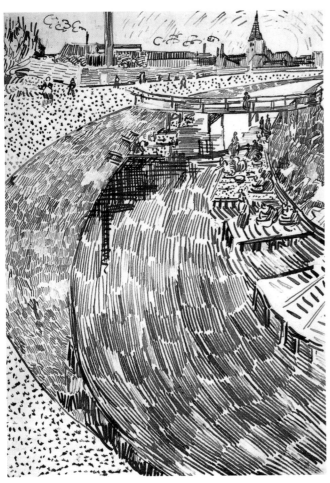

Vincent Van Gogh, *The Roubine du Roi Canal with Washerwomen*, 1888, drawing and goose quill pen.

Circle of Andrea del Verrocchio (Leonardo?), *Half-bust of a Nude Boy*, Uffizi, Department of Drawings and Prints, Florence, black chalk, white paper.

Fra' Bartolomeo, *Rocky Landscape with Monastery*, Graphische Sammlung Albertina, Vienna, pen on white paper.

Andrea del Verrocchio, *Young Woman*, Christ Church, Oxford, black chalk, white lead, traces of pen.

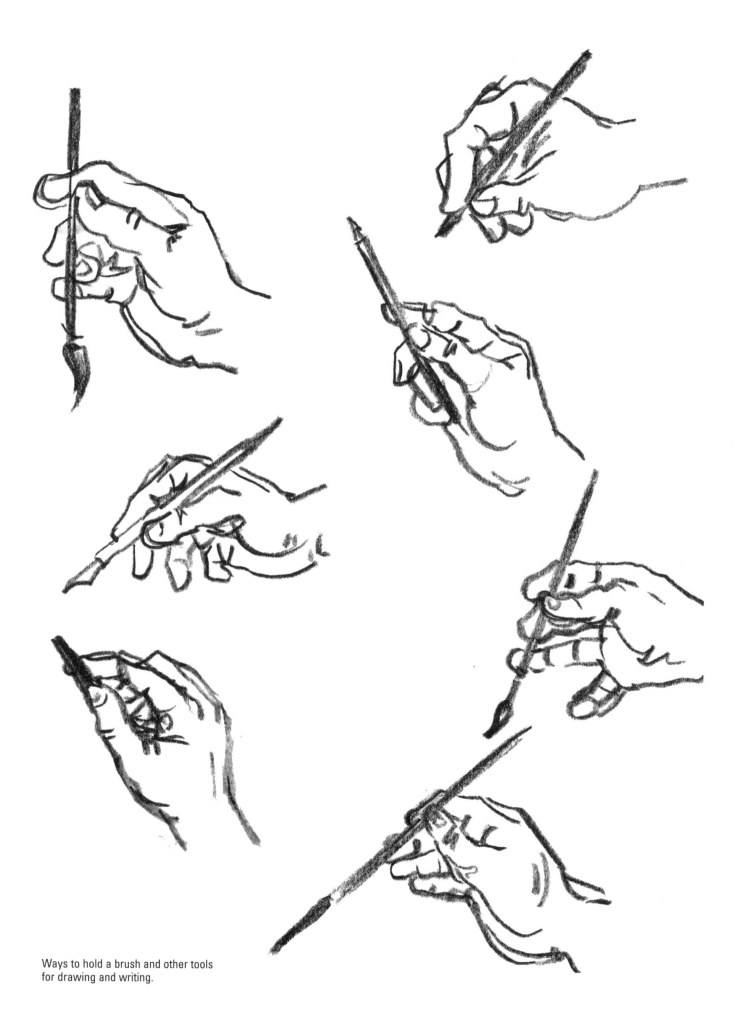

Ways to hold a brush and other tools
for drawing and writing.

First-year course students explore their potential 'hand' by writing their signature in different ways: slowly, quickly, with lots of pressure, lightly, using their right, left and both hands at the same time, and even without looking at the paper. The goal of this exercise isn't to conduct a graphological analysis of their personality, even if handwriting is considered one of its most indicative expressions, but rather to explore the varied and infinite ways to draw and write. Repeating one's signature over and over again on a large piece of paper with different tools and methods can be the first way to approach ductus, and the first step to becoming aware of the characteristics of one's hand, those that will emerge in drawing with adequate practice.

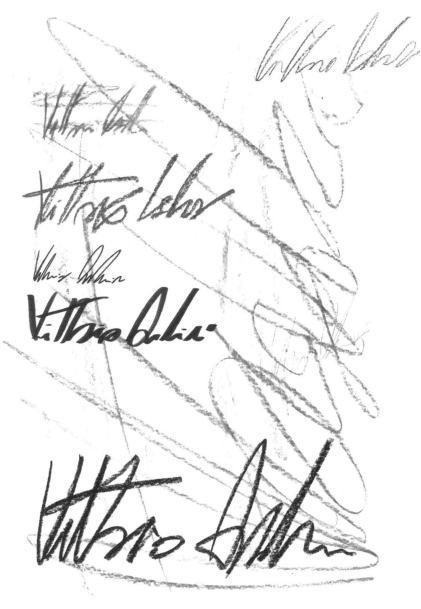

Copying a photograph can be a great opportunity to practice while seeking out one's own ductus.
The departure point for this quest coincides with the identification of that which characterises one's hand and which has qualities that are individual enough to be hard to reproduce. It's a bit like someone's signature, which already, unconsciously, contains all or almost all of the elements which we've mentioned.

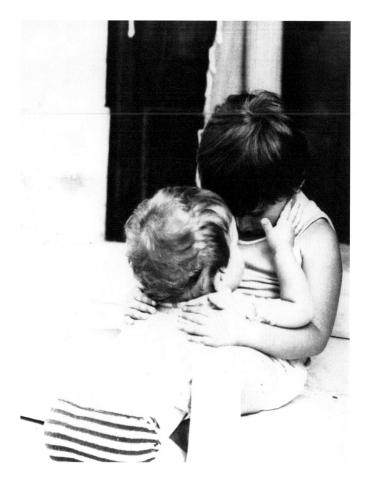

A photo of Clelia and
Fabio interpreted with
different ductus.

Freehand drawing done with a fine-
point pencil with continuous lines,
without picking up the pencil from
the paper.

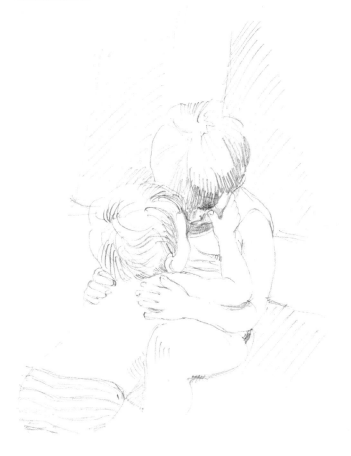

Light pressure, 2h
pencil.

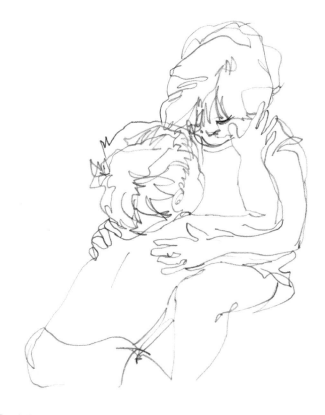

Partially-blind contour
drawing.

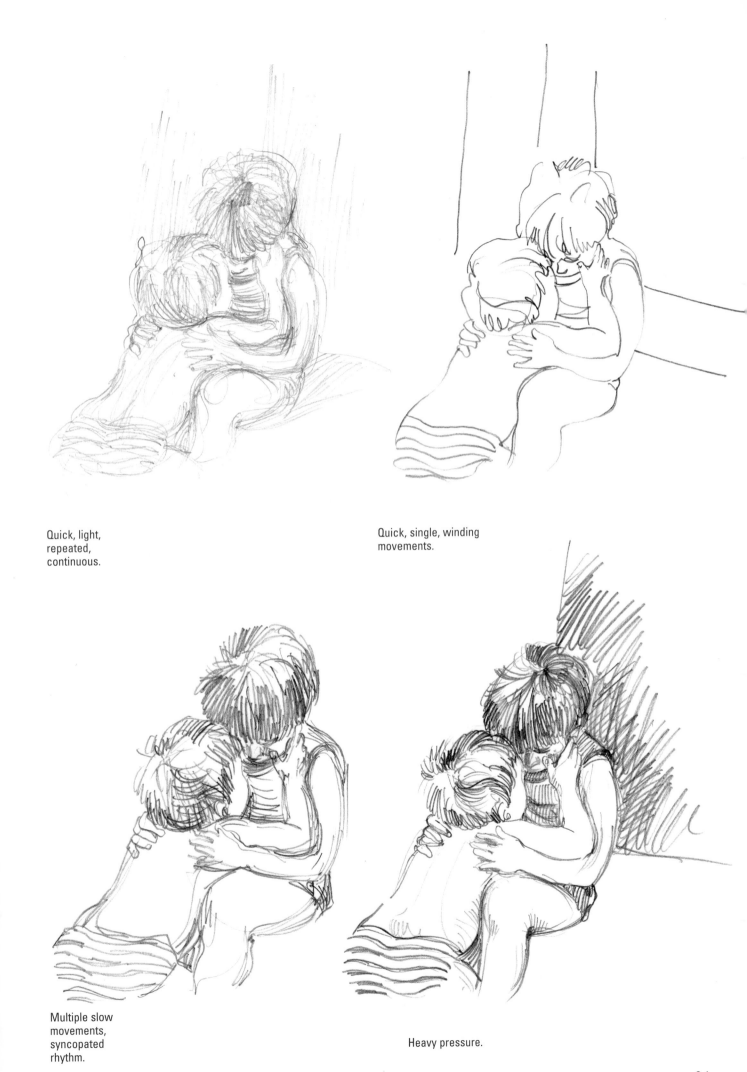

Quick, light,
repeated,
continuous.

Quick, single, winding
movements.

Multiple slow
movements,
syncopated
rhythm.

Heavy pressure.

I suggest experimenting with different types of marks and lines, and doing so with different materials in order to identify the method that is most spontaneous, flowing and resembling one's personal taste, sensibility and, in particular, which is most natural to the artist's character.

Each type of line has its own value; no single one is 'the best' or better than the next.

Experts base the authentication of a work on the line quality; as you study, you could also explore tools and materials to make your hand and the marks on the paper even more unique.

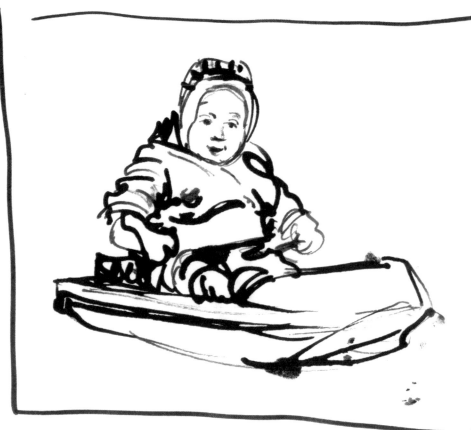

Wood pen and ink.

Dropper and Luma® ink.

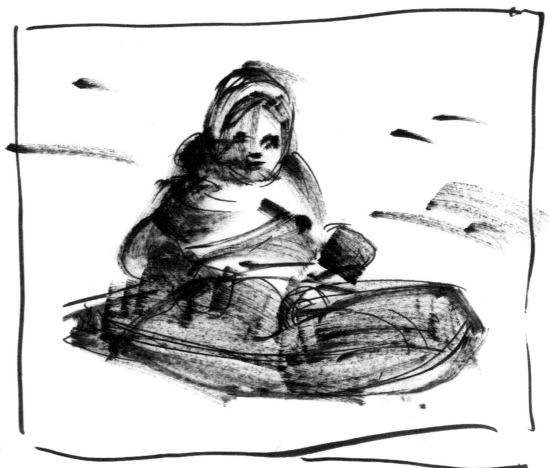

Liquitex® paint
marker highlighted
with a fine brush.

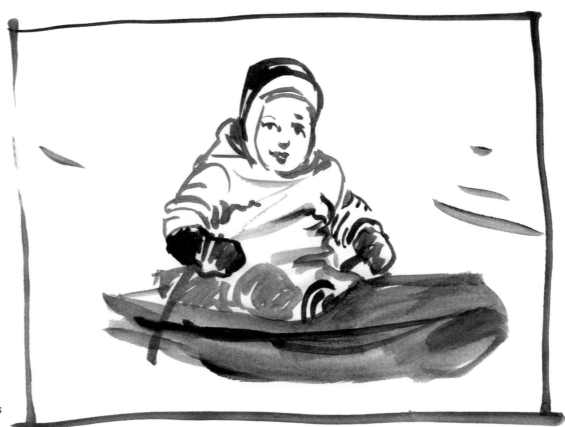

Art Graf®
watercolour pencils
and paintbrush.

93

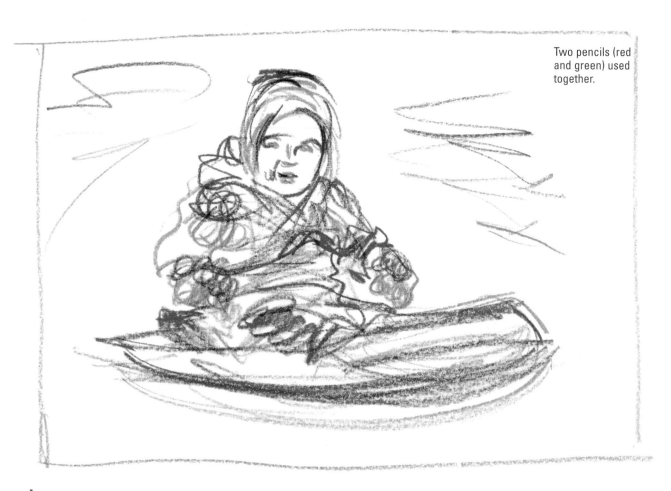

Two pencils (red and green) used together.

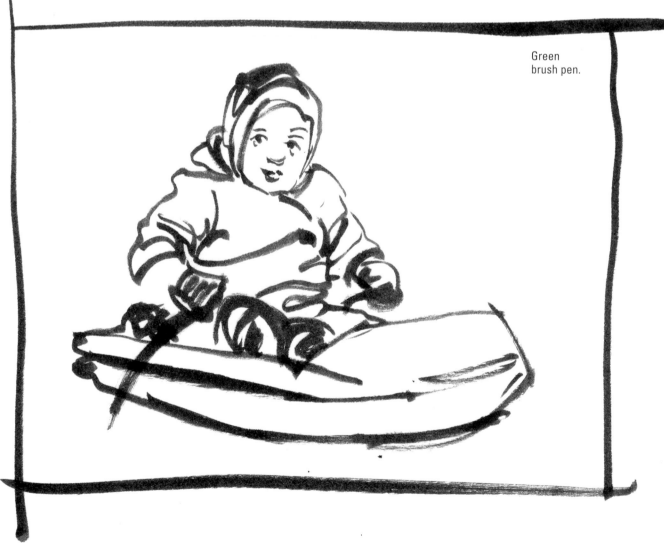

Green brush pen.

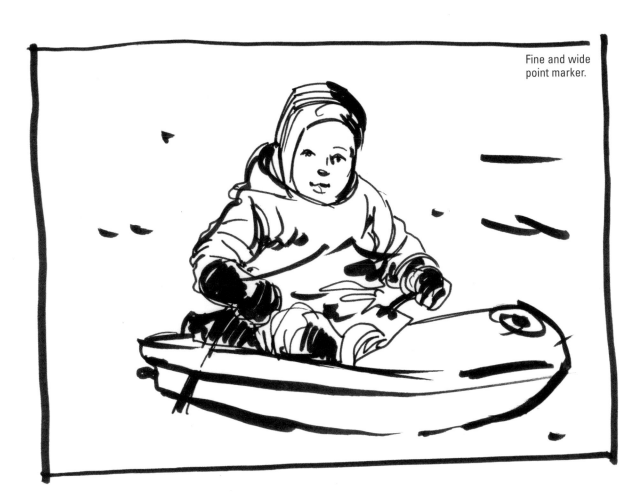

Fine and wide point marker.

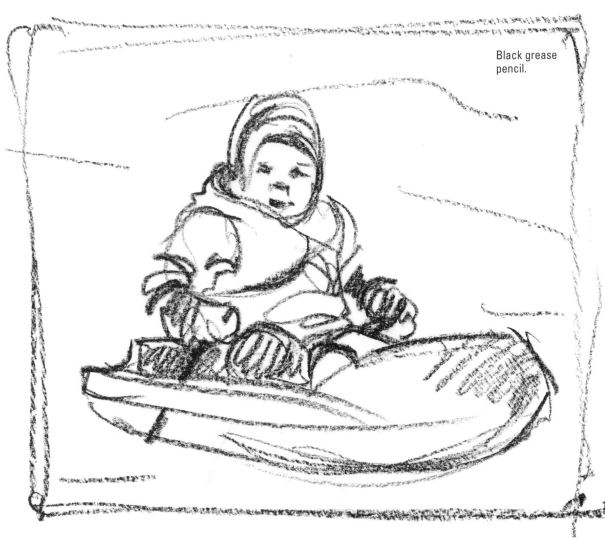

Black grease pencil.

The way the tool or medium is held influences the quality of the mark, making it more or less dense, more or less precise, thicker or thinner, and, in many cases, giving it a different character (depending on the medium used). Some materials can be held in different ways, including brushes and brush pens.

Di Napoli explained the importance of how the tool is held: "Correctly holding a tool is the result of lengthy, and

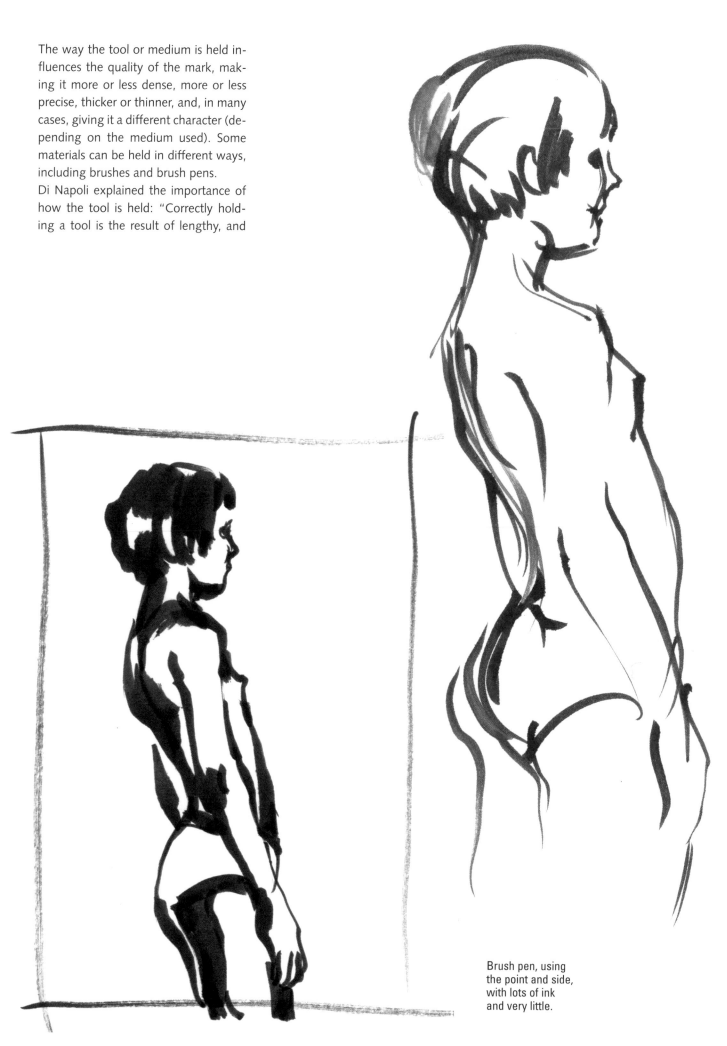

Brush pen, using the point and side, with lots of ink and very little.

at times exhausting, training which rewards those who have the perseverance to see it through. Finger placement, the ability to read, during execution, the points where the slightest, yet decisive, pressure variations should be introduced, from the pressure, angle, speed..."(Di Napoli, op. cit.). Grip is of utmost importance for calligraphy, varying according to the tool used and the type of writing.

BLIND CONTOUR DRAWING

In his instructional text, *The Natural Way to Draw,* Morison Press, 2013, p. 10, Kimon Nicolaides developed a method which was founded on a few different procedures. One of them was particularly important, subsequently taken up by many other artists: contour lines and blind drawing. "Imagine that your pencil point is touching the model instead of the pa-per. Move your eye *slowly* along the contour of the model and move the pencil *slowly* along the paper. Often you will find that the contour you are drawing will leave the edge of the fig-ure and turn inside, coming eventual-ly to an apparent end. When this hap-pens, glance down at the paper in or-der to locate a new starting point. This

A boy of just a few months as he sleeps.

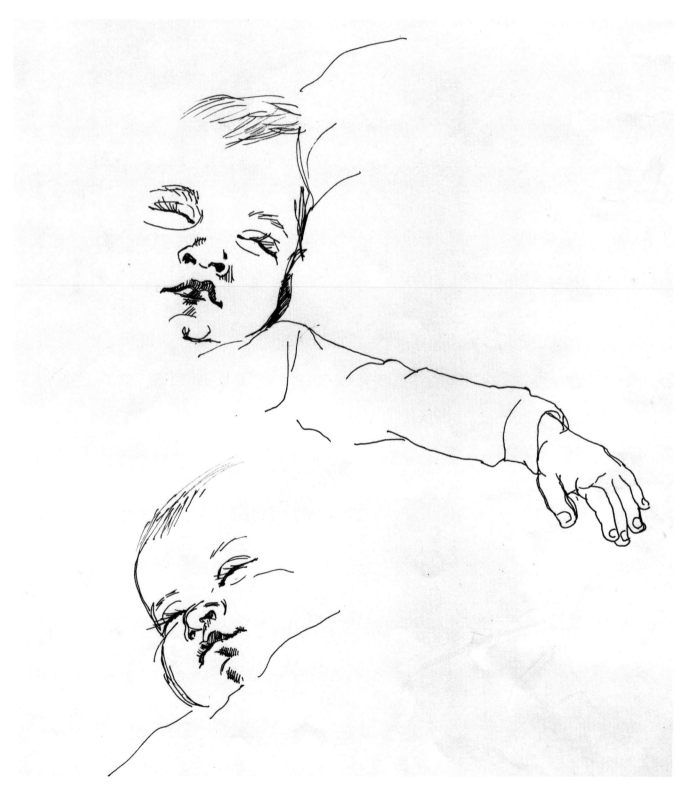

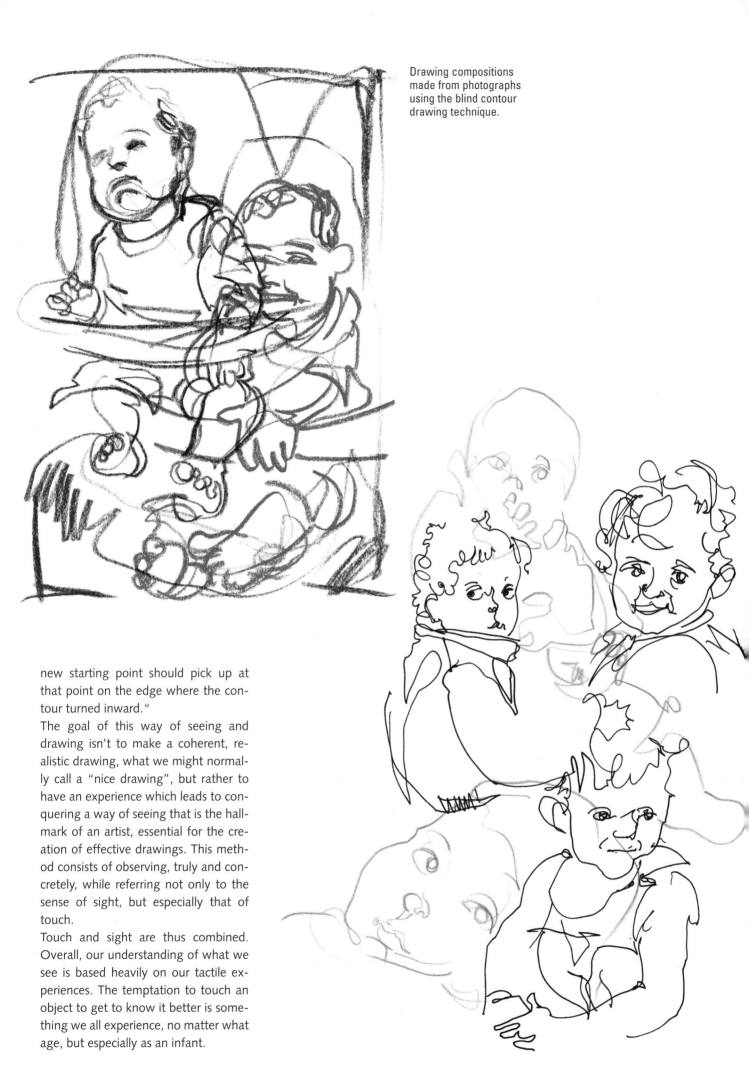

Drawing compositions
made from photographs
using the blind contour
drawing technique.

new starting point should pick up at that point on the edge where the contour turned inward."

The goal of this way of seeing and drawing isn't to make a coherent, realistic drawing, what we might normally call a "nice drawing", but rather to have an experience which leads to conquering a way of seeing that is the hallmark of an artist, essential for the creation of effective drawings. This method consists of observing, truly and concretely, while referring not only to the sense of sight, but especially that of touch.

Touch and sight are thus combined. Overall, our understanding of what we see is based heavily on our tactile experiences. The temptation to touch an object to get to know it better is something we all experience, no matter what age, but especially as an infant.

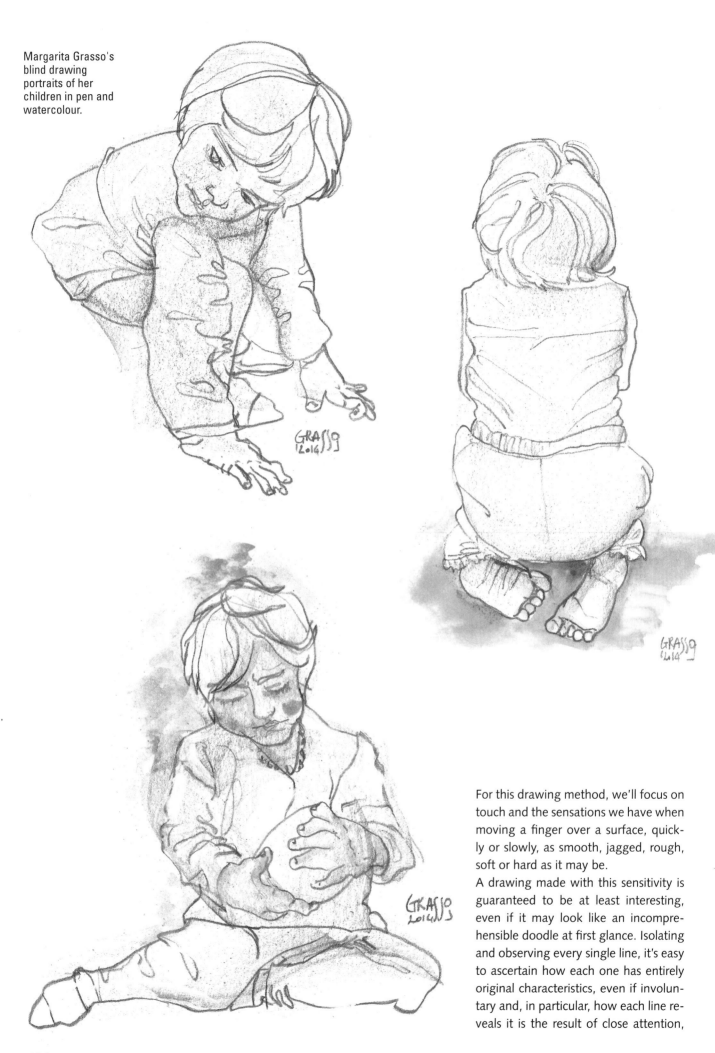

Margarita Grasso's blind drawing portraits of her children in pen and watercolour.

For this drawing method, we'll focus on touch and the sensations we have when moving a finger over a surface, quickly or slowly, as smooth, jagged, rough, soft or hard as it may be.

A drawing made with this sensitivity is guaranteed to be at least interesting, even if it may look like an incomprehensible doodle at first glance. Isolating and observing every single line, it's easy to ascertain how each one has entirely original characteristics, even if involuntary and, in particular, how each line reveals it is the result of close attention,

100

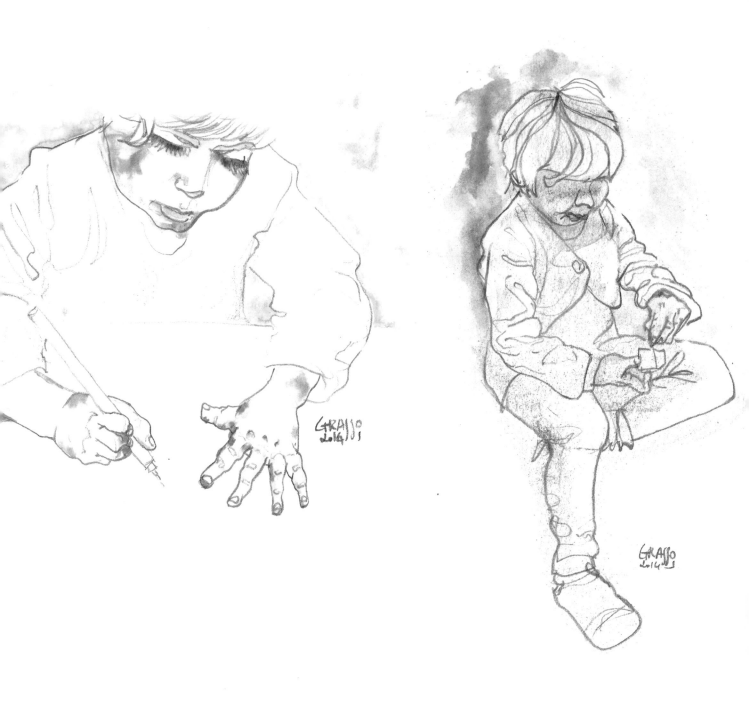

of accidental and anomalous respect for everyday experience.

The line changes. Modifying the pressure, surfaces grow more complex, contour lines become sensible, enriched by infinite micro-details, while curves are faithful, concave or convex.

One finally sees that which is and not that which one believes there to be, closing in on and becoming better at drawing as an artist, while, at the same time, the study's objective and results have begun.

With children, this methodology is best suited to drawing from photographs. As immobility is a quality required for carrying it out, capturing kids while still in real life is rare, happening only when they're asleep or absorbed in activities which completely capture their attention.

If you have a nice picture with the subject in the foreground, it isn't the portrait or a resemblance that matters in this type of work. Rather, what counts is the ability to carry out a true study of the head, understanding its proportions, the various parts of the face, the way the hair looks and moves, the subject's profile.

One draws well when able to completely forget what is being drawn and concentrate on the experience of touch in addition to sight. When translating each element into a mark, it's best not to call them by name: I may draw a nose, mouth, etc., but what I'm really drawing is a curve that nestles into another, a short dash or a long line that ends by inserting itself into a uneven surface, and so on.

Blind contour drawing is never useless; each experiment helps the artist better understand something, even if it's only

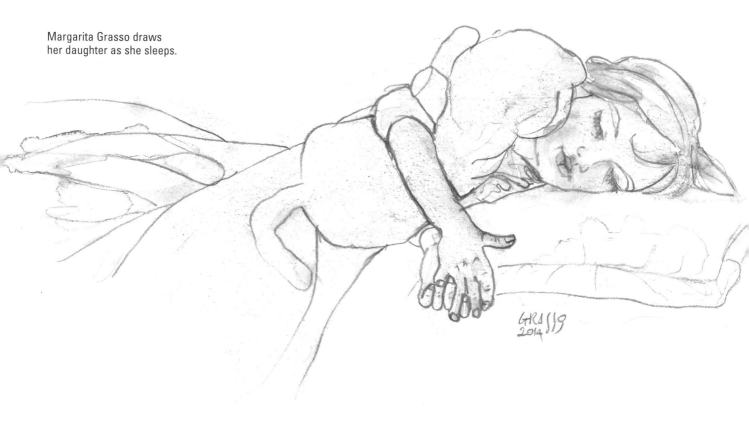

Margarita Grasso draws
her daughter as she sleeps.

a small detail which in a seemingly chaotic whole was comprehended and rendered exactly as it is, becoming the encouragement necessary to proceed with one's studies.

Everything can offer significant gratification with this simple method, the best way to free the artist from the fear of making a mistake.

Drawing children as they sleep or concentrate on something doesn't just help one to understand their traits, but also to capture their character or emotions in the moment. I don't believe there is a parent or grandparent in the world who hasn't lost track of time when contemplating their child or grandchild as he or she sleeps. They're so special, entirely lost in sleep after a day spent pursuing a thousand interesting discoveries and frenetic activities.

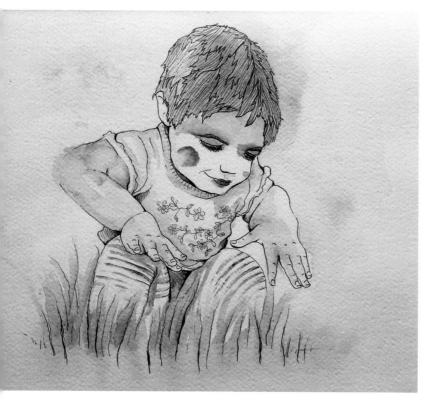

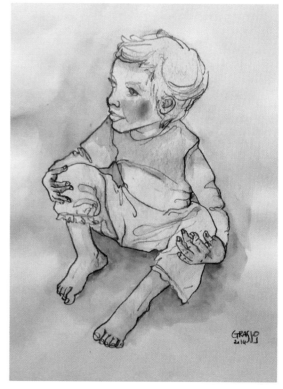

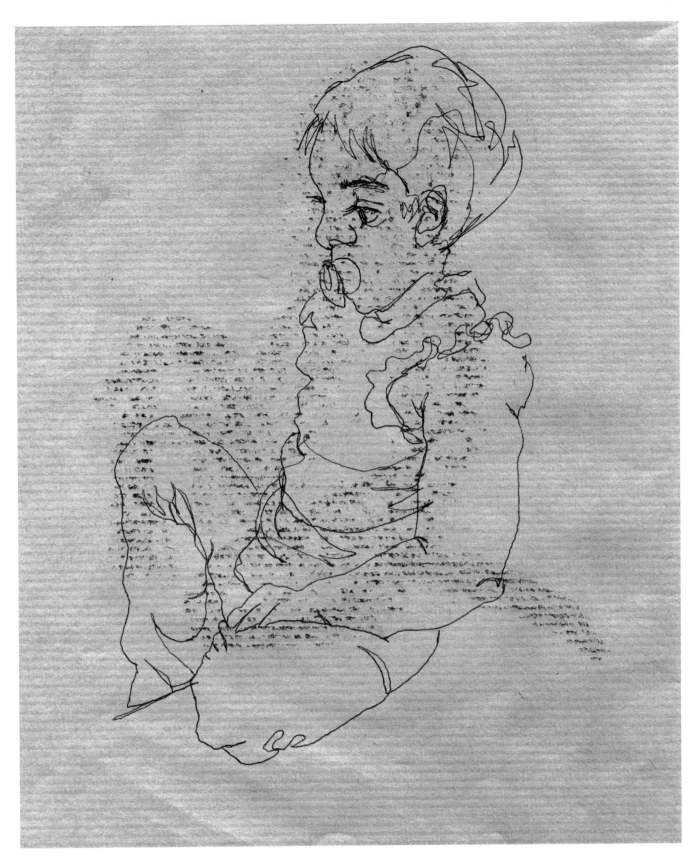

The pencil or the pen must be placed on the paper, imagining that the point is touching the subject instead of the sheet. Your eyes and the tool you're using must focus precisely on the same point and, from there, move slowly but contemporaneously, as if the point of the pencil was touching the outline of the model. The eyes tend to move faster than the hand, so be sure to control them. Draw without looking at the paper. Look at the drawing only when disoriented or when you wish to move on to another side or to the interior in order to identify another departure point. Continue on from there. The important

Rachele Santini draws her little sisters (two and six) with blind contour drawing, using a Biro® pen and graphite on packing paper.

part is to draw without looking at the paper. Be sure you are fully convinced that you are touching the model.

If you want to compare the two techniques, you can draw a few contours while looking at the paper and others while only looking at the subject. Once completed, you'll easily recognise the differences between the two types of marks and the different qualities of the two types of observation.

Naturally, anything can be drawn with this system. The more complicated a subject is (on the human body, for example, there are hands, faces and feet or certain exaggerated expressions), the more blind drawing can help overcome any difficulties in its comprehension.

Nicolaides must be credited with isolating and reinforcing an action that a well-trained artist does naturally, without even realising it, when facing par-

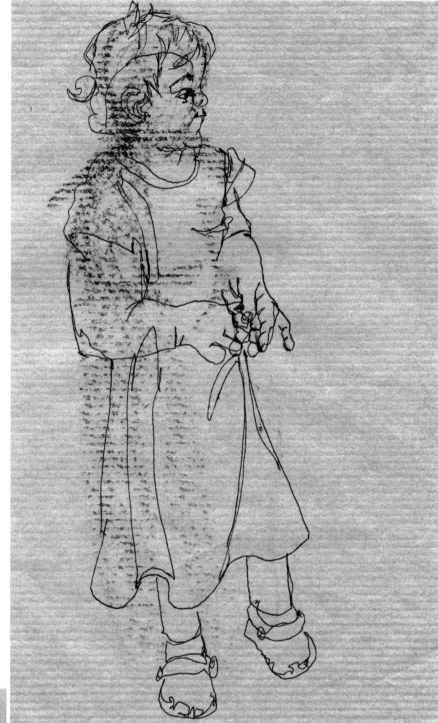

Drawings by Rachele Santini.

ticularly contorted, hard-to-see details. I recommend artistic training in that regard. Just a few minutes a day dedicated to drawing just about anything are enough to quickly make progress and achieve satisfying milestones in no time, in addition to being a rather fun activity.

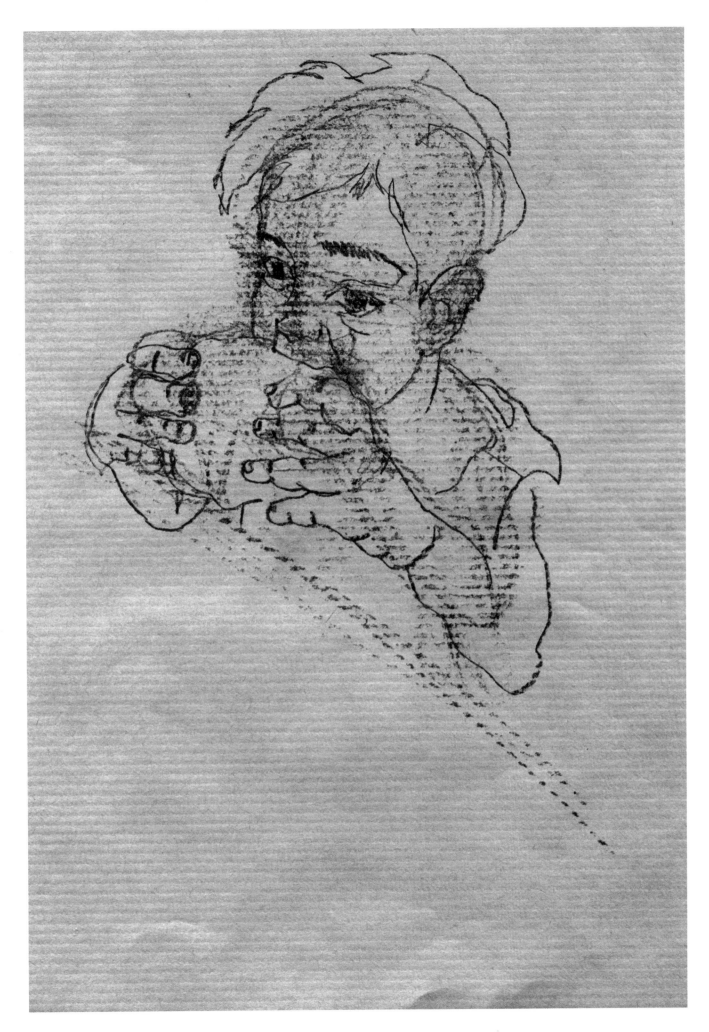

Examples of different, overlapped readings: 1) freehand drawing of the entire subject moving with blue watercolour and a wide brush, 2) blue pen was used to establish the proportions, starting from the size of the head, 3) red watercolour pencils were used to quickly blind contour draw the entire figure, checking the image only to respect the proportions.

Later washes in red watercolour to render the effect of the light.

MODELLED DRAWING AND FORCE LINES

Another approach that benefits from a speedy execution is modelled drawing. This method quickly and easily produces interesting, effective results.

It's called 'modelled' because the same procedure is used as a sculptor when s/he models or sculpts a subject. From the centre towards the edges, the sculptor adds clay to frame in wood, iron or another type of material which acts as a support for the rest of the sculpture. By doing so, s/he acts directly on the volumes, focusing on them progressively.

The same is true of modelled drawing. The most important element is that one's way of drawing is overturned: instead of starting with the external outlines which define the volume, one starts by studying the subject from the internal origins of force, that is, from the core of the movement, proceeding, step by step, to create the volume and shape of the subject as a whole.

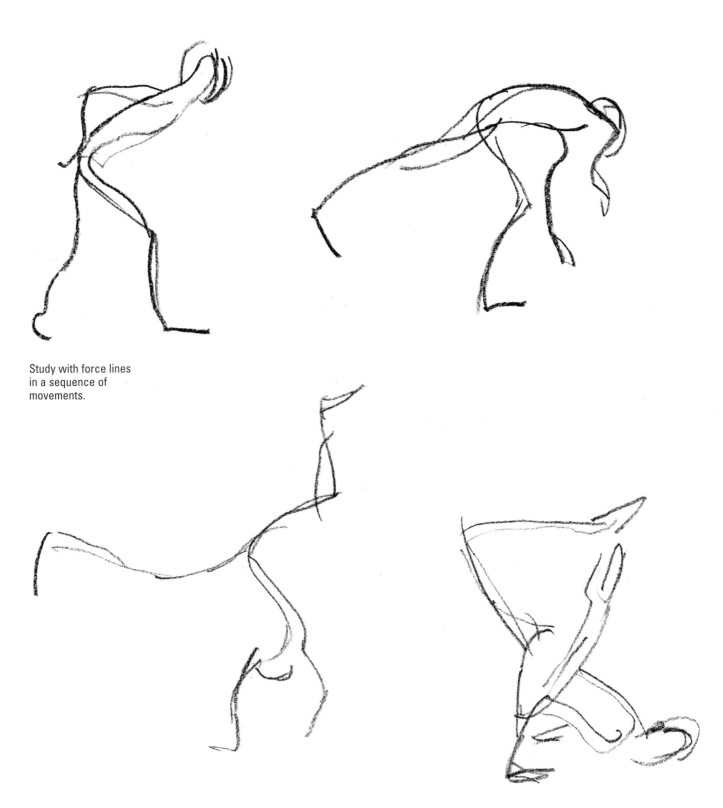

Study with force lines
in a sequence of
movements.

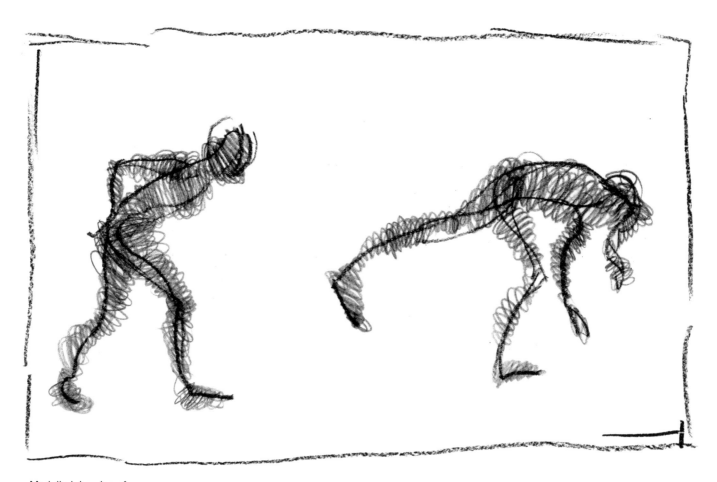

Modelled drawing of
volumes which started
with force lines.

This drawing technique is particularly useful when wanting to quickly capture moving subjects in their entirety. Features can be made through rotation or other repeated marks. It's best to draw continuously, without lifting the pencil off the paper. "I allowed my pencil to hover around - rather like the stick of the water-diviner", explains John Berger in *Berger on Drawing* (Occasional Press, 2007).

This procedure helps the artist understand the individual parts, perceived and drawn like a single whole in movement. The goal is to capture what the subject is doing, instead of what it's made of. The form may also be a bit imprecise as one identifies the meaning which connects the living, moving essence with its nucleus. Varying the pressure of the pencil on the paper, and using slightly overlapping hatch-

ing, you can vary the parts of a subject, blending the chiaroscuro to create volumetric effect which suggests closeness (lighter) or distance (darker).

The process is similar to shading, but here you'll apply more pressure in the areas that are carved out or in shadow with respect to the pressure required to shade the parts in relief. For example, on a face, the darkest parts are generally the eye sockets, while the nose and cheeks come forward as more luminous.

Force lines are another way to express the nucleus of movement, the motor which, from the spine, reverberates in the upper and lower limbs, all the way to the head.

Drawing the force lines of any living subject is the first step to understanding his or her body as he or she carries out a given action.

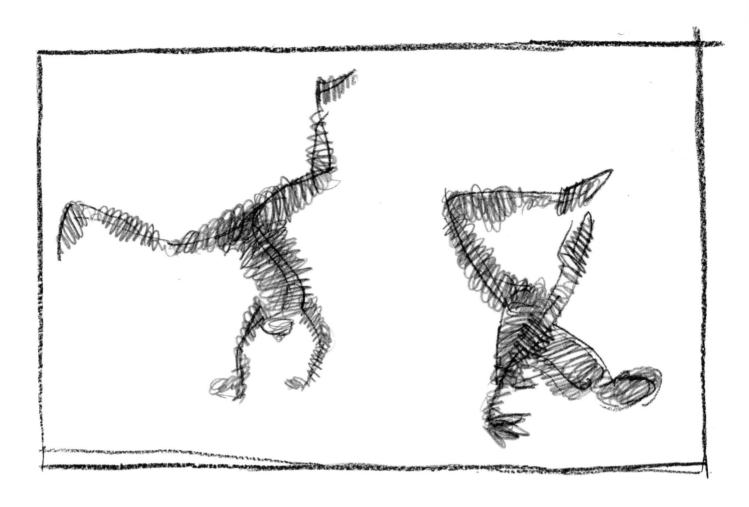

Initially, to practice sculpted drawing, I recommend starting by drawing from photographs, choosing dynamic positions, or using freeze-frames to find images which help bring the action into focus. Drawing from life is more engaging and effectively is the best way to truly understand moving subjects. With children it can be a bit more complicated, but with repeated movements, like in quick drawing exercises, it's feasible and can even make it simpler to understand the form as a whole. The sketches should be done in a few short minutes, two or three at most.

This drawing method could even be used when one wants to take advantage of those few minutes of stillness when children are busy concentrating on one of their activities, the moments when they're most attentive and quiet. They're such intense and capti-

vating moments that they're worthy of adults' utmost attention and comprehension. In fact, adults can even learn from them, as this natural condition for children is a rare, regenerating one for adults. Drawing is certainly one way to reach such a state of grace, one in which time stands still and yet also moves quickly.

It's a way of perceiving time which demonstrates the activation of the right side of the brain, the one which handles non-verbal, intuitive functions, which thinks in figures and doesn't allow for simplifications or deal with numbers, letters or words. In short, this is seeing as an artist, and "when you see in the special way in which experienced artists see, then you can draw."Drawing and Seeing", *Drawing on the Right Side of the Brain*, J.P. Tarcher, 1979.

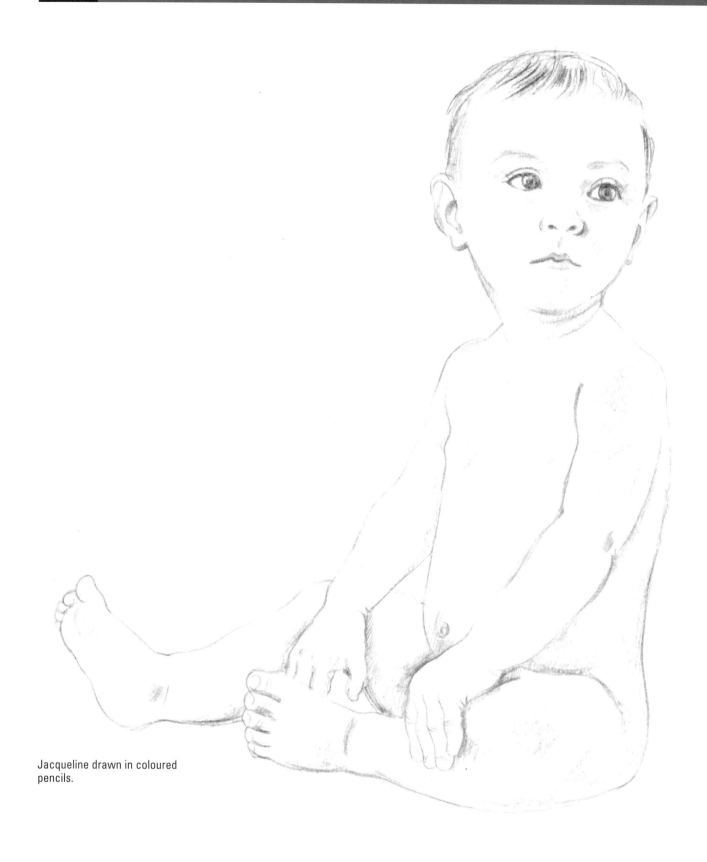

Jacqueline drawn in coloured pencils.

Children, like any other subject, certainly are suitable for learning how to use graphic and pictorial techniques as freely as possible.

In this chapter, I'll provide technical and interpretative suggestions to enrich the experiences and skills of those who want to really try their hand at representing children as well as other subjects. This book is not, nor does it strive to be, a manual on pictorial and graphic techniques. The goal is simply to get people curious and motivated enough to practice painting and drawing by proposing a series of exercises and solutions. It's always advisable to try each route and not get discouraged by the first unsatisfying attempts. It's the only way to identify the best tools and instruments to express each individual's personality and objectives.

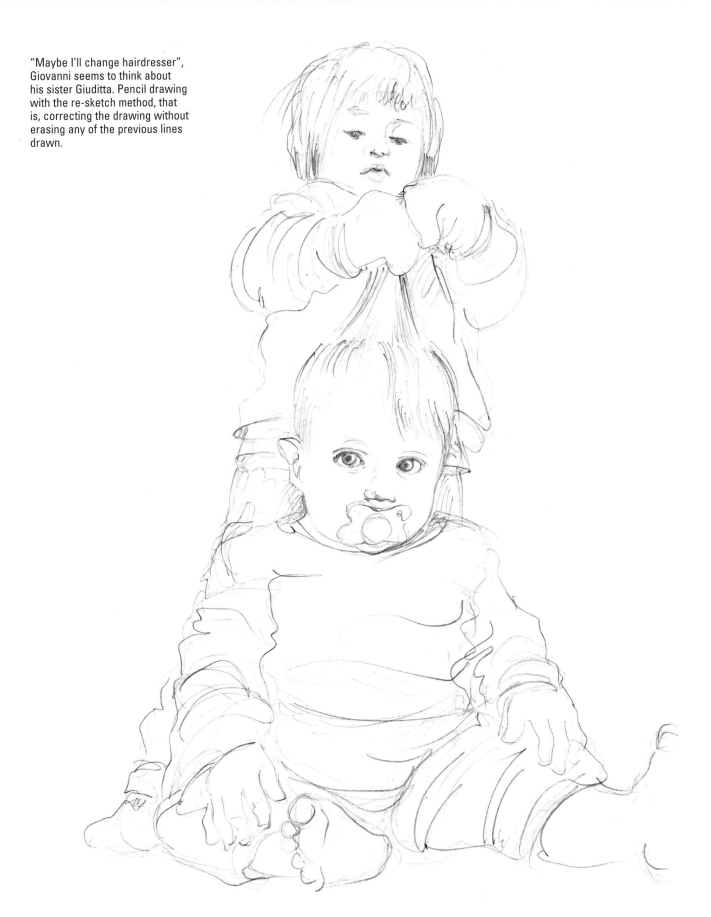

"Maybe I'll change hairdresser", Giovanni seems to think about his sister Giuditta. Pencil drawing with the re-sketch method, that is, correcting the drawing without erasing any of the previous lines drawn.

To draw from life, all tools which lend themselves to the quick interpretation of subjects (especially those which are rarely still for depicting, such as children or animals) are suitable. That means all types of coloured or regular pencils, graphite, brush pens, ink, watercolours, refillable brush pens with a watery ink solution, fountain pens, Biro® pens and all their variations, pastels, especially thick watercolour crayons.

They're all tools which can be kept close at hand and which allow for perfectly opportune extemporaneity when representing surprising, unpredictable subjects such as children, even if they may at times let themselves be portrayed without putting up to much resistance.

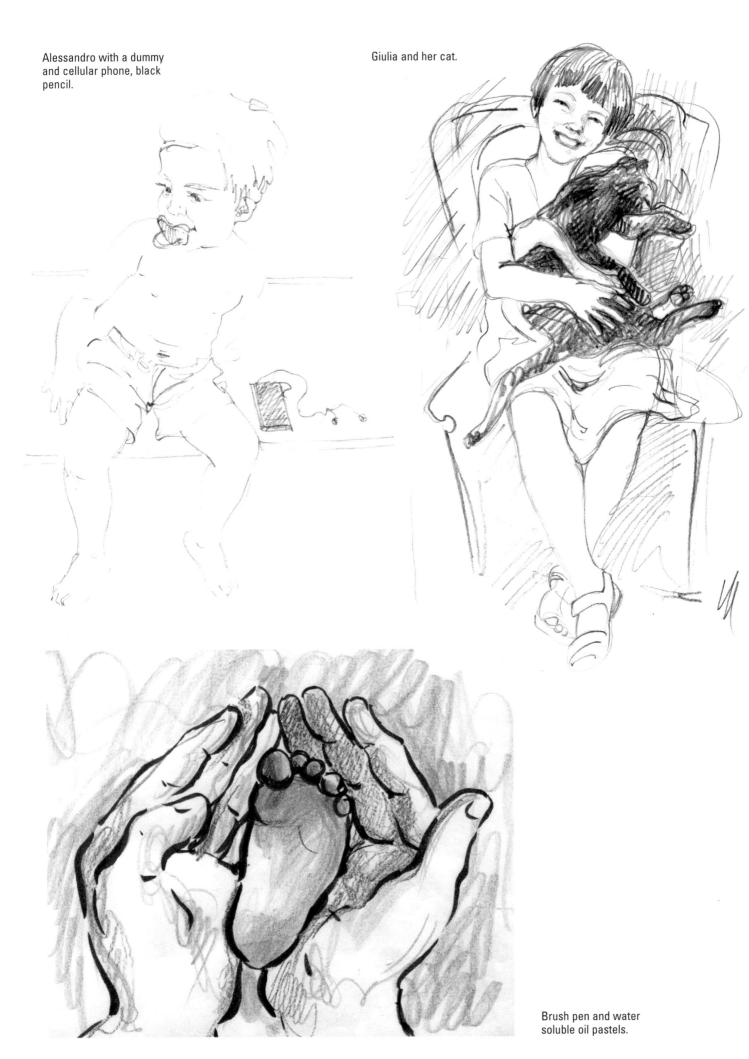

Alessandro with a dummy and cellular phone, black pencil.

Giulia and her cat.

Brush pen and water soluble oil pastels.

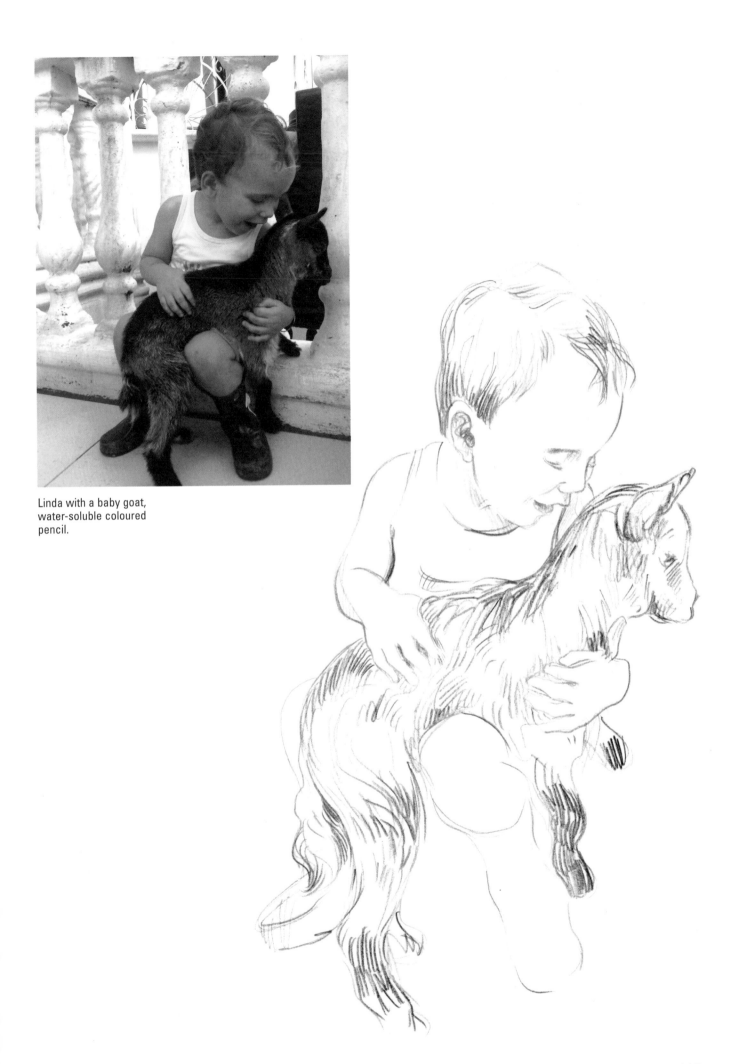

Linda with a baby goat,
water-soluble coloured
pencil.

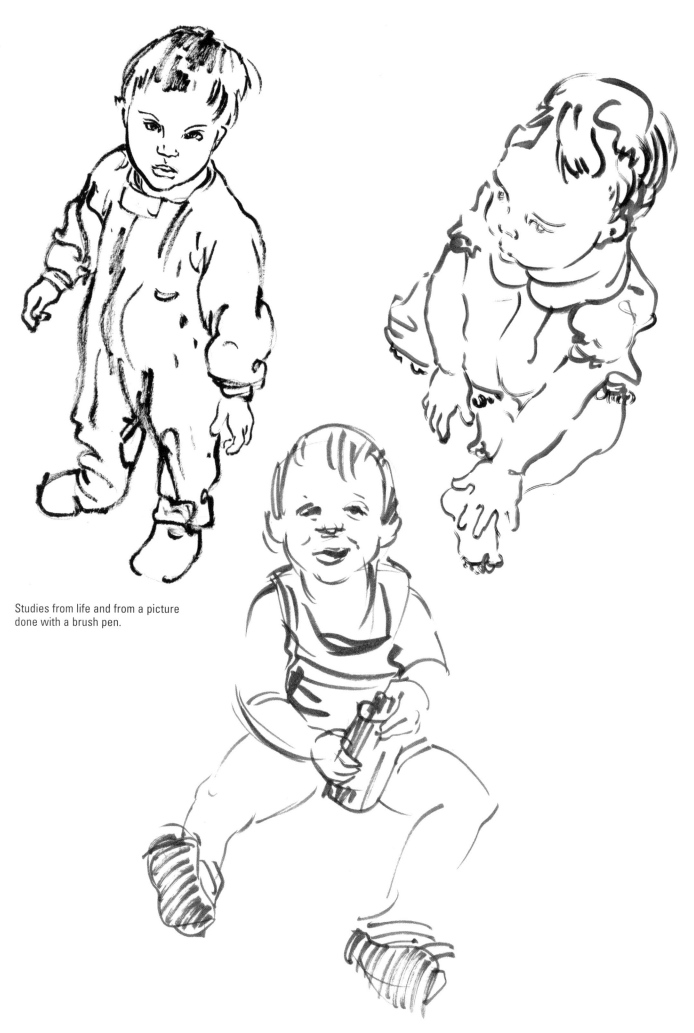

Studies from life and from a picture
done with a brush pen.

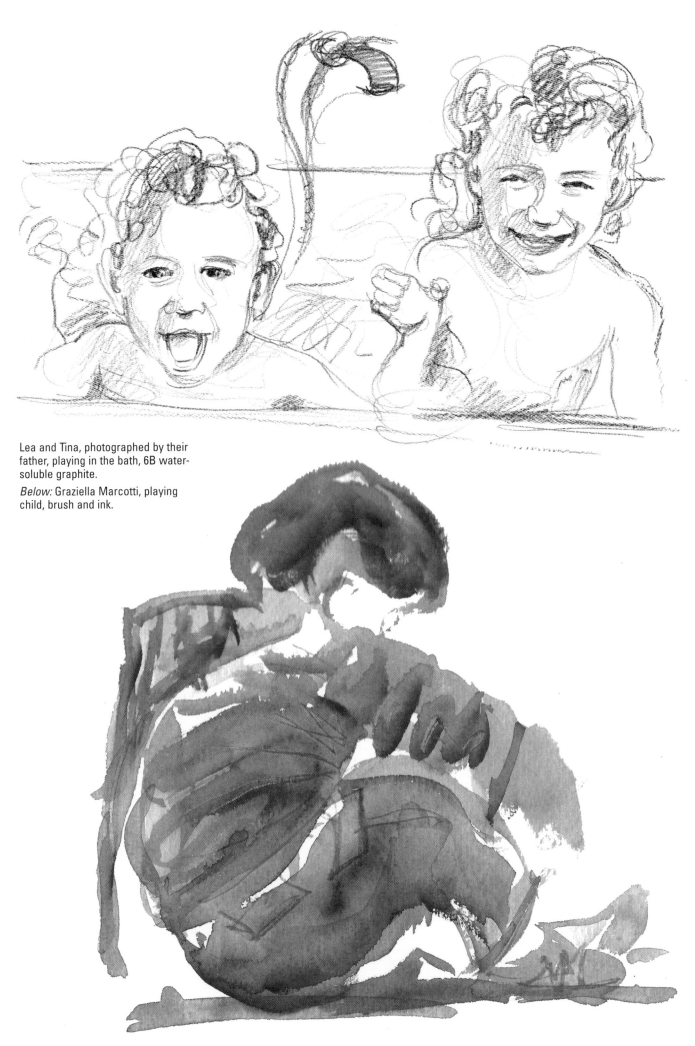

Lea and Tina, photographed by their father, playing in the bath, 6B water-soluble graphite.

Below: Graziella Marcotti, playing child, brush and ink.

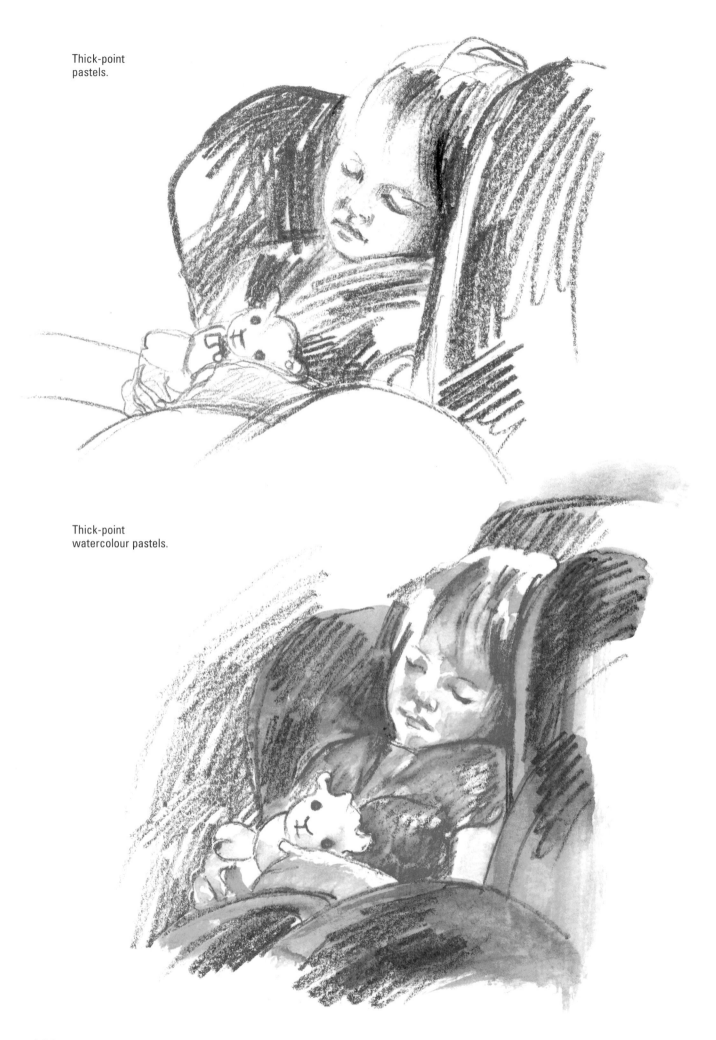

Thick-point
pastels.

Thick-point
watercolour pastels.

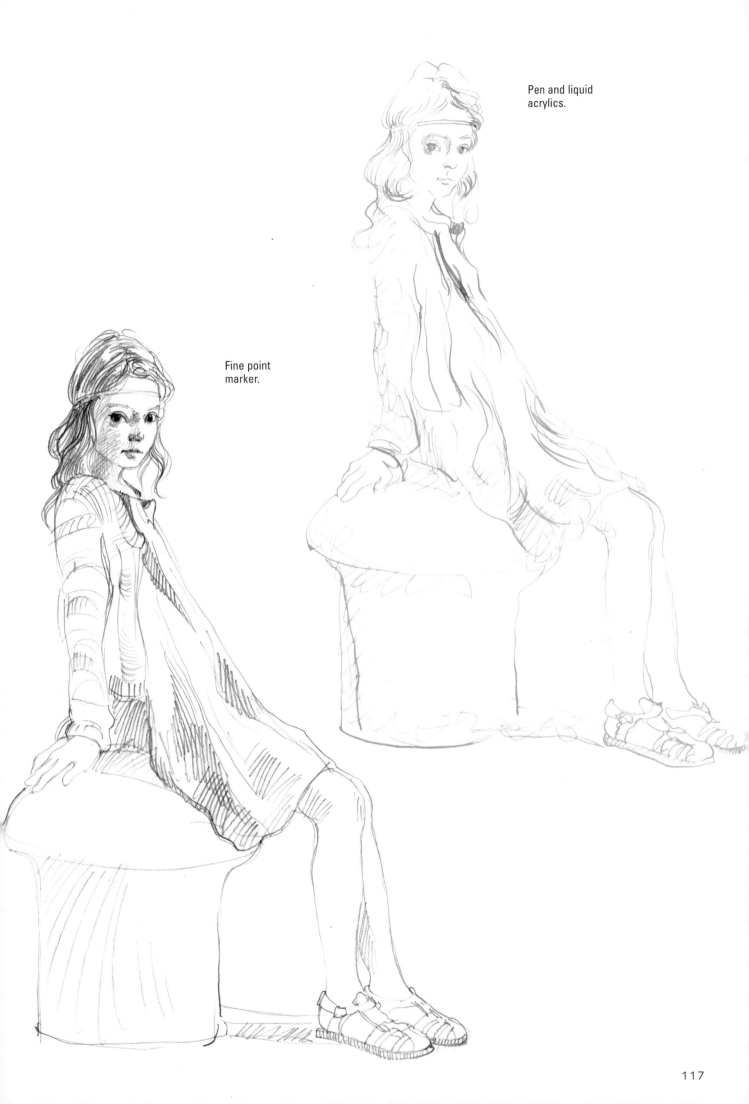

Pen and liquid acrylics.

Fine point marker.

117

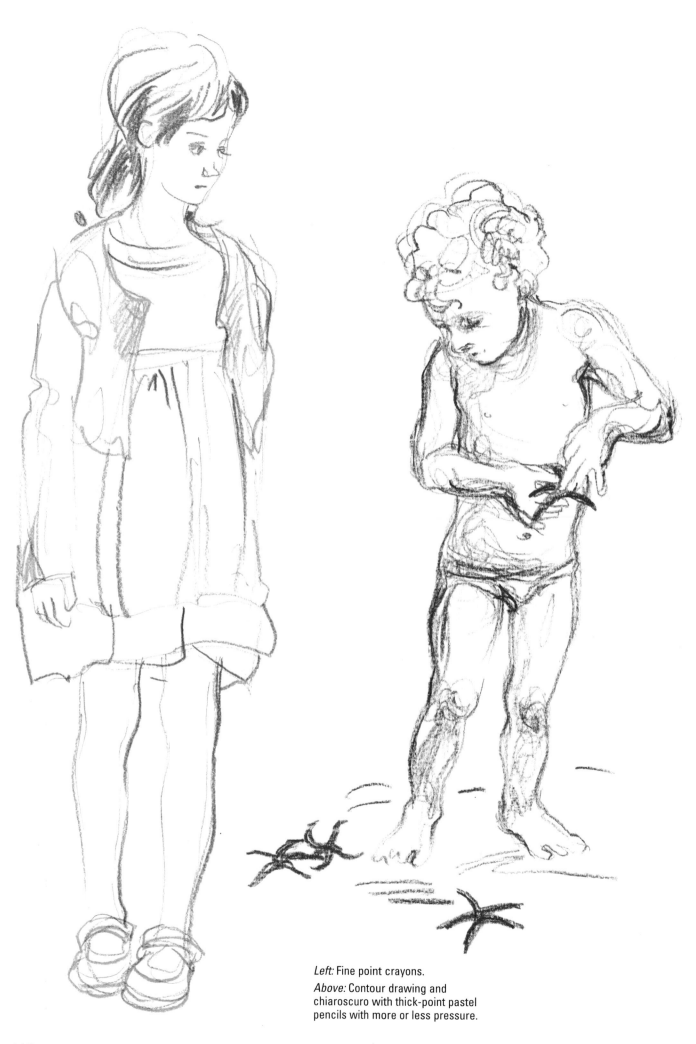

Left: Fine point crayons.

Above: Contour drawing and chiaroscuro with thick-point pastel pencils with more or less pressure.

118

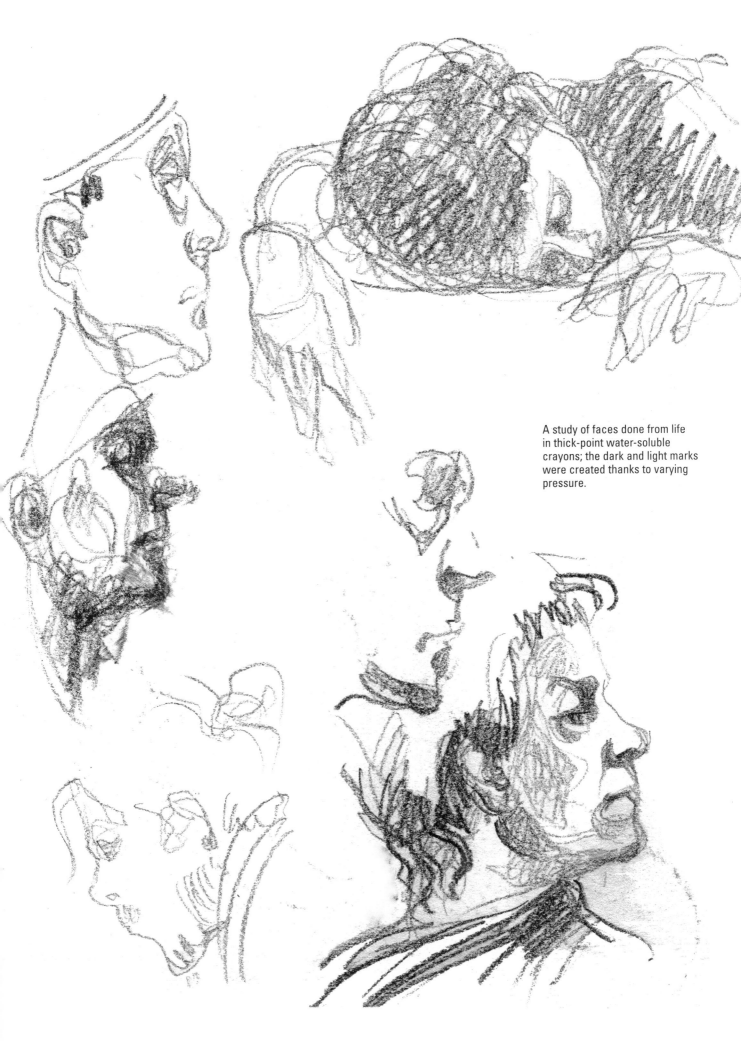

A study of faces done from life in thick-point water-soluble crayons; the dark and light marks were created thanks to varying pressure.

This field encompasses all the most ancient techniques: Conté crayon, charcoal, graphite, pastels, crayons, clay and all other means which can be used to draw marks on a surface for the purpose of defining an image in which the outlines are delineated and in which chiaroscuro is used to represent light and volume.

The outline doesn't necessarily need to be uniform. As seen in the previous chapter, its modulation offers interesting effects when the pressure isn't always even and the lines, thick and thin, express not just forms but the effect of light and shadow, bringing a sense of depth and relief to the subject.

The choice among all the materials listed before for line drawing depends on personal taste, the situation or the desired result. In any case, the technique is never indifferent with respect to the expressive study you wish to explore. The methods and techniques used to carry

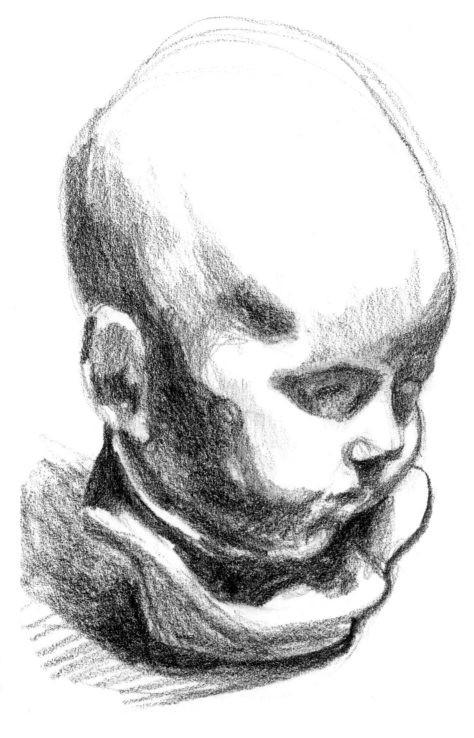

Copy of a sculpture: head of a little boy of about one year in graphite.

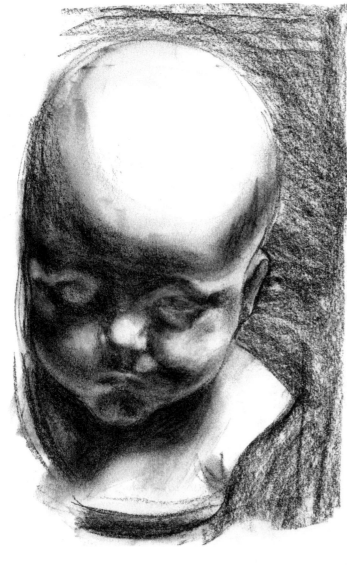

Copy in charcoal.

Copy in vine
charcoal.

out a drawing will create different ef-
fects in terms of graphics and, as a con-
sequence, in terms of expression.

Line drawing requires a certain amount
of training, which is why it's a good
idea to practice as always on afforda-
ble pieces of paper, such as packaging
paper, copy paper or other common-
ly-found options. Exercises and prac-
tice make the hand fluid, light or heavy,
both when using hard tipped tools and
soft ones such as charcoal or a brush.

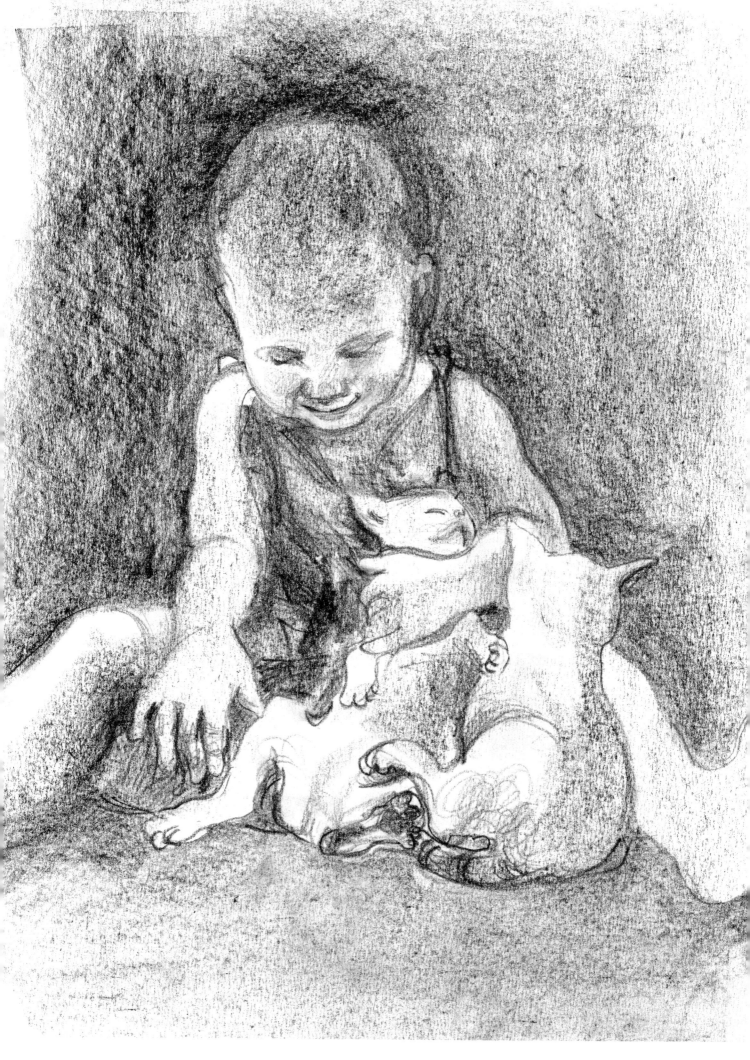

It's useful to reiterate that an outline is an abstract concept, an expedient to delimit everything which is visible. In reality, lines don't exist; they're a way to think and define the borders between forms more than see things. We don't perceive the world through lines, but through contrasts and the different light and colours between figures and backgrounds.

Opposite page: drawing in graphite used on it's side and tip.

Above: little boy, dog and monster drawn from life (except the monster) with a fine point pen.

Right: white and black pastels on brown paper.

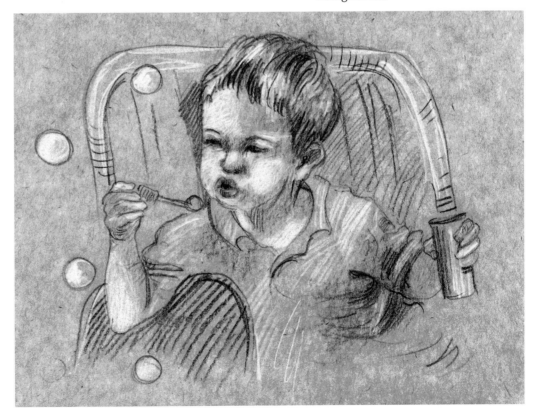

Hatching belongs to the realm of single tone techniques which makes it possible to create sculptural, relief-like effects thanks to chiaroscuro. Hatching is used to portray the volumes of a subject in relation to the light source and place it in a setting where near and far are indicated through the variations in lightness and darkness. The lighting will determine the atmosphere of the whole and create shapes in light and in shadow.

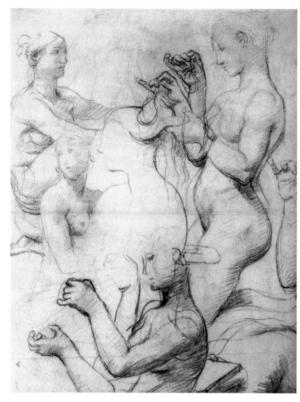

Ingres, *Study for the Turkish Bath*, 1859, Louvre.

Ingres, *Study for the Golden Age*, 1859.

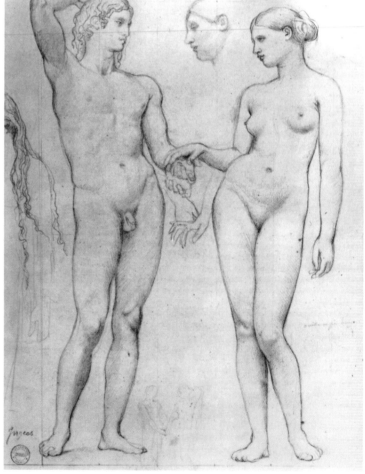

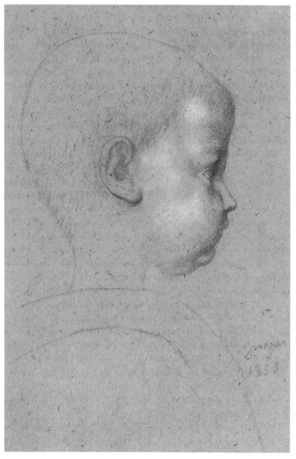

Ingres, *Portrait of a Boy in Profile*, 1853, private collection.

Daumier, *Two Male Heads*, circa 1830-34, Museum Boijmans Van Beuningen, Rotterdam, charcoal on paper.

Federico Barocci, *Study of a Head*, 1590, Nationalmuseum, Stockholm.

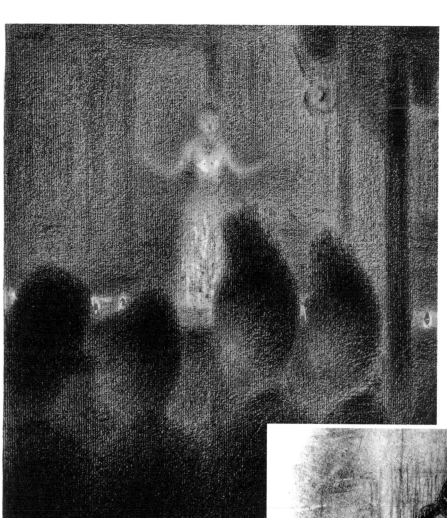

Georges Seurat, *At the Concert Européen*, 1886-88 ca., Museum of Modern Art, New York, Conté crayon and gouache on paper.

Toulouse Lautrec, *May Belfort Without a Hat*, 1895, Bibliothèque Nationale de France, Paris, lithograph with pencil and scraper.

Hatching may be light and subtle or heavy and dark, features created with straight or curved lines, crossed or free-standing and disorderly or orderly, but the important thing is to properly evaluate the expressiveness of the mark in relation to the type of light or the degree of plasticity desired.

Hatch lines normally go from left to right. For left-handed people, however, they will go in the opposite direction. Da Vinci was left-handed, which is clear from the direction of his hatching. Chiaroscuro can be blended or not, depending on if the shadows are faint or rather marked, creating deep contrast (which happens in the presence of an intense, up-close light source.

Before adopting any type of hatching, it's a good idea to use light strokes to trace the outlines of the shadows, which will subsequently be given values of differing intensity, and to highlight the lightest zones which will remain without hatching.

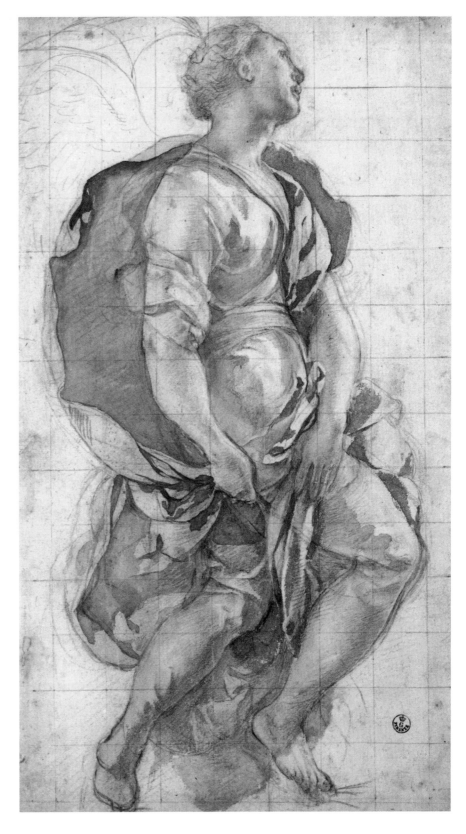

Pontormo, *Study for the Annunciation*, 1527-28, Capponi Chapel, Florence, black and sanguine pencil.

In his Treatise on Painting, Da Vinci defines shading as follows: "The light and the dark, that is, illumination and shadow, have a midpoint which cannot be called neither light nor dark, but equally participant in this light and dark; at times it is equally distant from the light as from the dark, and at times closer to one or the other".

A drawing can be given values with shading, which has the power to make tonal transitions delicate and soft. Shading is done in a few different ways according to the materials and the tools which are used, and personal taste.

An effective, versatile tool is the blending stump, which is passed over hatching to soften the contrast. It can also be used to draw with directly.

On a shaded base, the darkest, clearest points can be reinforced or left as light suggestions, according to the effect you want to study.

Even a rubber can be used to blend hatching, or you can proceed with shading the tones directly using graphite powder or Conté crayon.

Leonardo da Vinci, *Draping around the leg of a seated figure*, study for Saint Anne, Louvre, Paris, black chalk, heightened with white and ink.

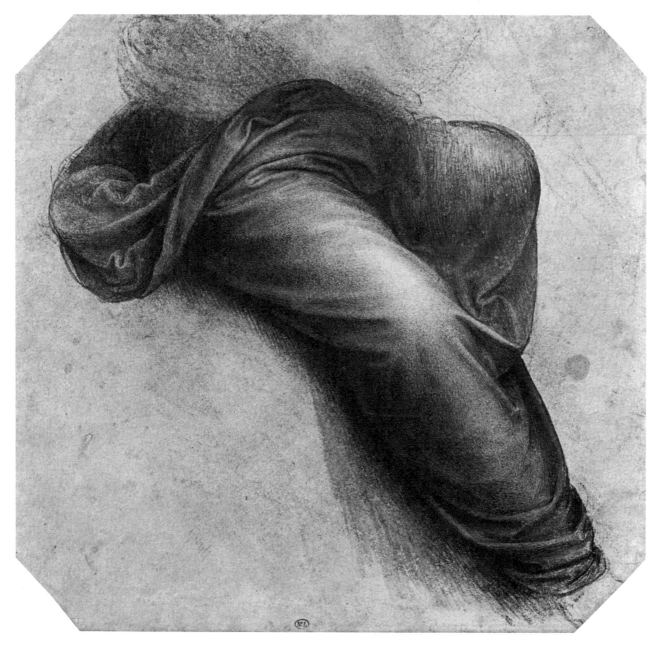

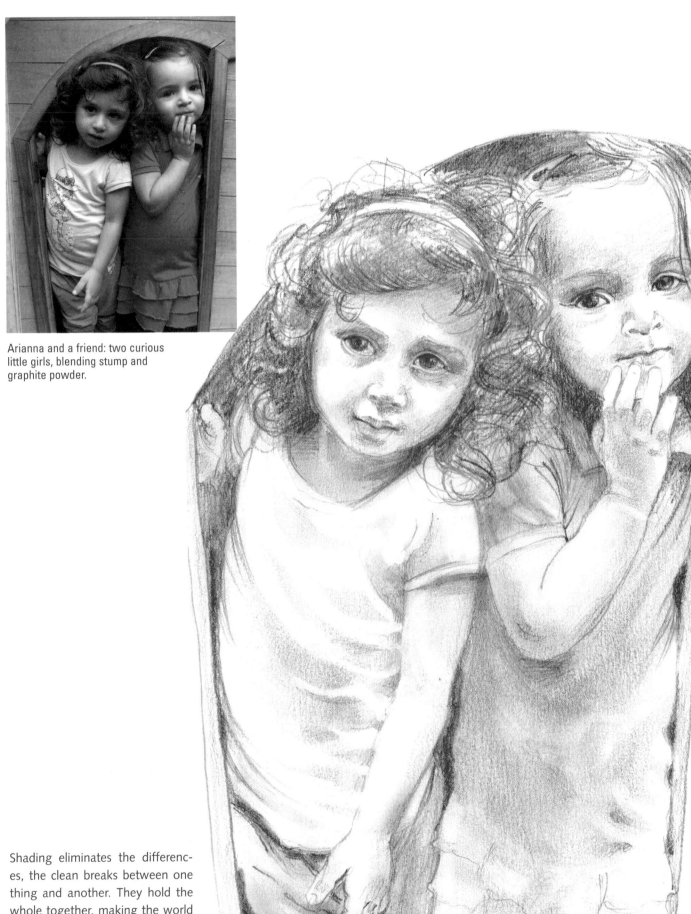

Arianna and a friend: two curious little girls, blending stump and graphite powder.

Shading eliminates the differences, the clean breaks between one thing and another. They hold the whole together, making the world seem like one organic "thing". If we outline a shaded object with a clean, uniform line, we immediately carve out a fictional, stiff effect. Give it a try.

THREE DIMENSIONALITY

In general, any one subject isn't more difficult than the next. They all require, first and foremost, the same way of seeing, whether it's a bunch of flowers, a landscape or a human figure. The same is true for creative drawings which are "seen" with the mind's eye. All one needs to do is understand which subjects stimulate one's interest. People and faces, in particular, are sure to be among them.

At around twelve years old, kids start to feel the need to draw things realistically. Before then, they draw what they know of shapes and space, any form, human or otherwise. The same representational methods are found in paintings from different periods. Linear and chromatic, perspective in Western culture appeared and was solidified in the Renaissance. From that moment on, Westerners drew what they saw, how they

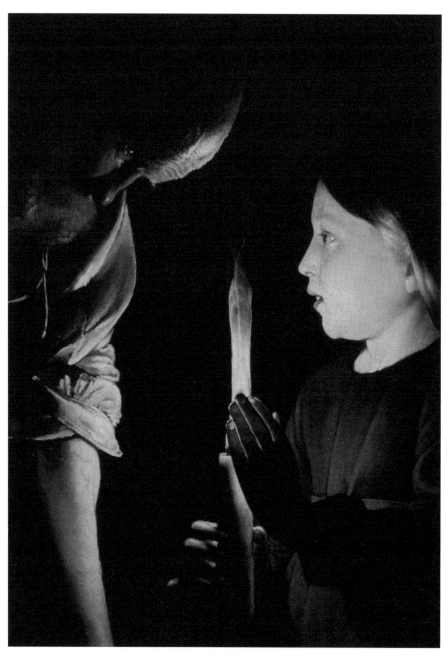

Georges de La Tour, *Joseph the Carpenter*, detail, 1642, oil on canvas, Louvre, Paris. Rather particular lighting which highlights the face of baby Jesus and back-lights his hand with the candle.

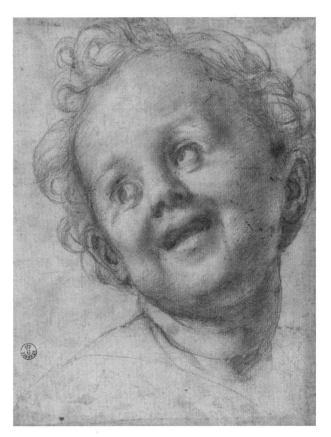

Pontormo, *Study for the Head of the Baby in the Pala Pucci*, 1518, Department of Drawings and Prints, Florence, black and white chalk. Chiaroscuro hatching accentuates the luminosity of the face.

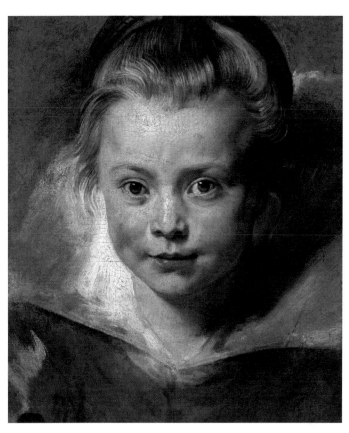

Rubens, *Head of a Girl*, 1616, Fürstlich Lichtensteinische Gemäldegalerie, Vaduz. A fresh, immediate image, almost a sketch. The broad, well-lit white collar seems to gather all the light and reflect it on to her cheeks, forehead and neck.

saw it, no longer depicting what they knew. However, childish symbols also influence adults, and when we draw we tend to put ourselves before the subject, like a sort of filter. This is exactly how a nose is reduced to the symbol of a nose, representing the general, generic idea of a nose yet not at all resembling that unique, specific nose. The same is true no matter the subject. The importance and extraordinary wealth of drawing as a tool: drawing truly becomes a means to understanding.

To realistically render a subject, one must first understand the role of light and recognise its values, that is, the difference between light and dark tones.

To express the volumes of a subject in relation to the light source(s) and type of light, we turn to chiaroscuro, a method used by artists throughout time.

Even to represent depth of field, i.e. space, we turn to a light scale. In this case, the proximity and distance from the foreground are shown through variations of chiaroscuro, which can be quite marked or blended.

Chiaroscuro is one of the most important methods to create a finished drawing and to render the overall effect of the atmosphere. Light tones for light and dark tones for shadows: light and shadow are inseparable, interdependent elements.

The direction of light can be lateral, central, from above or below, even from behind when backlit. However, the ideal light, that which is widely used to represent children, is diffused light (indoors or outdoors), a type of light which transitions to one value to the next softly. Grazing light creates an expressionist effect, not the best for representing children, radiant beings with very little darkness.

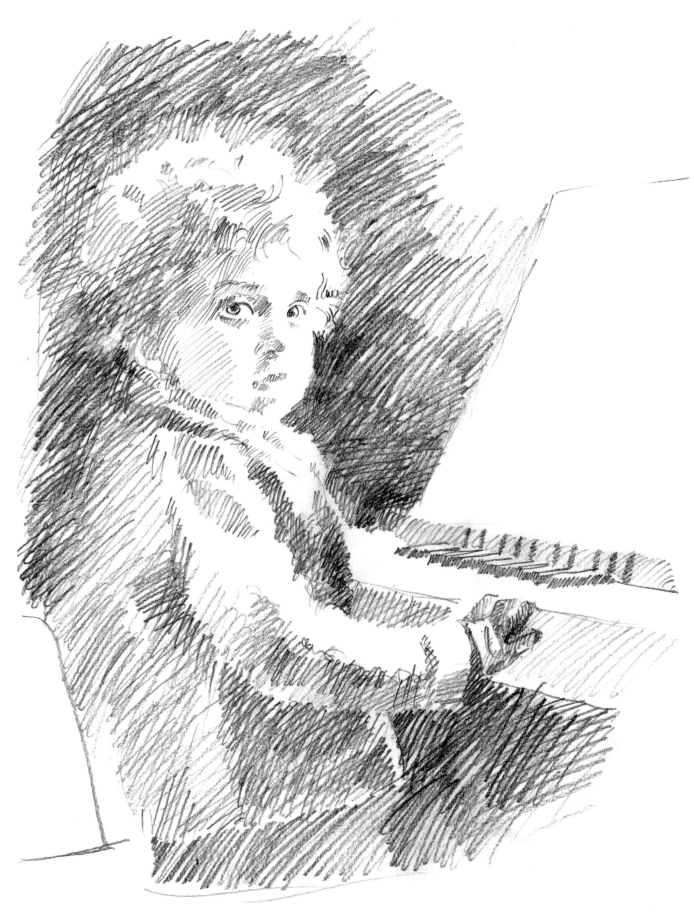

When drawing, hatching is the most suitable way to construct a transition in chiaroscuro and recreate light, depth and the surfaces of an original subject, shaping it in a way that creates an illusion of the reality we perceive. Diverse materials can be used, each of which behaves quite differently from the next: graphite, Conté crayon and vine charcoal are the most widely used, and also the oldest materials known.

Hatched drawing made from a photograph: when the outlines aren't traced, the forms emerge exclusively thanks to the difference in tonal values, to greater realistic effect.

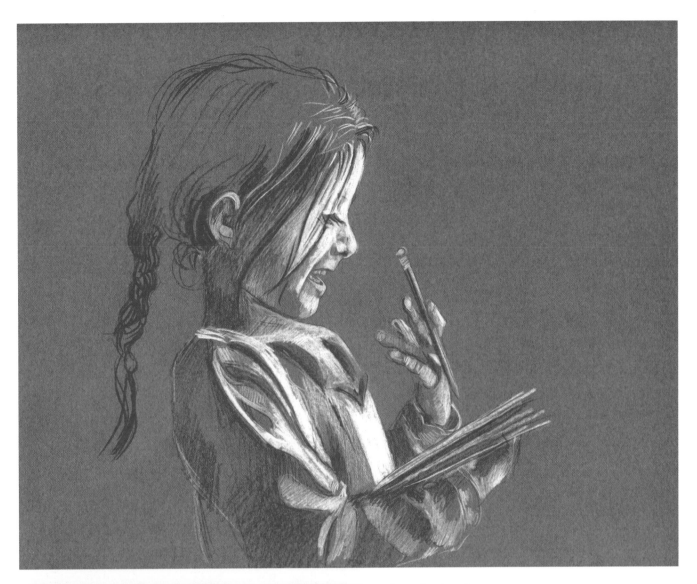

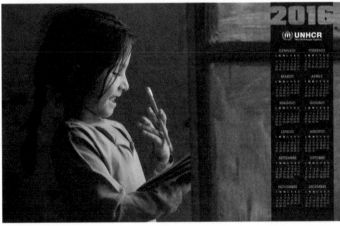

Copy of a photo from the 2016 UNHCR calendar on a grey sheet, starting from the light areas. Using a medium grey background can facilitate the work as it already has a value to which light (by whitening) and shadow (by darkening) are added.

In essence, there are two starting points to creating chiaroscuro: starting from light or starting from the shadows. It's always advisable to use black and white photographs or b/w photocopies or prints of colour photographs. This will facilitate the process as at first it will be difficult to translate colours into a light scale.

The light and shadows which fall upon a subject create forms which indicate its structure and suggest its shape.

Go from general to specific for increasing definition of the details.

First, create a quick sketch of the figure as a whole and then divide it up into light and dark zones, delimiting them clearly, as if it were a geographic map. On a dark or black sheet of paper, you'll whiten the parts struck by light, and if working on a white sheet of paper, darken the shadows.

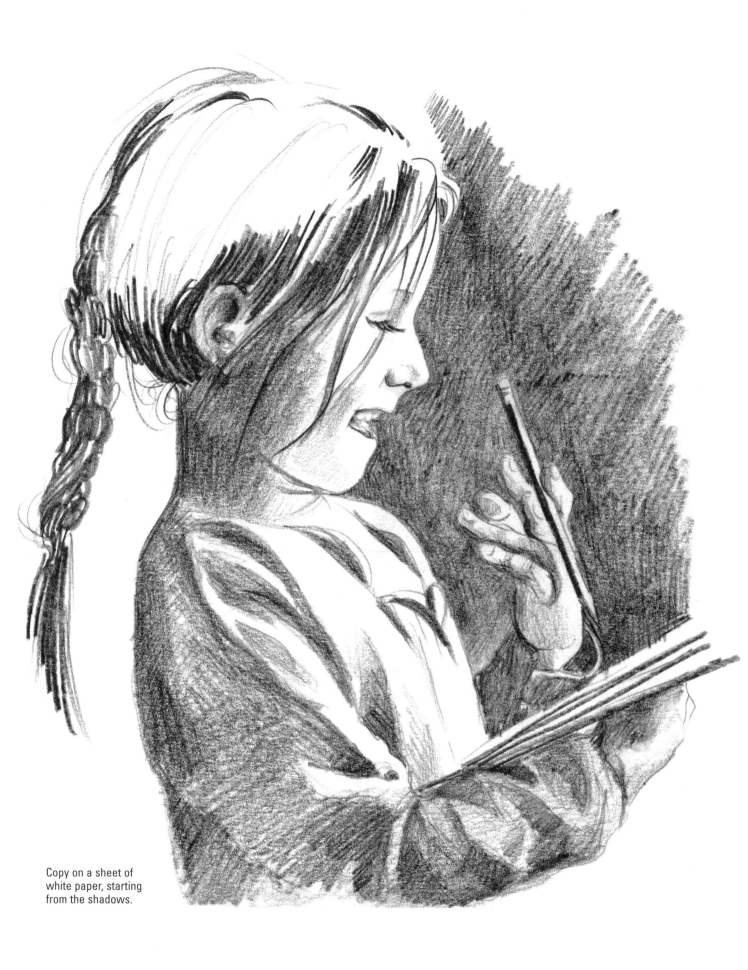

Copy on a sheet of
white paper, starting
from the shadows.

Filippino Lippi, *Head of an Elderly Man Wearing a Hat,* c. 1495, Devonshire Collection, Chatsworth, England, metalpoint heightened with white on bluish-grey prepared paper.

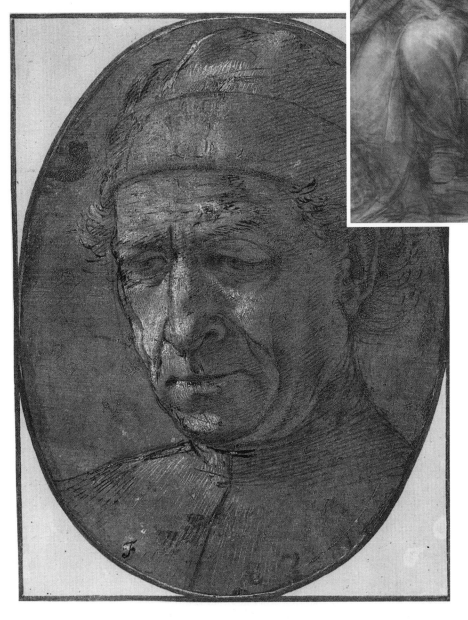

Leonardo, *The Virgin and Child with St Anne and St John the Baptist*, 1506-08, National Gallery, London, charcoal and chalk on paper.

In drawings by the masters from the Renaissance onward, when drawing became a true genre of its own, chiaroscuro became inevitably used on every subject. Through chiaroscuro, people acquire truth and realism.

Light and dark can interconnect softly or with more contrast; light bathes bodies with shadow and chiaroscuro is the instrument used by artists to express depth. The alternation of these different contours, sharp or blended, bring vitali-ty to the drawing, in addition to more effectively rendering a realistic result. In addition, it is also a way to focus a subject with respect to others, to highlight the figure-to-background relationship or to bring out some parts of a single subject.

Study of a head of a little girl in terracotta with the erasure method of the light parts on a background darkened with charcoal.

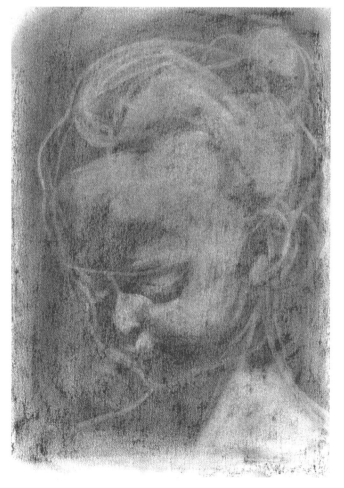

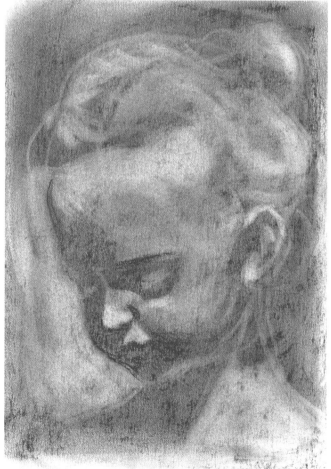

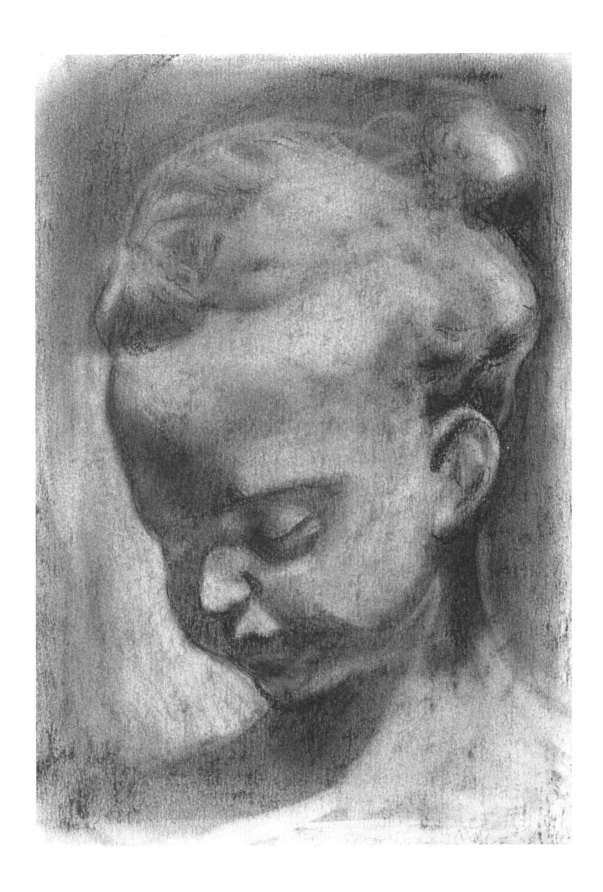

Such a sharp breakdown helps us see and understand volumes. However, it's helpful to add mid-tones for a more realistic effect and, as was mentioned before, when drawing children, the play of light and shadow is always preferably *sfumato*. You can thus prepare a medium grey background from which you can bring out light with a rubber or add greys on a white sheet of paper, avoiding filling in the light parts. To simplify the task, it's best to use a reduced light scale: two values for the light parts, two for the shadows and a medium value for the subject.

At first, avoid darkening too intensely.

Try to render the whole with a limited scale of greys to get the best impression of the subject. Only at the end should you identify and accent the lightest and darkest parts, continuing to compare the original and the drawing while squinting.

After having traced the essential lines of the drawing, begin to create the chiaroscuro, the light/dark contrast, starting from the lightest tones. Keep comparing the original with the drawing to verify that the tonal relationships comply. Go from the general to the specific gradually without exaggerating the darker tones. Only after having rendered the effect of the whole will you be able to understand where the darkest and lightest points are. If you start by making everything too dark, you run the risk of not being able to easily render the mid-tones and, in particular, you won't be able to recover the light parts, which are those which most contribute to the 3-D effect.

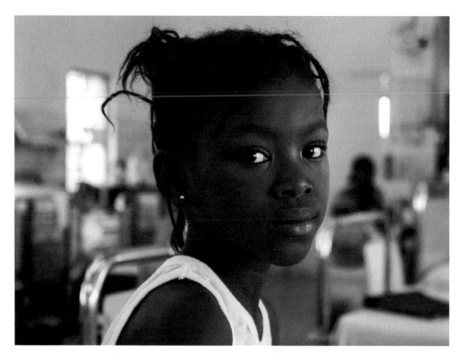

A photograph of a girl taken in the Emergency hospital in Sierra Leone by Massimo Grimaldi.

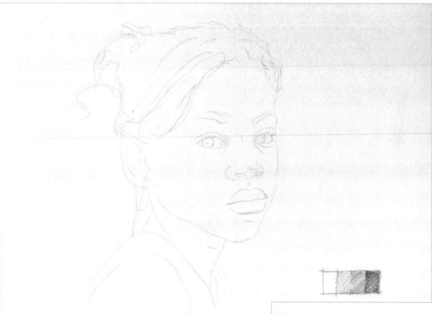

A light-handed drawing is done in a 2h pencil; the grey scale should go from white (paper), to light grey (HB), to medium grey (3B), to dark grey (6B).

Right: step with light grey (HB).

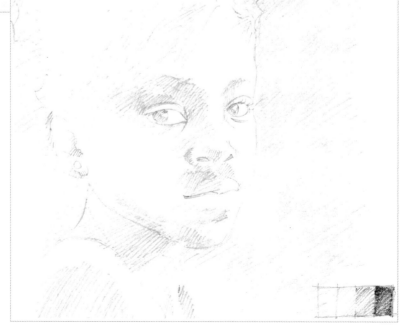

Observing from a distance or while squinting is the most effective way to check the resemblance between the picture and the drawing. By doing so, you'll eliminate the details, while the whole of lights and darks will be viewed synthetically. As a result, the subject's volumes and the relationship with the background (depth of field) will be more comprehensible. By half-closing your eyes, you'll simplify the observation process and it will be easier to identify the predominant tones which will be reduced to three main values: light, medium and dark, with the fourth and final value being the white of the paper. This also facilitates the translation of the chosen subject into colours, and could be the base upon which to paint in washes, as painters did in the 1500s. Each colour changes according to the zones which are illuminated and those in shadow. The starting point to understanding a colour is the light scale, in other words, chiaroscuro. For example, a red may be lighter than a yellow if struck directly by light while the yellow is in the shadow.

In the words of Joe Singer, "To me, painting – all painting – is not so much the intelligent use of colour as the intelligent use of value. If the values are right, the colour cannot help but be right. Joe Singer, *How to Paint in Pastels*, Watson-Guptil Publications, 1976.

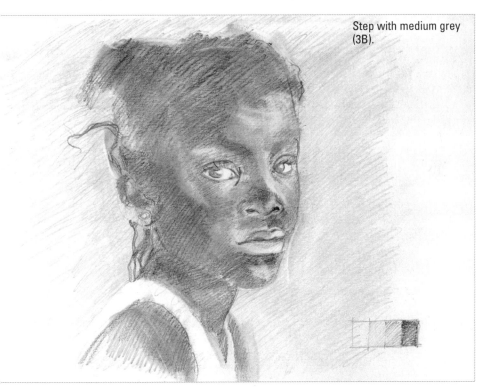

Step with medium grey (3B).

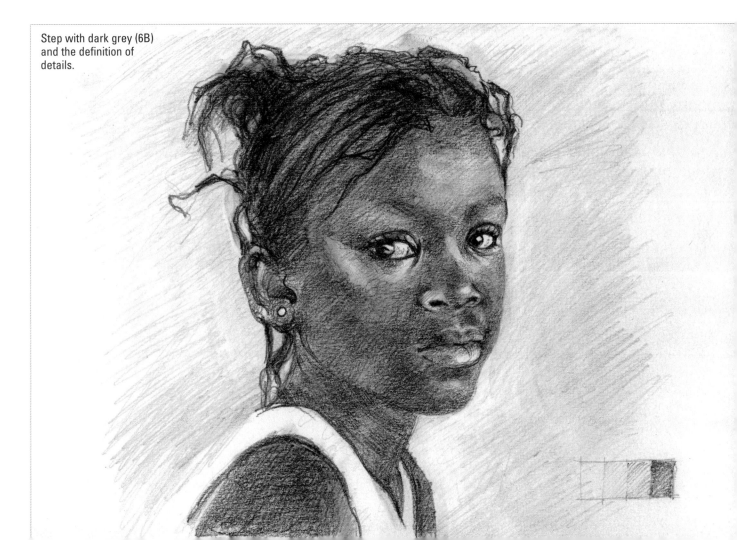

Step with dark grey (6B) and the definition of details.

PAINTING TECHNIQUES

When using photographs or film stills, you can take advantage of the chance to work with more difficult painting materials such as tempera, acrylics, oil paints or even watercolours and mixed media. Collage mixed with painting techniques could also be quite interesting.

Each technique has qualities that makes it more or less suited for certain types of artwork or expressive study. What technique you choose also depends on the artist's personality and style.

Painting techniques differ according to the type of binding material which is mixed with pigments in order to stabilise the colours: honey or gum arabic for watercolours, egg whites, ox bile, rabbit-skin glue or other animal-based glues such as fish gelatin, casein and egg, or wax melted in oil for tempera, flax oil or poppy-seed oil for fine oil paints, up to synthetic materials for acrylics.

ACRYLICS

Acrylic painting is certainly one of the most common painting techniques used in illustration, becoming abundantly popular in the world of painting after WWII. For certain aspects, it is also the most approachable technique as it allows the artist to modify already-painted parts multiple times, correcting any errors or changing tones.

Acrylic is a synthetic material which dries quickly and which, once dried, forms a waterproof layer that other layers of paint can placed on top of. Only light or white tones are dulled once a dark colour has been painted. To avoid this problem, after having finished the drawing, delimit the light areas and paint them at the very end.

To learn painterly techniques, you can refer to one of the numerous manuals on the topic. However, it is also quite important to grapple with the skill by starting with simple subjects and then gradually moving on to more complex ones. But more than anything else, the most important thing is not to get discouraged.

In painting, just like in music, hours of practice are necessary if you want to tackle a difficult painting or a complete piece. All arts require passion, patience and tenacity.

In painting techniques, the absolute star in terms of tools is the brush, rather than graphite or charcoal and all other graphic techniques. Lines are replaced by brush strokes, with the use of a series of brushes: pointed, flat and filbert, from number zero to flat and wide brushes up to four or five centimetres wide.

I recommend practising how to use a paint brush through a particularly effective exercise: painting the image of an egg, trying to render its volume with shading, modulating its light and dark tones. It's a great way to practice with acrylics, tempera and oil painting and thus compare their similarities and differences. It's useful for another reason as well: the tonal values of the egg, the optical properties of its surface and light effects are quite similar to those of skin. All three techniques were used in this exercise.

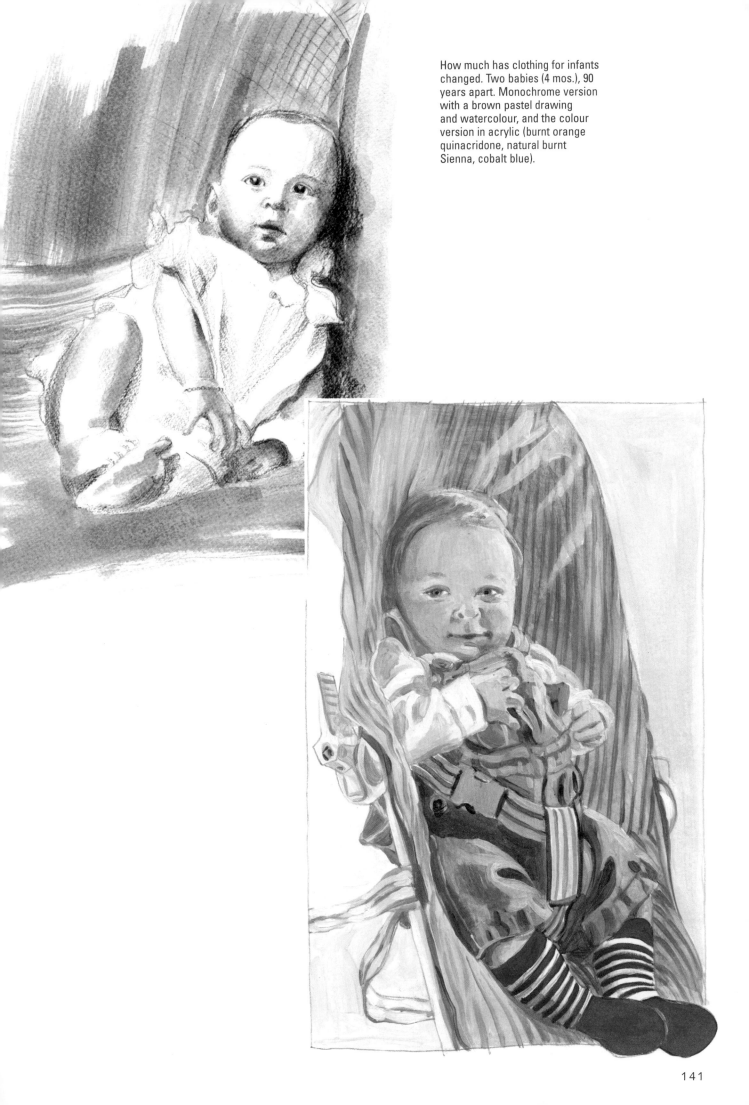

How much has clothing for infants changed. Two babies (4 mos.), 90 years apart. Monochrome version with a brown pastel drawing and watercolour, and the colour version in acrylic (burnt orange quinacridone, natural burnt Sienna, cobalt blue).

141

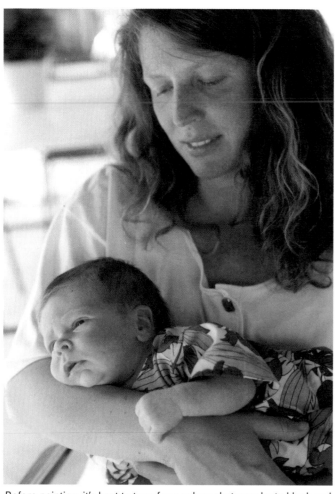
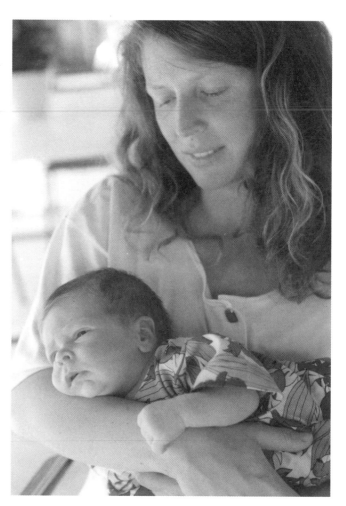

Before painting, it's best to transform colour photographs to black and white. This makes it simpler to paint, starting from the grey scale.

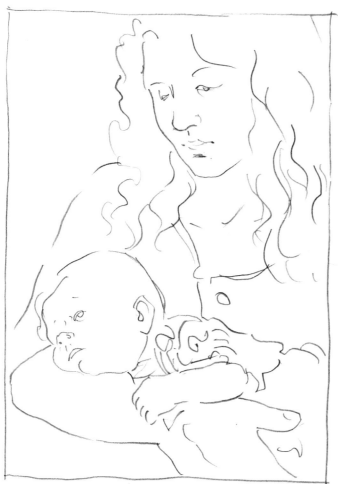
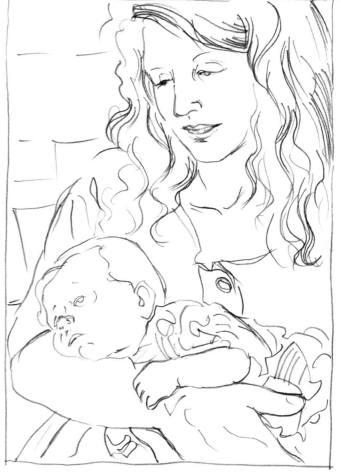

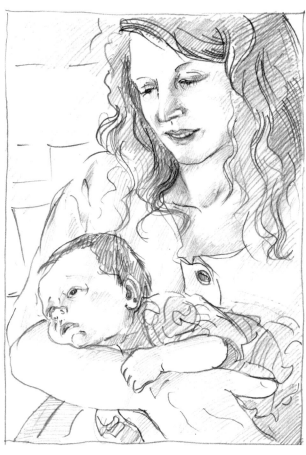

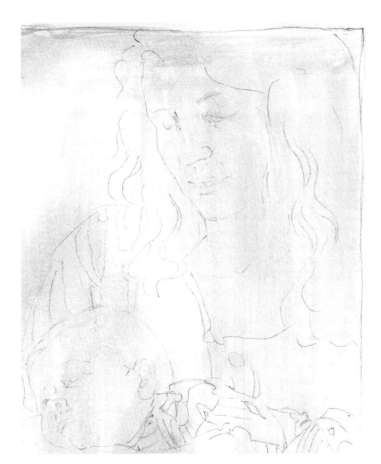

Study of the subject, drawing and shading done in a soft lead pencil. This makes it possible to understand the tonal values which form the base of the colour and to implement chromatic choices which are consistent with the foundation colour.

Identifying the common chromatic denominator of the entire scene depends both on natural or artificial light and on the relationship between all the colours present, so mix it partially with all the colours which make up the image.

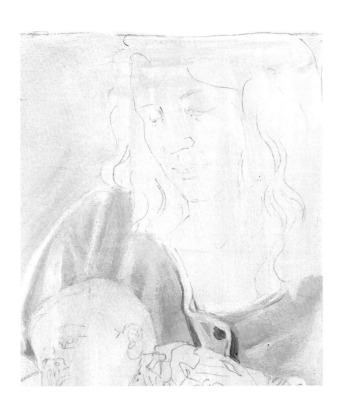

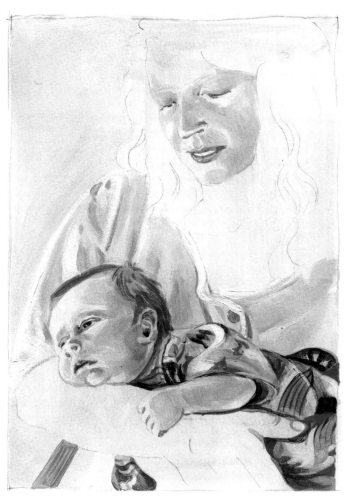

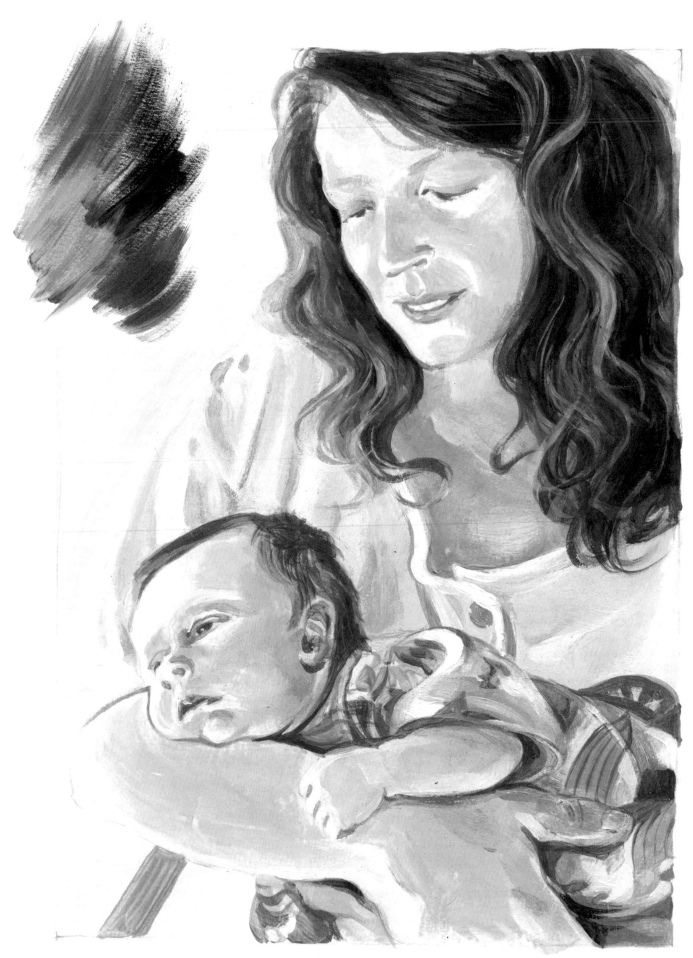

The finished painting.
Cobalt blue, burnt Sienna, Carmine
red, burnt umber, and white were
the colours used to create the
image.

Phases transforming a photograph to a
monochromatic painting.
The colours used were: Sienna
earth (raw or burnt), titanium white.
Chiaroscuro contrast is accentuated in
the second version.

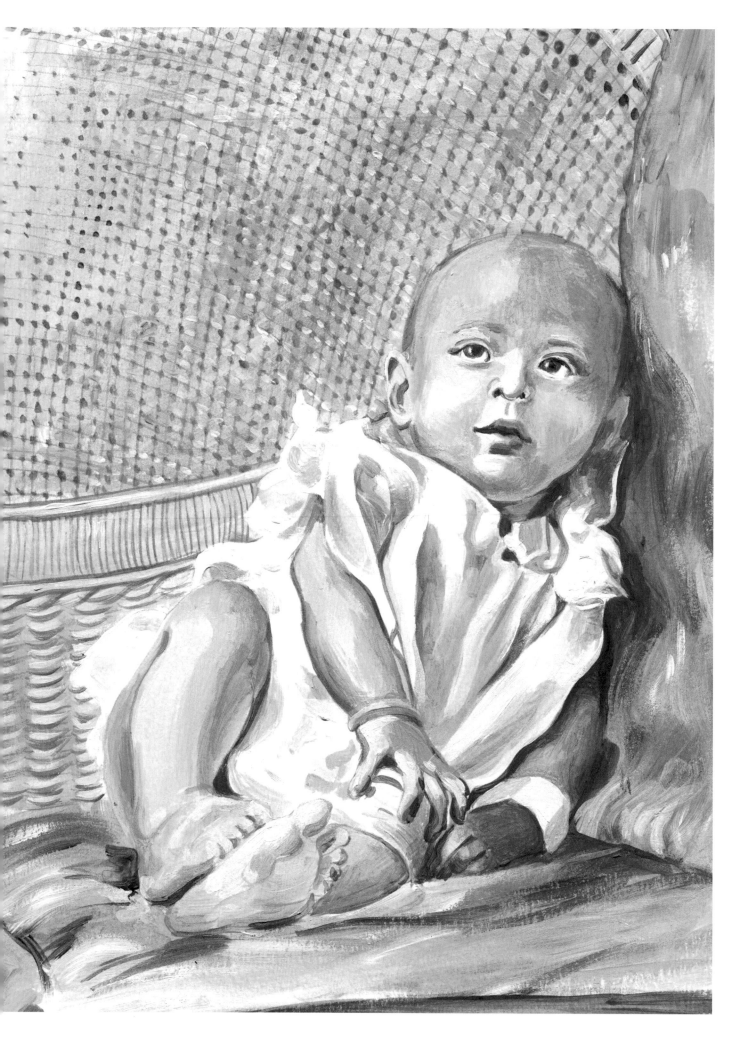

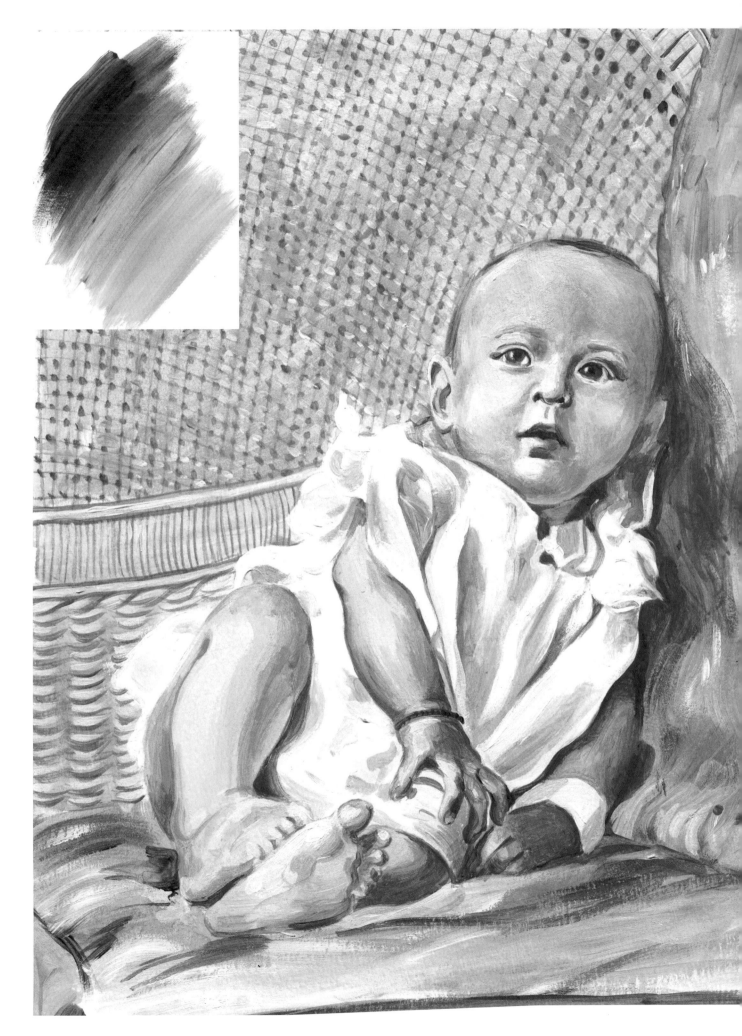

TEMPERA

Tempera is the oldest painting technique of those discussed in this volume. Traces of it have been found in Etruscan tombs, especially those in Tarquinia and Chiusi, going back to the 6th century BC. Colours were painted on the tuff rocks which burial chambers were cared from, over a thin layer of plaster. Tempera paints are opaque, meaning they fully cover whatever is underneath. When diluted very little and the layer below is fully dried, multiple layers can be placed one over the other. Even light colours can be placed over dark colours because tempera is quite dense.

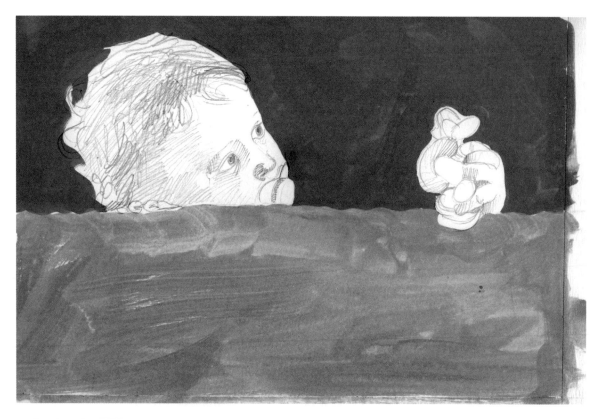

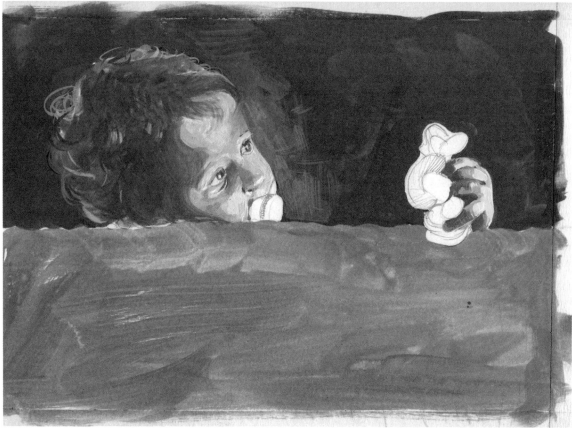

However, for the best results, you'll need to paint quickly to ensure the colours underneath don't re-emerge.

It's a versatile technique and, like acrylic, it can be used more or less diluted and applied with different types of brushes. Tempera can also be combined with other materials for good results: coloured pencils, marker, pen.

Tempera is characteristically opaque and silky. One method for its use is to first paint the background colours followed by the subjects which need to be handled with greater precision. Generally, in the end, any outlines disappear, and tonal nuances are obtained by quickly applying the paint.

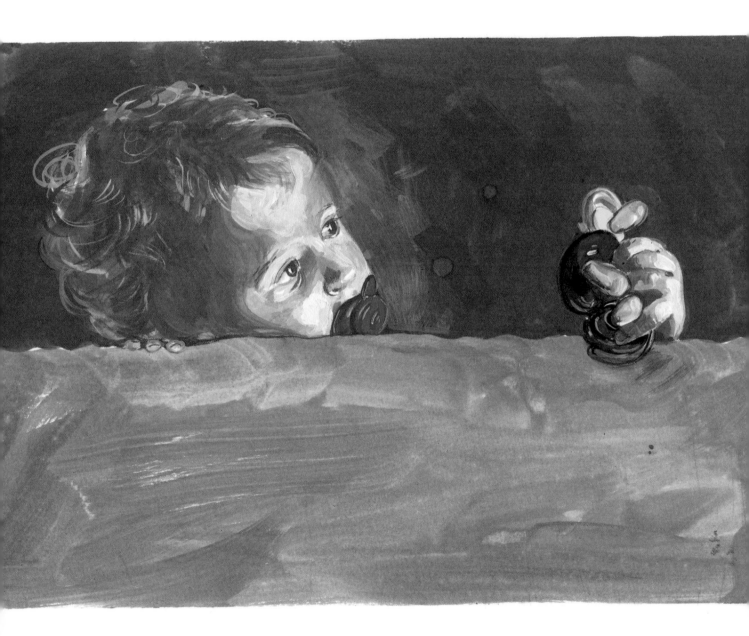

Tempera-based interpretation of a photo by Filippo Bianchi, broken down in a sequence with the three main phases: background, figure and details. The colours used are: olive green, titanium white and magenta. In the details: ultramarine and vermilion red.

Above: A very diluted layer of paint was applied, already differentiated in the various areas.

Below: depth is added with the densest, most-covering colour, starting from the darkest parts.

Again using a dense mix of paint, all the image's elements were defined last.

Or even over the pencil or charcoal drawing (called the sketch or draft), you can lay the first layer of very diluted paint, but be sure it is already differentiated in the various light and dark zones. Then, with denser paint which covers that beneath it, define the subjects first with darker colours, ending with lighter ones. Start from a vision of the whole, approximating the entire image from the get-go to, then gradually hone in on the various subjects.

This procedure makes it possible to maintain the existing relationships between all the elements which make up the image.

Not seeing each single part of the painting separately makes it so that the final result is more cohesive in that there's one luminous, chromatic atmosphere which brings unity and realism to the whole.

Like all techniques, tempera also requires experimentation and practice phase before getting truly satisfying results.

With tempera, it's also possible to directly blend two layers of overlapped paint. With enough water, the lower layer may give way and mix with the one above it. Lastly, when the painting is perfectly dry, touches of very dense paint can be added to highlight the most important points.

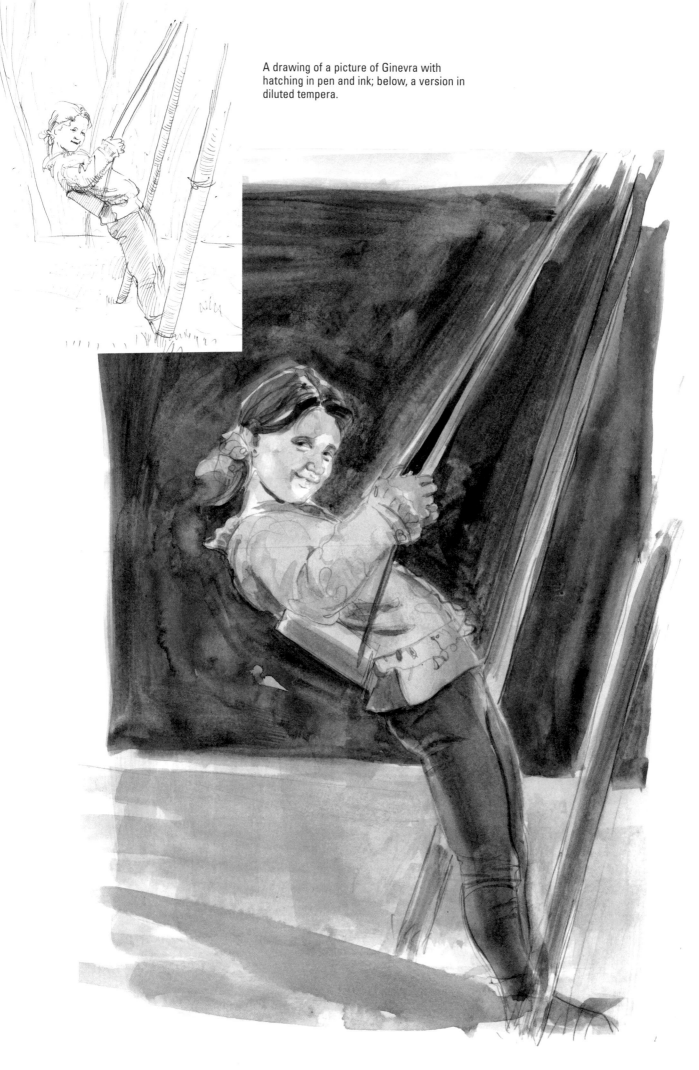

A drawing of a picture of Ginevra with hatching in pen and ink; below, a version in diluted tempera.

WATERCOLOUR

Watercolour painting is the most popular technique at the moment because it is easiest to have on hand anywhere and any time: in the office, travelling, outdoors. All you need is a box of cups, two brushes and a small container for water or even brushes loaded with water, which further reduce the amount of equipment you have to carry with you. Speed of execution is the fundamental characteristic of watercolour painting and, for this reason, it has become the preferred technique for the sketcher that travels the world to capture impromptu settings and situations. It can be used on pencil strokes or directly from a brush.

It isn't a particularly easy technique - actually, it's generally considered quite complex, if not the most complex method of painting overall. With thicker paints, it's easier to remedy random inaccuracies and hide mistakes, changing them only in part. But with watercolour, which is transparent and quickly-executed, such operations are not easy and thus best avoided.

Before starting, be sure you have an idea of the distribution of colours and, in particular, identify the zones with the most light, to be left white, letting the paper shine through. It is no coincidence that white paint is almost never used in watercolour paintings.

The final product should be immediate, spontaneous; the colours can be added on a dry or wet surface; and the resulting effects will obviously will be quite different. If you're looking for precision, it's best for the paper to be perfectly dry. If, on the other hand, you want gradual, informal transitions between colour, it's best to wet the area involved ahead of time.

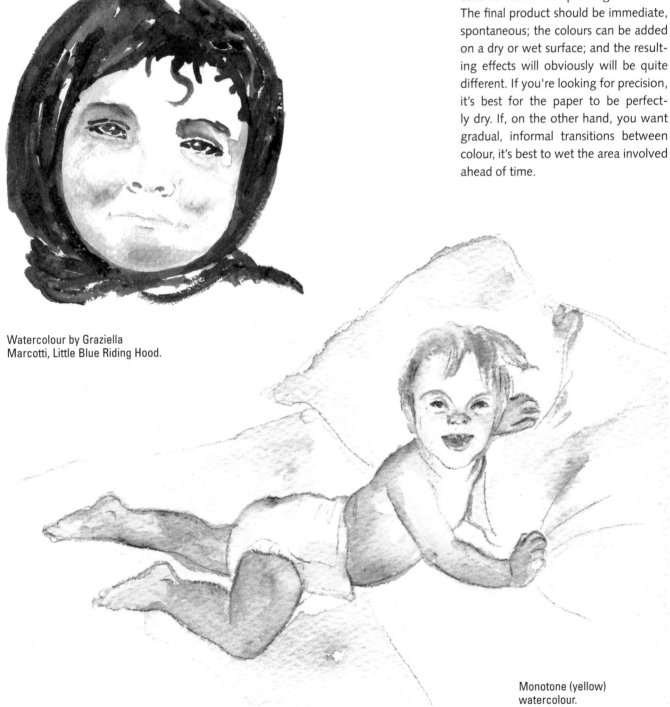

Watercolour by Graziella Marcotti, Little Blue Riding Hood.

Monotone (yellow) watercolour.

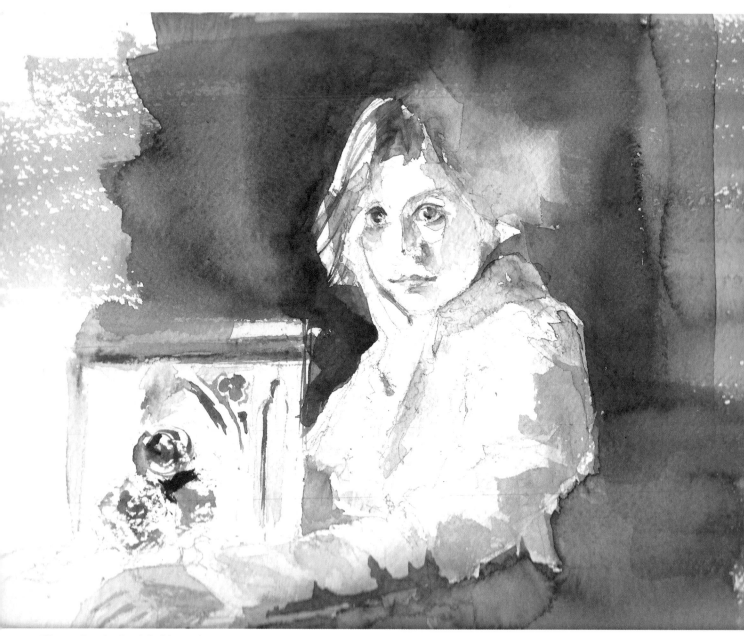

Watercolour by Graziella Marcotti.

Watercolour can be applied in stains or washes. With the former, the result will be partially involuntary and the paints used must already be in the desired tones. With washes, you get to the end result gradually, overlapping.

When starting from a preparatory drawing, it's a good idea for it to be simple and essential, little-defined in its details but correct in its proportions. The marks made by the pencil should be light, barely hinted at.

Watercolour can also be used with graphic techniques such as pencil, pen, or water-soluble pastels.

When using this technique, it's essential to pay close attention to keeping the full-light zones free of paint, which will be represented through the white of the paper itself.

Everyone can find their own way of working through experimentation, making use, at least at first, of a good manual.

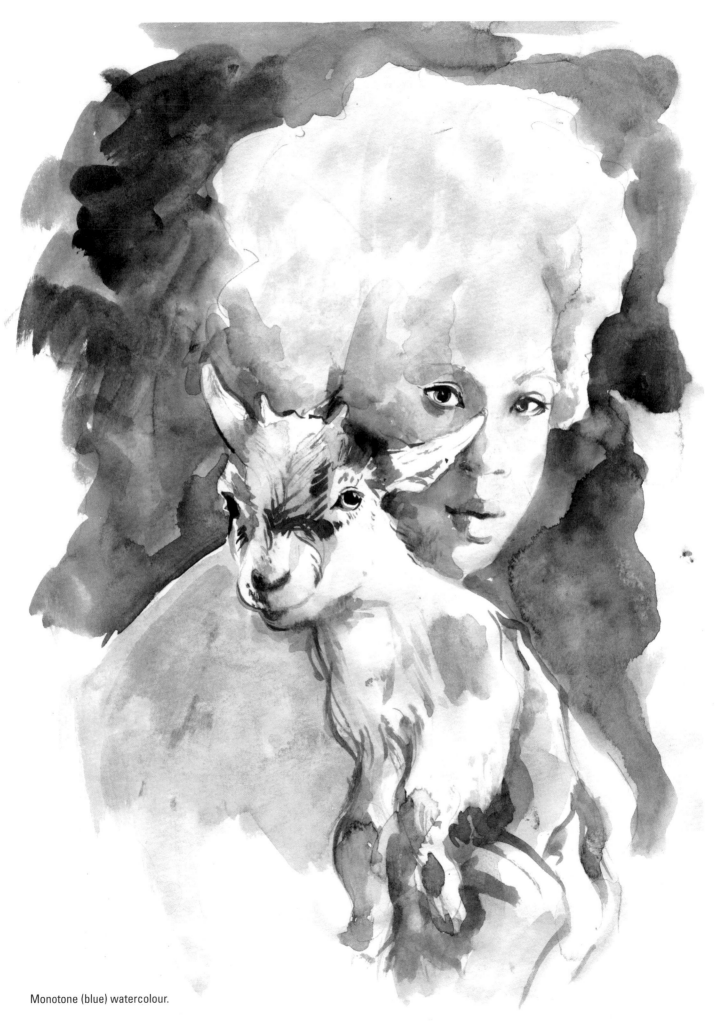

Monotone (blue) watercolour.

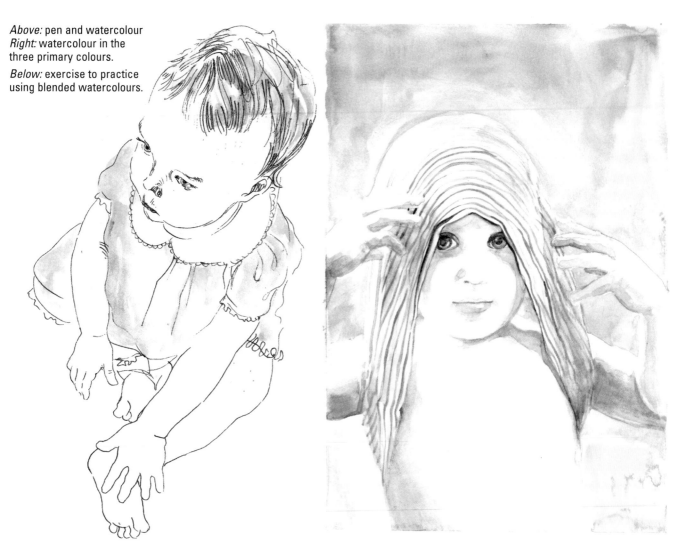

Above: pen and watercolour
Right: watercolour in the three primary colours.

Below: exercise to practice using blended watercolours.

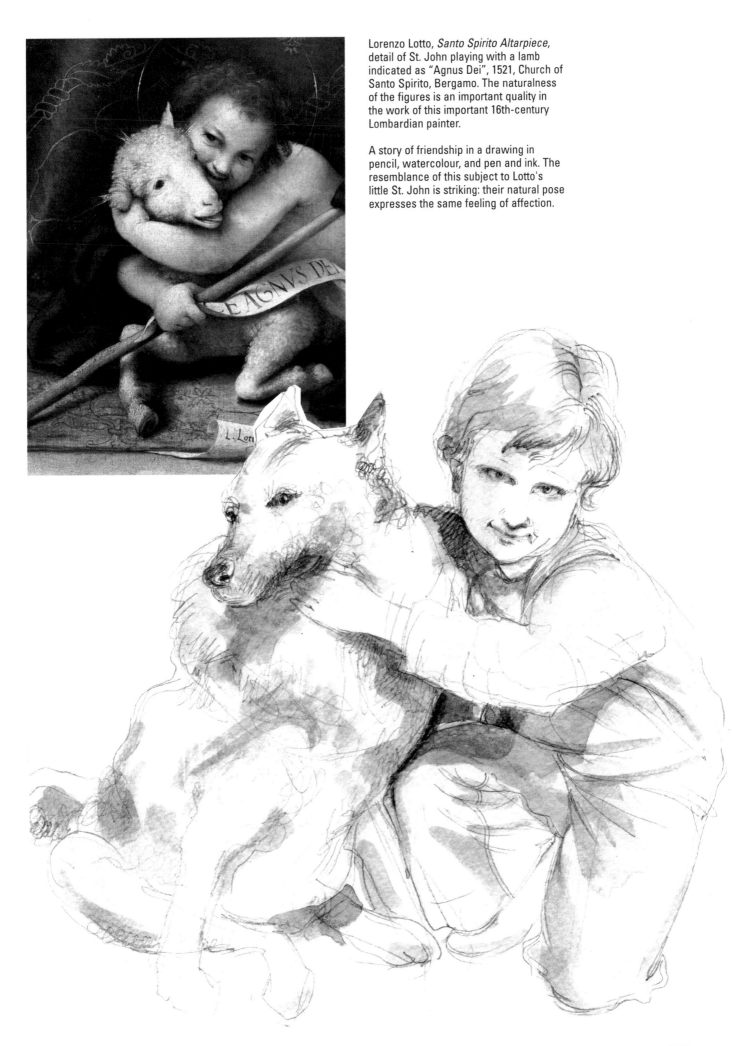

Lorenzo Lotto, *Santo Spirito Altarpiece*, detail of St. John playing with a lamb indicated as "Agnus Dei", 1521, Church of Santo Spirito, Bergamo. The naturalness of the figures is an important quality in the work of this important 16th-century Lombardian painter.

A story of friendship in a drawing in pencil, watercolour, and pen and ink. The resemblance of this subject to Lotto's little St. John is striking: their natural pose expresses the same feeling of affection.

The final result of a given technique and material varies as you change the surface they're used on. Which is why you should try various combinations to identify, among all possible effects, which ones you like best and which ones give you the results you were striving for. Paper comes in varying types and grammage; that intended for watercolour is generally expensive but optimum. However, it's always best to start with inexpensive paper or even paperboard or other unique surfaces such as wood, medium density fibreboard and canvas. Each technique can be adapted to any of these supports. What matters is finding the combination you prefer. In particular, with watercolours, it's always best to use paper with a consistent weight (grammage).

Oils

Oils are another ancient technique, traces of which have been found in paintings from Egypt, Greece and Pompei. But it was Flemish painter Jan Van Eyck who perfected its technique with the skill of a genius, handing down oil painting with the characteristics which are still found today.

Oil paints are perhaps the most fascinating material for the brilliant range of colours they offer. Pigments are mixed in flax seed oil or poppyseed oil, with the resulting paints drying extremely slowly and leaving a solid layer of paint on the surface of the support.

Oil paint's slow drying speed means it can be blended with relative ease. The colours are better maintained in the process compared to other materials, but this slow speed, in some circumstances an advantage, can also be an obstacle.

There are also many manuals which will teach you how to paint with oils. Some are better than others, so it's best to seek out a good manual and experiment. It could be the technique that is best suited to a particular sensibility or timing, the one which helps you make your aspirations a reality more than any other.

Portrait of Ginevra, washes of oil paint over an acrylic base.

In addition, before the 19th century, especially before the Impressionism 'revolution', artists prepared the base of their paintings with a grey scale. This established, before adding colour, the structure of the brightest lights to the most intense shadows, often working in metalpoint.

The first step is a study of chiaroscuro in pencil on a prepared background.

Below: Overlapping oil paint washes over the chiaroscuro drawing. The colours used were: Sienna earth, titanium white, and earthy green.

Here, the contrast between graphite and acrylic is a way to highlight the subject of the painting.

Below. Monochromatic oil on canvas. First, you'll need to prepare a light scale that goes from white to yellow, made up of two light tones and two dark tones, to be applied in the areas already defined in the drawing. Oils dry slowly, making the next step of blending the different tones easier.

EXPERIMENTATION

It's always quite interesting and stimulating to try different ways to use varying techniques, mixing them as well, to interpret the subjects we love the most, either from real life or a picture. I've chosen a picture from many years ago which I'm quite fond of, a snapshot of my grandmother with my son. It may not be the most artistic photo-graph, but it captures such a special, unrepeatable moment of family connection that trying to interpret it in many different ways offered me the pretext for immersing myself in that moment and rediscovering ancient magic.

When working with photographs, I whole-heartedly recommend choosing only those that have something you're intensely drawn to, for better or worse, something that you like in particular. No matter what, it should have special meaning to you. Even class photos with a beloved (or hated) teacher will do just fine as a liberating pretext.

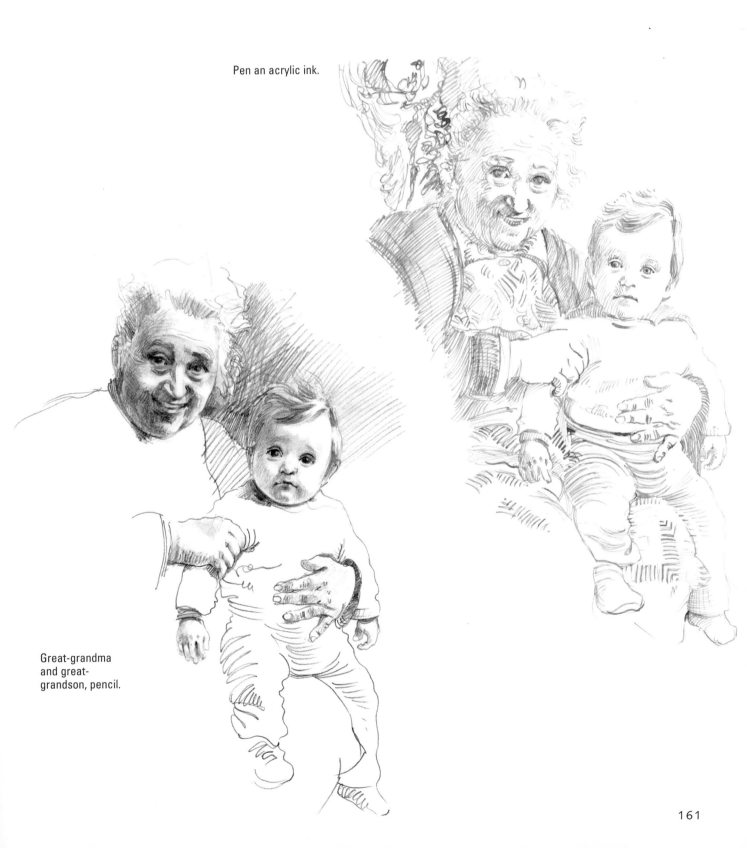

Pen an acrylic ink.

Great-grandma
and great-
grandson, pencil.

Hatching with pen.

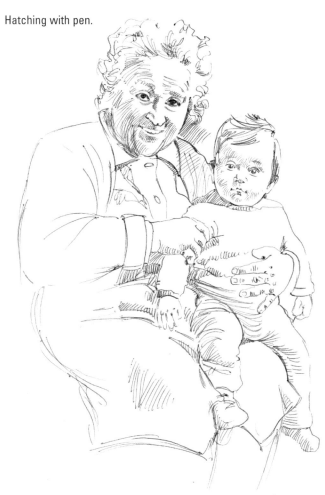

Pen hatching
and Pantone®.

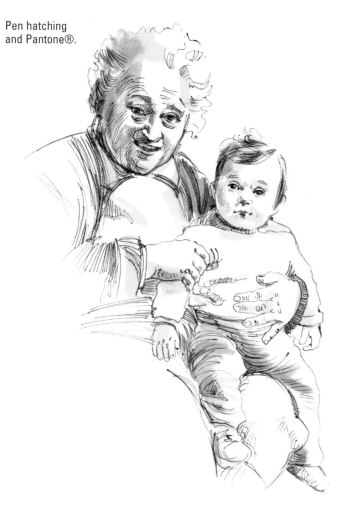

Black grease pencil
and Pantone®.

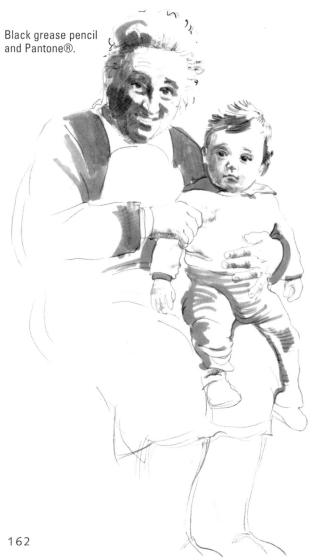

Sanguine.

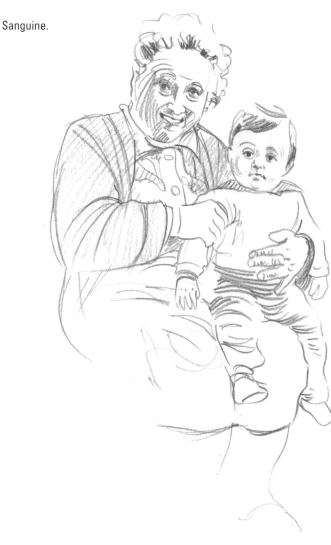

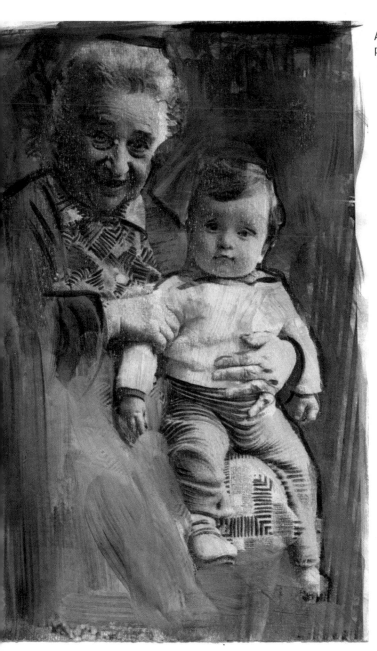

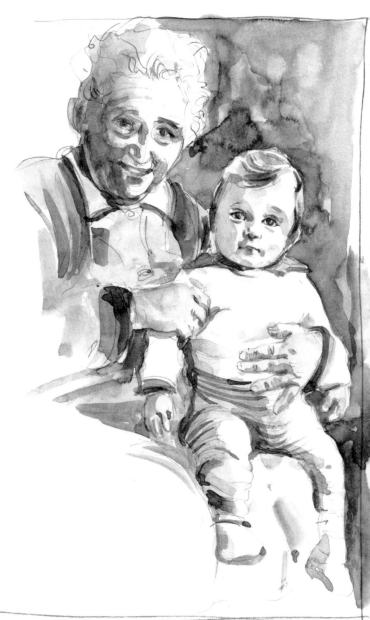

Pencil and
watercolour.

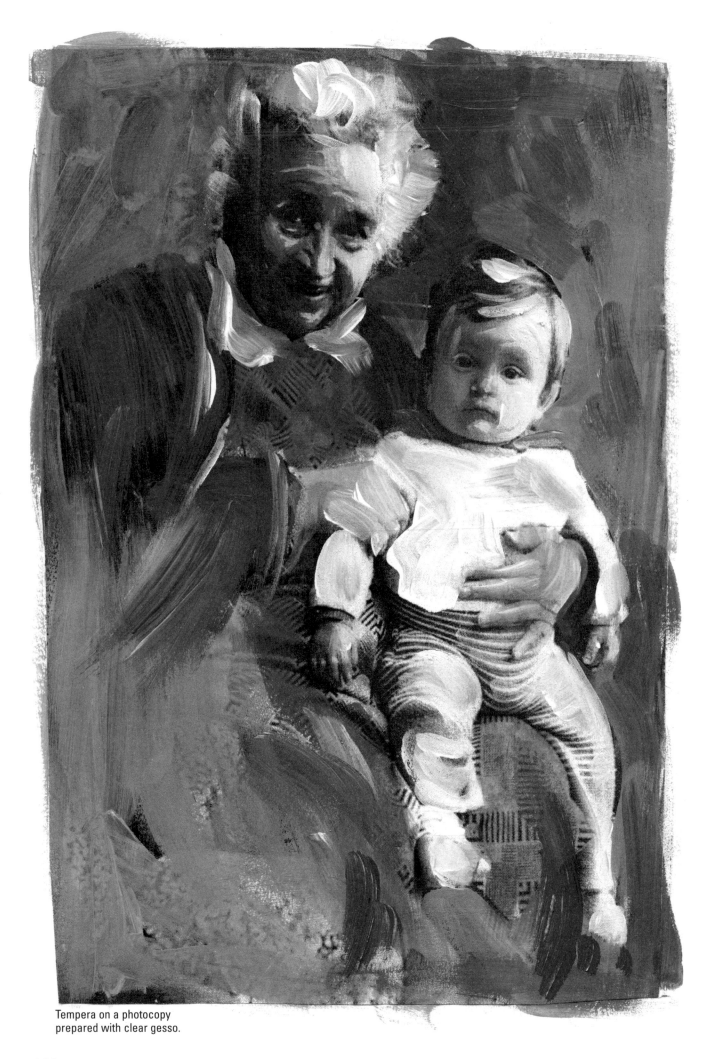

Tempera on a photocopy
prepared with clear gesso.

164

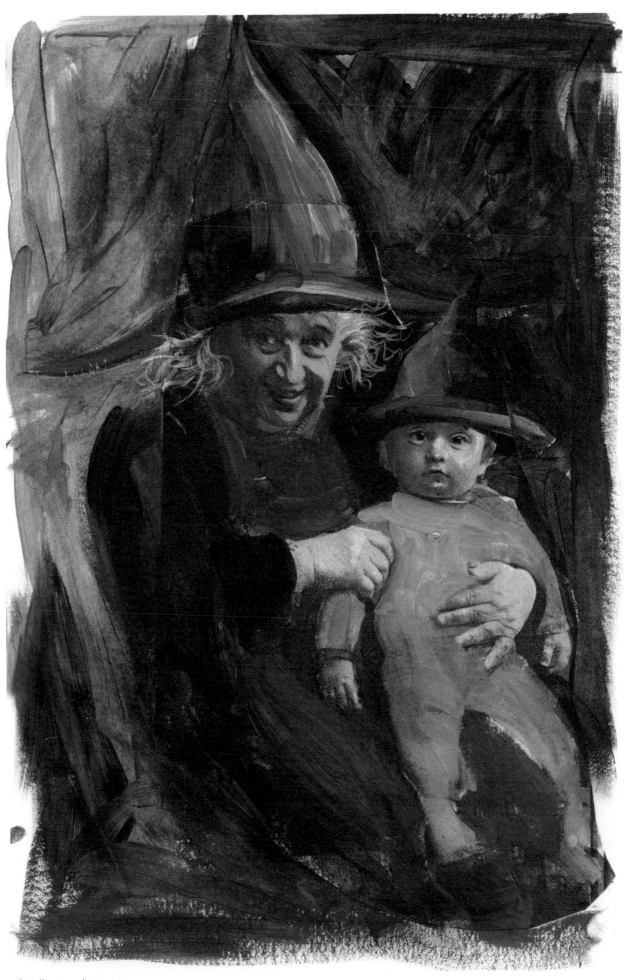

Acrylic on a photocopy
prepared with clear gesso.

There is no better way to study a print, painting, illustration, sculpture or any other work of art than to draw or paint it.

At the Palazzo Ducale in Urbino, Italy, I stumbled across what I think is a magnificent painting: a portrait of Federico da Montefeltro and his son Guidubaldo by Pedro Berruguete.

Among so many fascinating pieces, why did I choose this one? There is no other reason than that I fell in love with it.

The method which seemed like the best way to deeply understand the painting and to feel connected to it was to reproduce it. I found the top of an old table and I used the back of it. After hav-

ing finished my version of the painting, I added striped fabric and a dark background in the remaining space. As the base, I used acrylics, passing over them with oil washes as a subsequent step.

By doing so, I was able to discover details that I had missed when just looking at it, and shading and shadows that were nearly invisible, yet essential.

Below: Pedro Berruguete, *Federico da Montefeltro with his Son Guidubaldo*, 1475, Palazzo Ducale, Urbino.

Right: Copy in acrylic and oil on prepared wood.

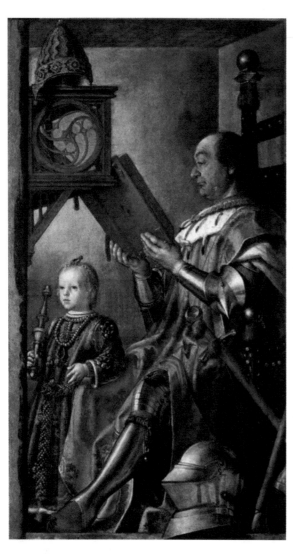

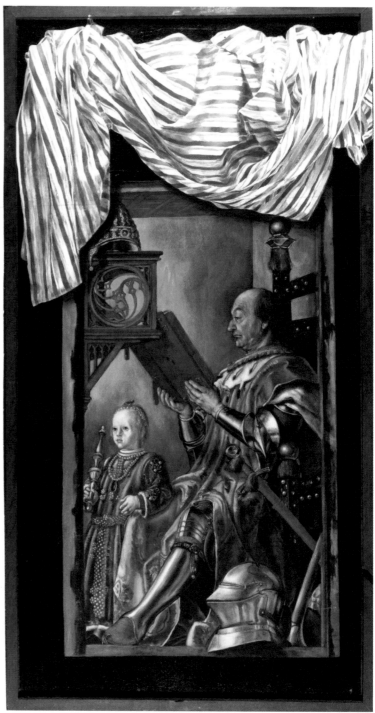

C. Larsson, *The Crayfish Season Opens*, 1894-96,
Nationalmuseum, Stockholm.

There are artists, painters and illustrators that, more than others who are just as good and as famous, capture our attention and inspire our admiration. They're the ones in front of which we find ourselves entirely immersed and captivated. We get lost, or find ourselves, in front of their work with entirely special attention and concentration. They arouse our desire to get to know them better and to learn more to discover what they can teach us.

To understand the drawing of a great master, it isn't necessary to be a great master, just as it isn't necessary to be a poet to appreciate great poetry. But if we don't know how to draw, we can't truly appreciate the virtues of a wonderful drawing.

A rather useful exercise to progress in drawing or painting is to copy the work of the artist(s) which you find most fascinating. Copying is the best way to truly get to know an artist and to enter into the world of his or her work.

Starting from the study of the work of a particularly appreciated and beloved artist you can progress in the quest for your own personal style.

At the age of 25, Delacroix wrote in his journal how important it is to copy the masters and carefully study, in pencil, their masterpieces.

Through copying and interpreting the work of great artists, you will enrich a precious personal archive made of experience and awareness which you can always tap into and apply the skills learned to your subjects. It isn't about creating counterfeits with the purpose of becoming equal to the original artist. The goal is to deepen one's imagination to increase awareness in terms of painterly techniques, composition and the use of light.

Artists have always grown by copying those who came before them, those that they considered the most important for their artistic growth. This includes the workshops of the Renaissance or even painters closer to our times, such as Picasso, who executed numerous copies of drawings and paintings by Ingres, an artist who at first glance seems quite different indeed.

Copying certainly hasn't overshadowed the artistic personality of those who have become the greats themselves by making use of this knowledge system, which of course isn't the only aspect of their training. Recently, an exhibit on Salvador Dali titled "The Dream of the Classic" focused on the Surrealist genius' path of studying the supreme techniques of Renaissance masters.

C. Larsson, *The Kitchen*, 1894-96, Nationalmuseum, Stockholm.

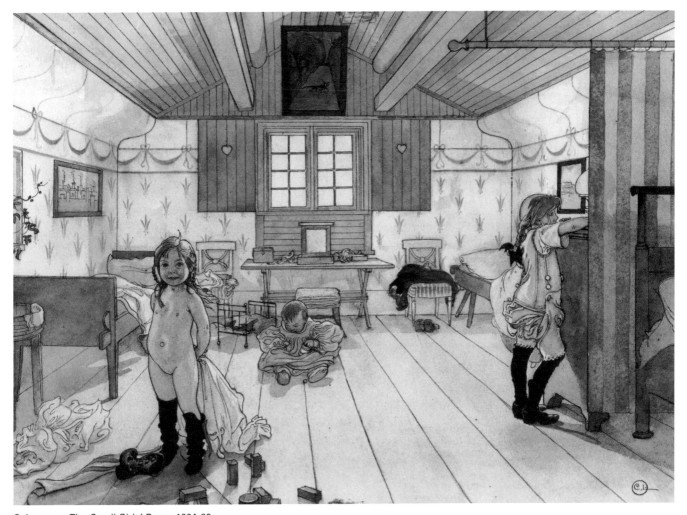

C. Larsson, *The Small Girls' Room*, 1894-96,
Nationalmuseum, Stockholm.

Below I'll propose a few artist-illustrators who often dedicated their talents to representing children and who found their own special way of representing them. Remember: any artist, past or present, which inspires your admiration can be studied. Explore his or her particular technical or stylistic approach as applied to subjects which interest you and, in this case, as applied to children, given the subject of this book.

Carl Larsson (Stockholm, 1853-1919) drew and painted wherever he went and is known as one of Sweden's most prolific artists. It seems he loved to travel, yet when he was notified that he had inherited a small farm, he decided to move there with his wife Karin. Their family quickly grew in

number and, as a consequence, their house was expanded. This included his studio, while the house was covered in decorations, wood sculptures, drawings and paintings and even a flower garden: definitely the house of a painter! The Larsson family lived there for over thirty years.

To deal with the difficulty of painting outdoors in particularly rainy or windy places, he turned his paintbrush to the interior of his house and its inhabitants: his wife and children (Ulf, Suzanne, Pontus, Brita, Lisbeth, Kersti and Esbjorn). The children posed as models and, as Larsson was incredibly precise, often had to hold those poses for long periods of time - something which surely didn't make them happy.

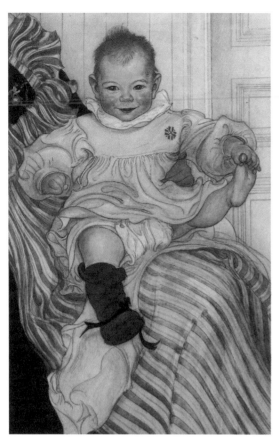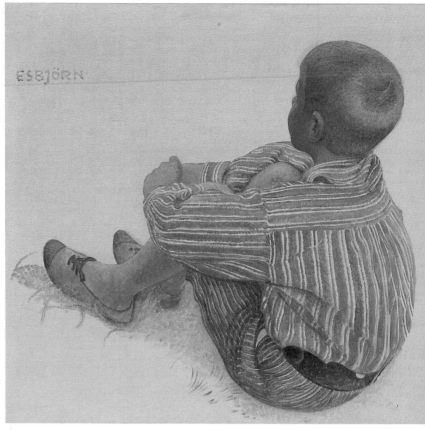

C. Larsson, *Esbjorn* (the painter's son), 1900 and 1910, Art Museum, Göteborg.

C. Larsson, *A Day of Celebration. From a Home,* 1894-96, Nationalmuseum, Stockholm.

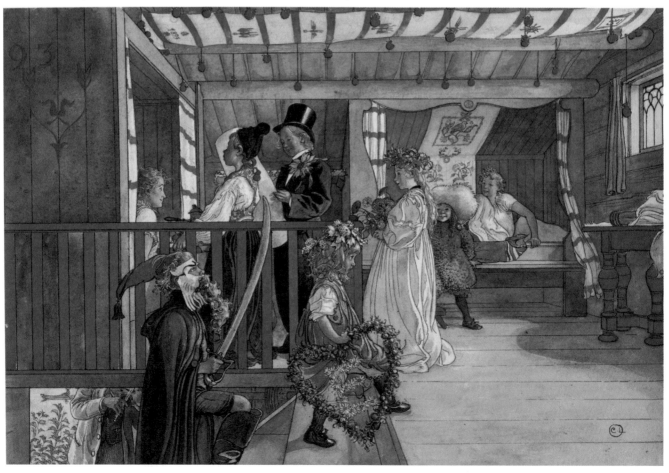

It seems that Pontus, one of his kids, once protested: "Having to pose as a model for a painter while on holiday should be illegal". But in those days, uprisings in the family weren't well tolerated.

Larsson had lots of models, but the most important ones for him were always his wife and kids, appearing in illustrations for books and paintings on canvas and on walls. He usually started with a pencil sketch of the subject he wanted to portray. He then went over the figure's outlines in pen and India ink. Last, he coloured in the outlines with watercolours. His paintings are quite detailed and rich with elements. His work has left us a story of his life on the Little Hyttnas farm and of the transformation of its spaces and residents, their habits and emotions.

Larsson mostly painted in watercolour and oil paints, but he also executed vast decorative cycles as frescoes. One of these can be found at the entry of the Nationalmuseum of Stockholm.

From the "Our House" album (1894-96), I've selected a few of his admirable watercolours, found at the Nationalmuseum in Stockholm.

Watercolour, as already mentioned, is the medium most suited to carrying out small-scale work out in the open because it doesn't mean you have to carry around heavy equipment such as an easel, chair and oils, solvents and a rest to place your tools on, with all the issues that brings. All you need is a container of water, a box of paints and one or two brushes, a clipboard with pieces of paper and a stool - the very same equipment Larsson used.

To practice his style, I recommend starting by copying a few of his pieces, especially those which you like the

C. Larsson, *Breakfast Under the Big Birch*, 1896, Nationalmuseum, Stockholm.

most (of course). Start from there to experiment with watercolours on dry and wet surfaces, but always make sure to let the white of the paper come through and leave the parts of the drawing which represent light blank. Paints can be diluted less or more, used as stains or with shading, drawing an initial sketch or starting right away with the brush. Experimenting as much as possible is always the first step and, at least at first, it's best to use photographs. Once you've established sufficient abilities with the technique, go on to directly painting from life. When you find available subjects, indoors or out-

Black and white photograph transformed into a colour painting inspired by Larsson's style.

doors, the most essential element is always the light.

Choose a nice, meaningful photograph to start to apply your skills to the artist. First create a light drawing in pencil, then use watercolours while trying to imitate his/her style. For Larsson, his interest in details requires us to work, in the majority of cases, on a dry surface.

It is best to start, as always, from a black and white photograph or from a black and white version of a colour photograph. This is because, as we've already seen, you'll benefit from greater liberty in its chromatic interpretation.

Photograph by Filippo Bianchi interpreted in India ink and watercolours.

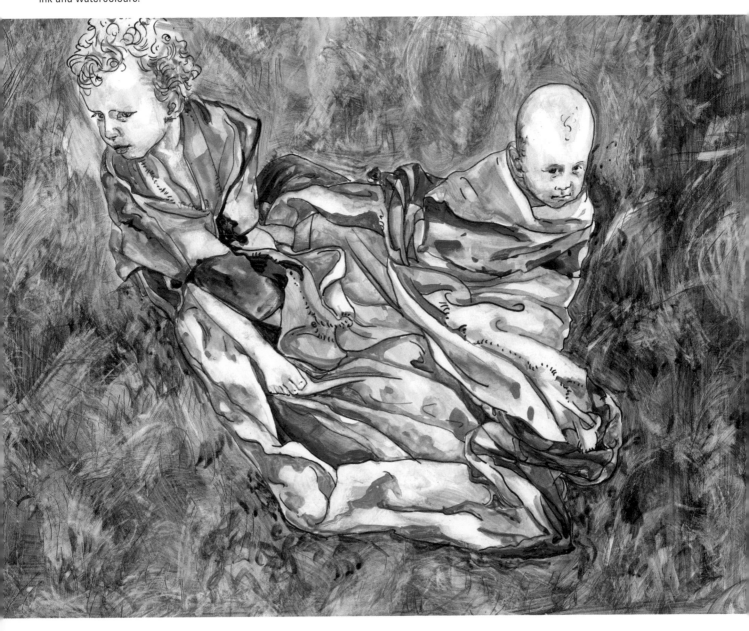

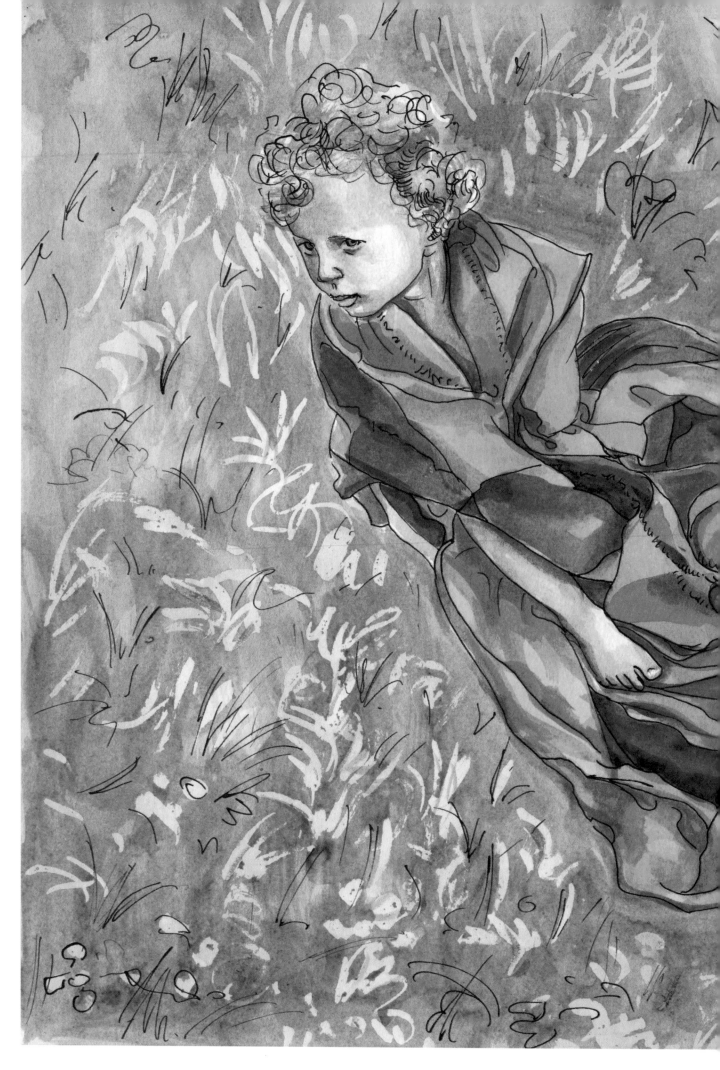

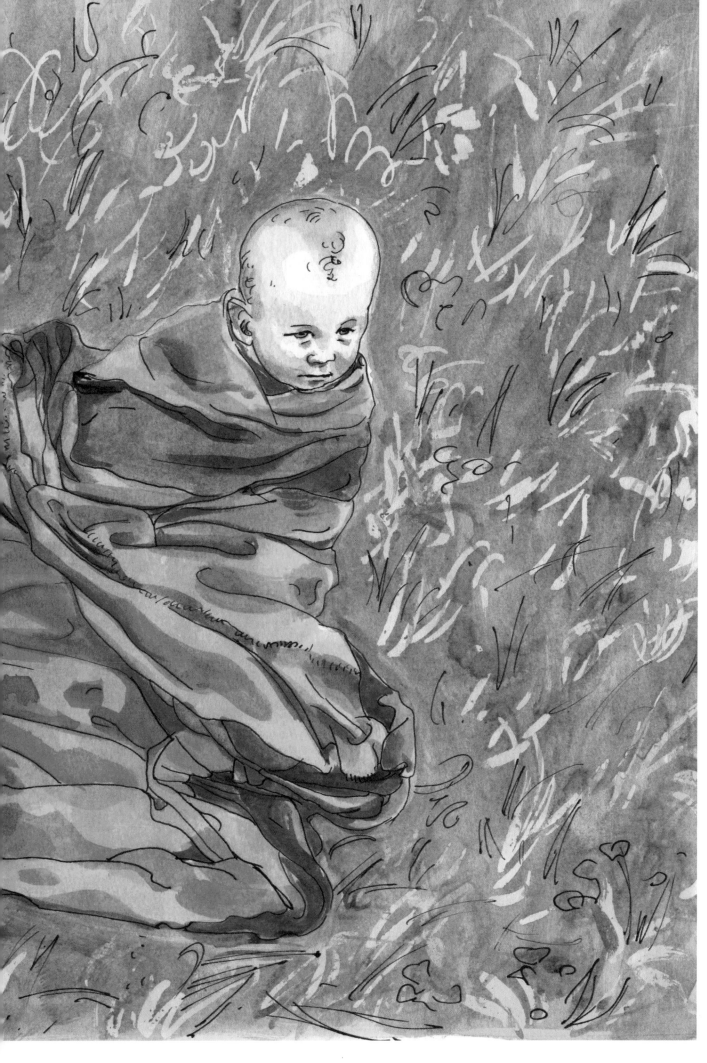

In the last century, another artist often dedicated his time to painting children: Norman Rockwell.

One of the world's most recognisable and appreciated illustrators and painters, Rockwell dedicated many of his illustrations and paintings to family life and children, often accompanied by animals and in a caring, optimist setting tinged with subtle, good natured irony. Born in New York in 1894, he spent the twentieth century as a prominent figure in American art. He died in 1978, and the Stockbridge Museum in Massachusetts, where he lived out the last years of his life, is dedicated to him. He began his career as an illustrator by collaborating with a few periodicals for babies and with two publishers for which he illustrated nine books. By the age of eighteen, he had already completed

Illustrations by N. Rockwell for the *Saturday Evening Post*.
Top left: January, 1920
Top right: January, 1910
Right: June 1921
Below: December 1912

THE SATURDAY EVENING POST
An Illustrated Weekly
Founded A? D! 1728 by Benj. Franklin

DECEMBER 28, 1912 5 CENTS THE COPY

Copy of a drawing by Rockwell by the author.

Below: from Rockwell, an acrylic copy by Anna Spreafico, executed during the first year of the illustration course at the IED in Milan.

his first cover for the *Saturday Evening Post* launching a collaborative relationship that would last his entire life and include a total of 321 covers. In those images, adults appeared little by little, at first only next to children, even if throughout his entire career, children never entirely disappeared from his repertoire.

Chronicler of American life for 65 years, he produced thousands of illustrations, drawings, paintings, covers and advertising campaigns. His interest in the daily lives of normal people and his ability to stun with the every day is, in effect, an incredibly rare gift for a painter.

Even today, Rockwell manages to bring empathy to our attention much more so than many photographs. In his work, he interprets reality, glimpsing its infinite shades through realistic details and the fun, caricature-like notes through with which he sees his subjects. It's a way of seeing expressed through details and, in particular, through body language and facial expressions.

His poetic path includes the centrality of the figure of the child; Day in the Life of a Little Girl from 1952 is a meaningful example of this. He expresses family values and teaches us to see what's special about the moments and situations which generally are taken for granted. He offers an interpretation rich with humour and dignity. Family life, the way we live as children and as elders, from birth and to being parents, inspired Rockwell with an infinite number of scenes to draw.

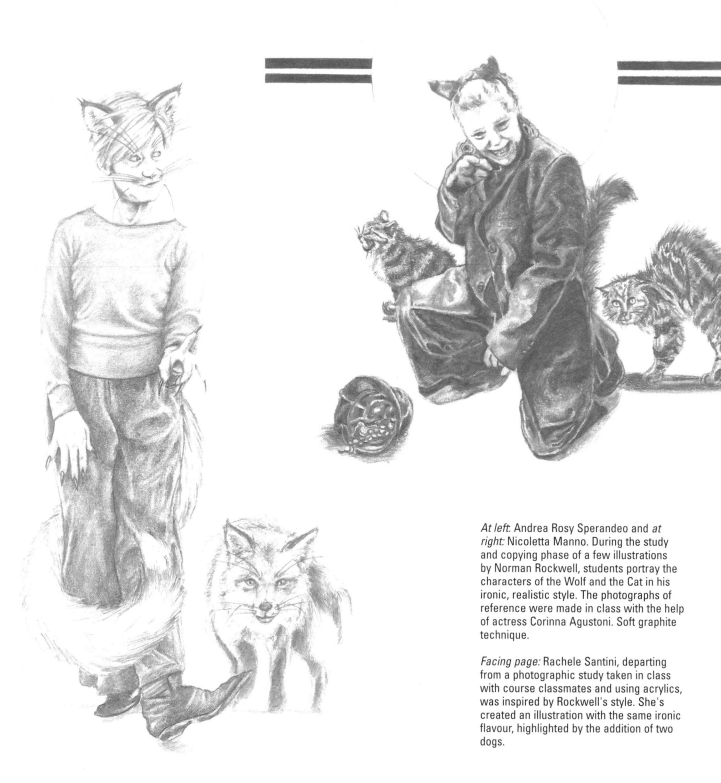

At left: Andrea Rosy Sperandeo and *at right:* Nicoletta Manno. During the study and copying phase of a few illustrations by Norman Rockwell, students portray the characters of the Wolf and the Cat in his ironic, realistic style. The photographs of reference were made in class with the help of actress Corinna Agustoni. Soft graphite technique.

Facing page: Rachele Santini, departing from a photographic study taken in class with course classmates and using acrylics, was inspired by Rockwell's style. She's created an illustration with the same ironic flavour, highlighted by the addition of two dogs.

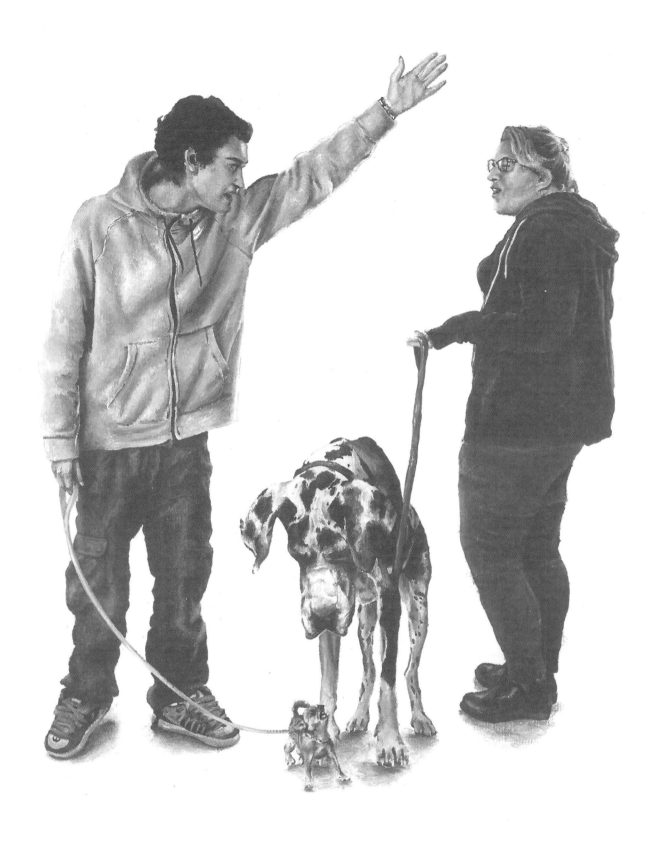

His illustration for *Look* magazine from 14 January 1964, The Problem we all Live With, represents an item from the chronicle section: a six year old African-American girl escorted to a school in New Orleans reserved for whites by four federal agents on the first day of the academic year. It's an exceptional statement against racial segregation. Photographic experimentation and scenic dramaturgy are at the base of Rockwell's paintings. He often used models which he found, in particular, among his neighbours and the common places and traditions, and the real costumes and spaces which he used to build the sets of his illustrations. After having taken a few snapshots, he would create drawings and sketches, which he often made in diluted oil paint. The definitive versions were done in oil on canvas, usually large scale (50x60 cm), and only in the last few years did he sometimes use acrylics or casein-based materials.

Among the exercises for the first year of the Drawing and Painting Techniques course, is that of copying a Norman Rockwell illustration and then creating a subject in their own in the same style. This activity is useful for both learning how to decode body language and use it when planning an image, and for learning how to use acrylics. These exercises require lots of patience, precision and time, all necessary, indispensable ingredients for any artistic activity.

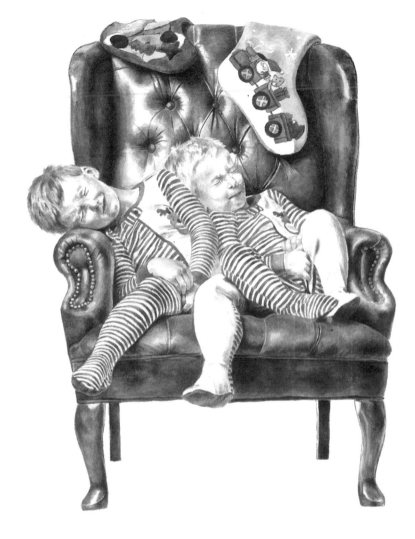

Copy of illustrations by Rockwell.
Above: Claudia Bernardi.
Below at left: Silvia Masdea.
Bottom right: Ilaria Generelli.

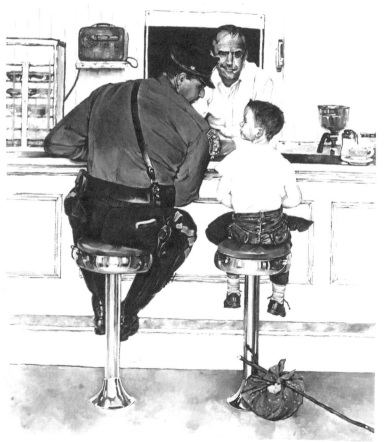

Francesca and Marco had beautiful twins: Alice and Viola. I was inspired by Norman Rockwell to interpret a few moments of their day. Joy and fatigue, subjects with a tender, everyday feel that the American illustrator often portrayed. Pencil.

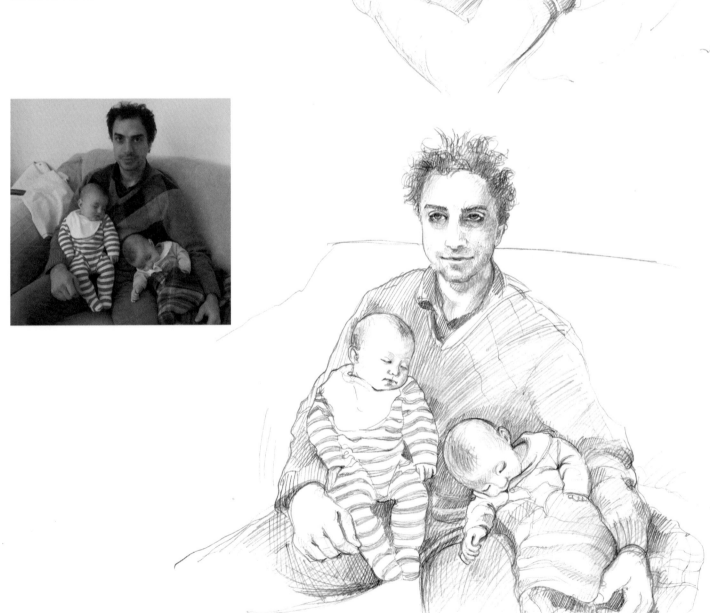

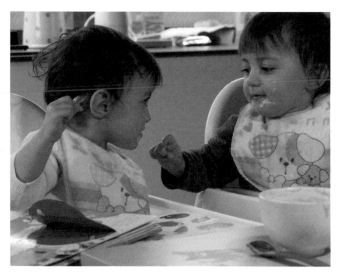

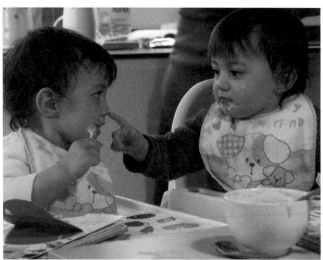

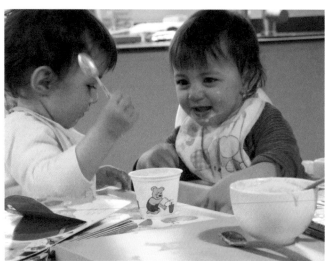

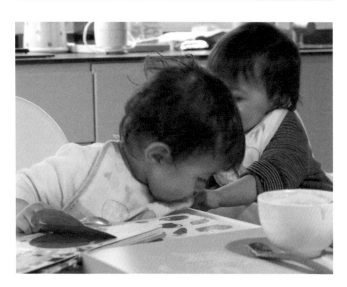

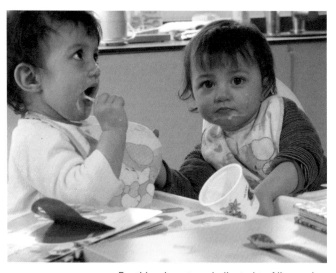

For this microstory dedicated to Alice and Viola's snack, grappling with yoghurt, I was inspired by the series of illustrations which Rockwell dedicated to a typical day in a child's life. A series of black and white snapshots, chosen and interpreted to create a sequence. Pencil and watercolour.

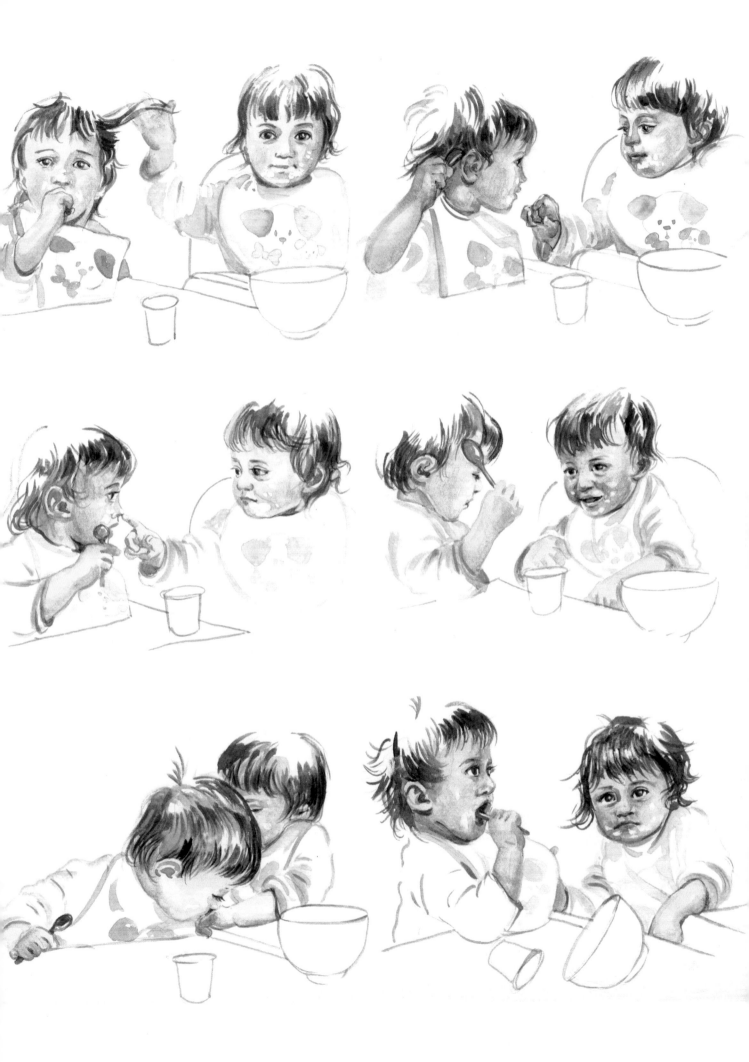

Brian Froud and Alan Lee are the artists behind the famous book published by Rizzoli: *Faeries*, first released in 1978. In it, they present the world of faeries and gnomes through beautiful illustrations. These characters are so precisely and believably represented that they seem to really exist. Besides, who are we to say that they don't?

Their illustrations are done with a naturalistic illustration method in which only a few of the subject's qualities are represented - the aspects which are special and visible, according to the artist's narrative intentions.

This isn't an abstract scientific study which divides up the subject as if it were on the operating table. Rather, attention is focused essentially on exterior morphological aspects, represented analytically or as a whole with different appearances and multiple viewpoints.

The psychology and social structure of gnomes and faeries are also presented, as are their places of origin, houses, the natural environment where they live and the legends and myths in which they appear. Fantasy and reality completely combine, producing an entirely credible result in a world invented and dreamed of by children, and perhaps some resistant adults.

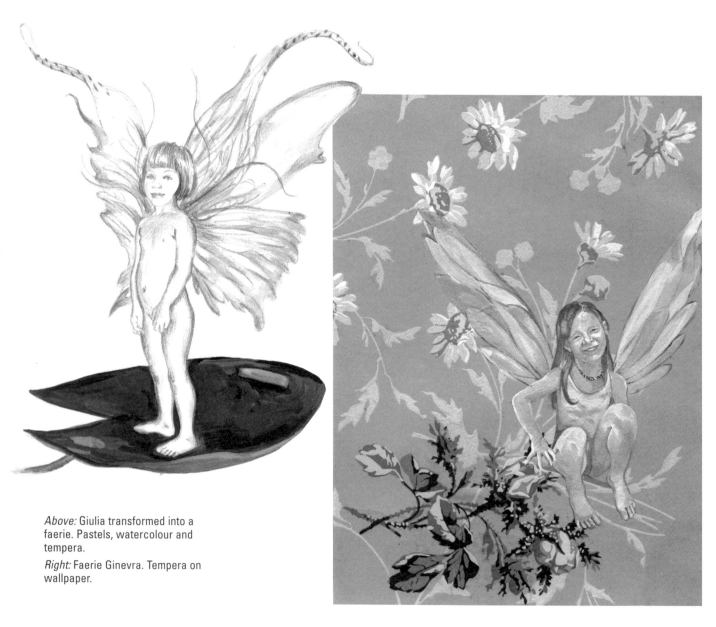

Above: Giulia transformed into a faerie. Pastels, watercolour and tempera.

Right: Faerie Ginevra. Tempera on wallpaper.

Another artist who often depicted children in his paintings is Joaquin Sorolla (1863-1923). Often considered one of the most significant artists of the late 1800s and early 1900s, especially in Europe and the United States. He also had lots of children who often appear in his work, large scale paintings and murals.

His collaboration with photographer Antonio Garcia Pérez influenced his artistic path, and, like Degas and Caillebotte, he was also an amateur photographer.

His painting methods were based on light, which became the central theme of his more mature works, expressed through fluid brush strokes and light colours, and by paintings of impressive dimensions. Luminism is the term coined to draw, in a generic form, his later style which was inspired by the work of Velazquez. He didn't just practice photography to study light and shadow, but also for framing, close up and with an elevated viewpoint, until almost eliminating depth. His work may also be a source of inspiration for copies or interpreting your subjects.

J. Sorolla, *Children on the Beach*, 1909, Prado Museum, Madrid.

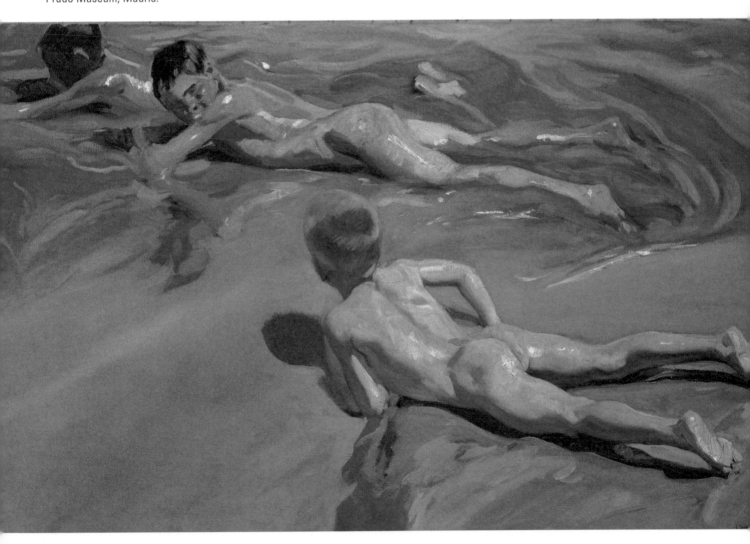

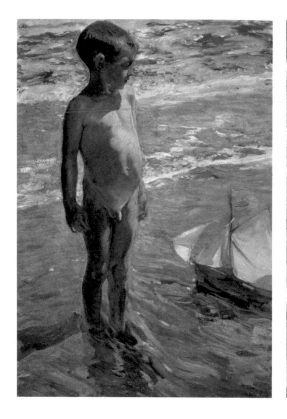

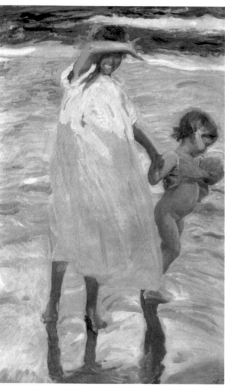

J. Sorolla, *The Little Boatman*, 1904, Sorolla Museum, Madrid.

Right: Two Sisters, Valencia, 1909, private collection.

Below: Girl on the Beach, 1910, private collection.

Opposite page
Left: J. Sorolla, *On the Beach, Valencia,* 1908, private collection.

Right: Looking for Shellfish, 1907, Sorolla Museum, Madrid.

Below: Valencia Beach in the Morning Light, 1908, Sorolla Museum, Madrid.

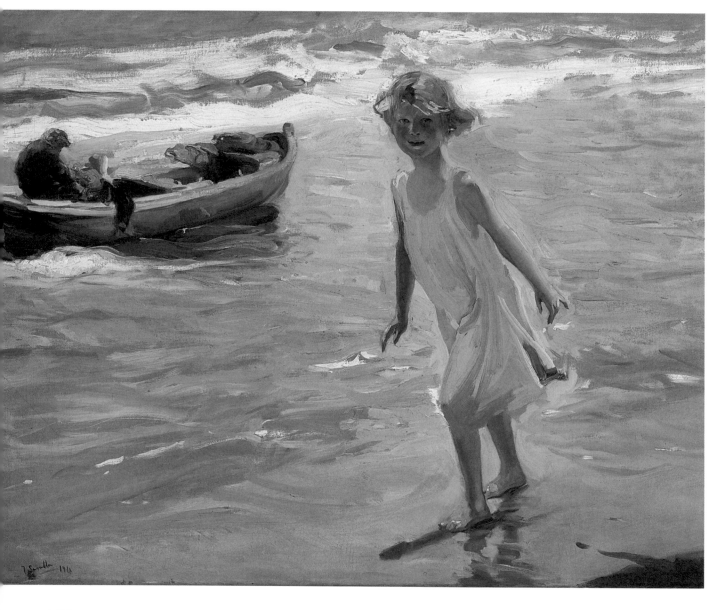

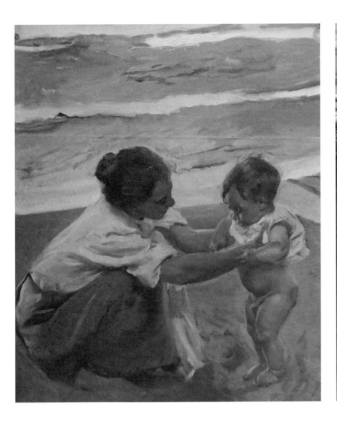

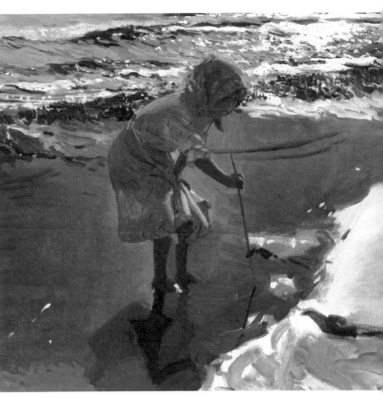

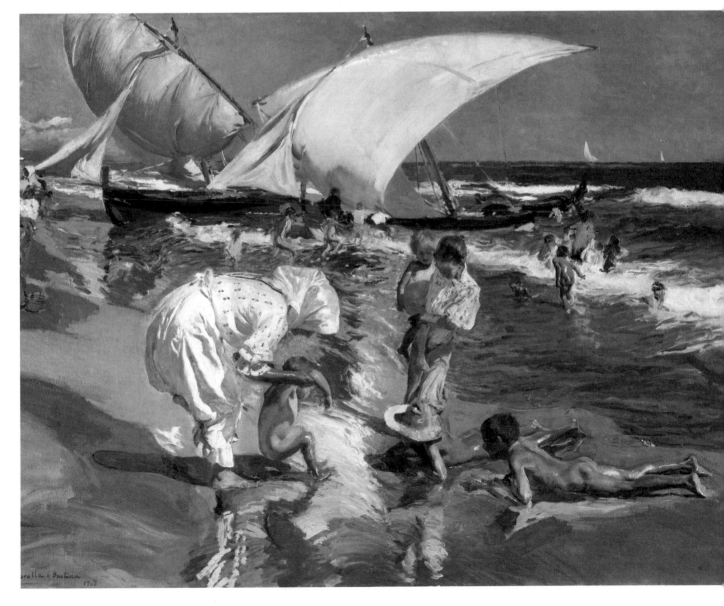

In the contemporary landscape of painters and illustrators that dedicate a large part of their imagery to the world of children, the work of Titti Garelli is surely noteworthy. A particularly gifted, talented artist, she almost exclusively portrays little boys and girls.

From Torino, she began illustrating for advertisements and the publishing industry. Then, in the late 1980s, she began producing more paintings, which are almost exclusively her medium of choice today. Specialising in painting children and natural scenes, she has dedicated an entire series to kids: *Bad Girls, Around the World in 80 Girls and Neo-Gothic Queens*.

Her refined painting style was inspired by great Gothic, Renaissance and Pre-Raphaelite artists.

At the base of her paintings is close attention to clothing, hairstyles and environs, which she renders with a detailed, refined style and impeccable technique. Enchantment and wonder together with her very realistic, detail-oriented style characterise her subjects, often inspired by dreams, fairy tales and fantasy.

Her illustrations feature little girls depicted in a seemingly realistic way, but one which also manages to generate a fantastic vision of the every day. Reality and fantasy strengthen each other as they aren't placed in opposition, but rather in synergy: one reveals the other, and each helps us understand the other. Through fantasy, Titti Garelli portrays elements of reality that otherwise would seem insignificant or boring.

A few of the refined pieces by Titti Garelli.

N.C. Wyeth, *Mowing*, 1907.

N.C. Wyeth, *The Children were Playing at Marriage-by-capture*, "Harper's Monthly Magazine", November 1911.

RESEARCH AND IMAGINATION

I repeat that any artist, painter, illustrator or photographer can become a stimulus to help you see with new eyes and to translate, in your own language, an image that in some way resembles you. N.C. Wyeth (1882-1945), progenitor of three generations of extraordinary painters and an outstanding example of American illustrative painters starting in the early twentieth century, wrote and illustrated many articles inspired by his personal experience in the West, supporting the need of American artists at the time, to have direct awareness of their subject.

His preferred materials were oils and egg tempera on wood boards. His paintings directly reflect a study of works by other artists, starting with the American impressionists. Fascinated by the technical mastery of Sorolla, Segantini and of post-Impressionist painting, his own style and technique changed while maintaining that stylistic depth can only arise from an exploration of one's inner life. On this matter, Wyeth said: "A man can only paint that which he knows even more than intimately, he has got to know it spiritually. And to do that he has got to live around it, in it and be part of it." *The Wyeths: The Letters of N.C. Wyeth, 1901-1945*, Boston: Gambit, 1971, p. 205.

His illustrations remain his greatest work. Nourished by personal experience as a landscape painter, they are incredibly suggestive. Whether viewed on their own, on the walls of a museum or among the pages of a book, they are an excellent accompaniment to any story.

He also painted various murals, like Sorolla and Larsson, on large-scale canvases. Along with his illustrations for books and magazines, they make up a fascinating and unique part of his career. At the same time, he never stopped working on the easel, painting still lives, landscapes and portraits which seem to have been a general test of the various techniques that he used and experimented with. His work always demonstrates deep attention to and interest in the technical aspect of a work of art.

N.C. Wyeth, Illustration for
Treasure Island by Robert
Louis Stevenson, Scribner's,
1911.

Facing page: Last summer I was lucky
enough to admire a little girl on the
beach as she sculpted a wonderful
crocodile. That scene made me think of
the illustrations of N.C. Wyeth, and of
one work in particular, *The Giant* (oil on
canvas, 1923), which served as inspiration

for the creation of the image executed in
tempera on paper. One classic example of
imagination (imagination in action) is that of
observing clouds and seeing shapes which
resemble people, animals and so much
more.

Interpretation of a picture of
Ginevra. Tempera on paper.

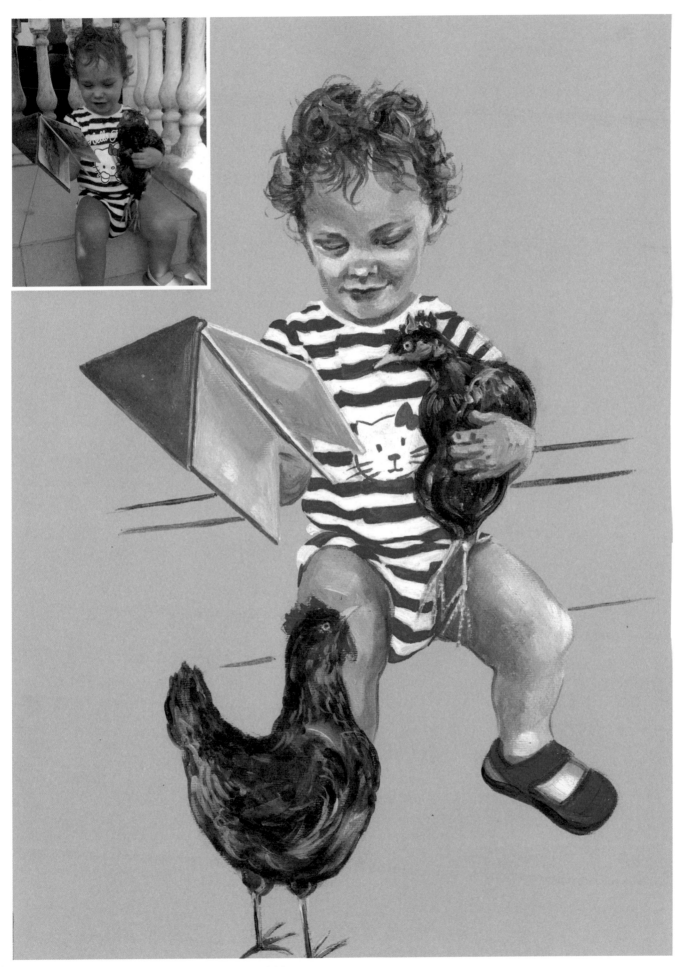

Picture and tempera interpretation. Linda reading her fables to
the chickens. Egg tempera: Titanium white, cadmium red, Indian
red, burnt Sienna, ultramarine.

In this case, the design on the blanket made me think of the possibility that the dove could come alive and fly away. Tempera on paper. Photograph by Filippo Bianchi.

Lastly, working with photographs can also provide the opportunity and the inspiration to travel through one's memories, overcoming the barriers of time and space and putting distant subjects in contact. People and situations can come together in a creative, funny way, as if in a collage.

Family members separated by time can talk to each other, parents and children can be the same age, you can invent environments and backgrounds, find similarities and differences, and experiment with styles and techniques.

The results which one obtains are both the result and stimulus for fantasy. They can be a chance to leaf through the photo album creatively, reconstructing the meaningful moments of one's life in an imaginary diary.

Grandpa Vittorio and his bicycle.
Opposite: interpretation, photocopy prepared with clear gesso, taken up with acrylics.

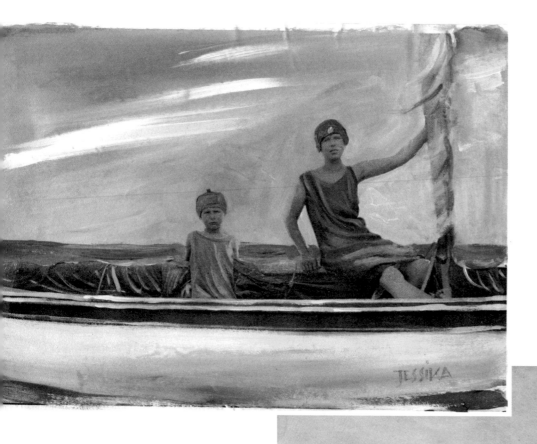

My grandmother, who the bombs of Milan took amid dust and plaster. In my interpretation, she sailed far away in a bright blue sky along with her son, the one who would become my father. Tempera on photocopy.

196

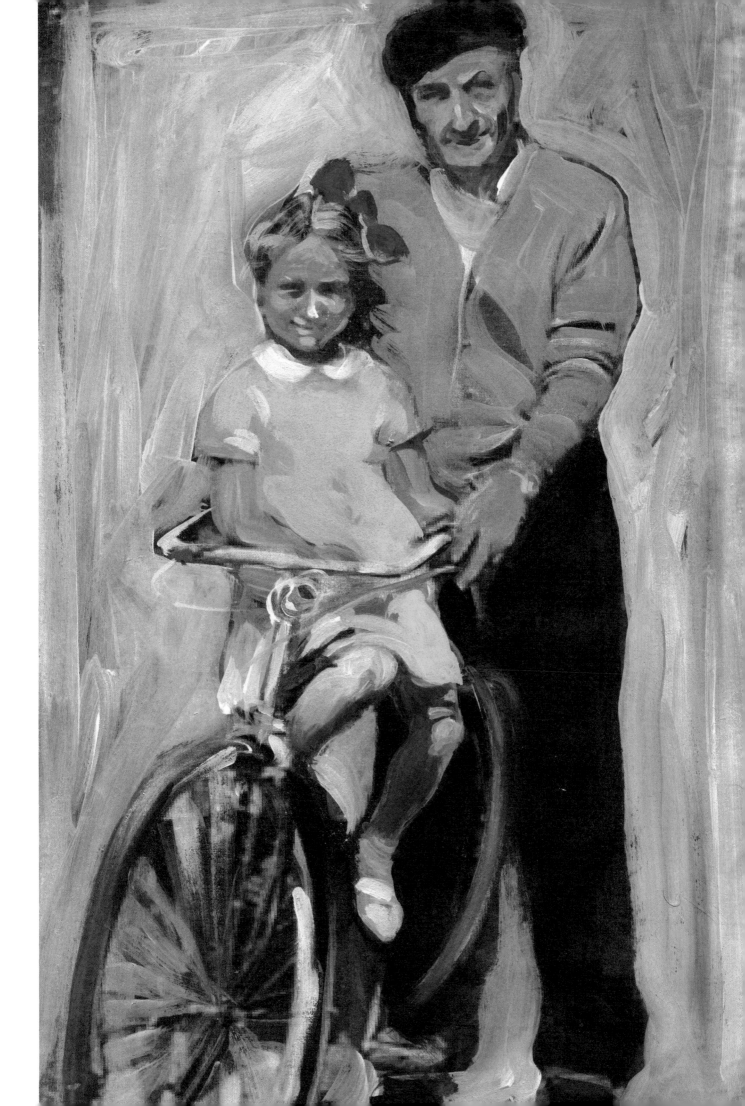

RECOMMENDATIONS FOR STUDY AND EXPERIMENTATION

To start a drawing course in general, and, in particular, one dedicated to children as a subject, I'll list a few suggestions in the form of a worksheet. These are exercises which are mainly intended to "break the ice", that is, to help you overcome any initial difficulties you may face for any sort of project, especially the infamous "writer's block" while staring at a clean sheet of paper. The hardest part is getting started, which is particularly difficult when working alone as we often tend to put this crucial moment off indefinitely.

But there can be no scapegoat: those who want to express themselves through drawing just have to draw, often and with pleasure. The more often you draw, the more pleasing it is.

LIFE DRAWING, QUICK OR GESTURAL DRAWING

- Complete at least 30 gestural drawings in a row, experimenting with the qualities of an HB pencil, ballpoint pens and coloured pencils. Limit yourself to 10-15 seconds for each drawing, observing subjects in motion or in particularly dynamic positions. Playgrounds and beaches are perfect locations.

- Dedicate 10-15 minutes to calmly looking at your drawings and identify the interesting parts of each one, but especially those in which you were able to capture the sense of action and dynamism particularly well.

- Repeat the same exercise with a graphite stick. You'll need to hold it differently than a pencil, and you'll be able to make clean lines or blurred ones, wide or thin. Try to use varying amounts of pressure and hold the medium at different distances from the point as you car-

ry out another set of 30 drawings, each 10 seconds long. Observe and evaluate the quality of the line.

- Grind the graphite (a few fine art stores sell it already ground into a powder). With a finger dipped in the powder, repeat the exercise and quickly draw the gesture. Try using a flat paintbrush that's 4-5 cm wide and, with diluted India ink, continue to capture the whole of your subjects in action. With this type of tool, it's almost impossible to get distracted by the details. Dedicate 30 seconds to each sketch.

- It's best to dedicate at least an hour afterwards to memory exercises, alternating drawing a simple subject from memory with drawing it from real life multiple times until you're able to reproduce it entirely by memory from any viewpoint.

- Working from photographs, start memorising the subject, dedicating the time required to mentally record every detail. When you're ready, turn the picture over and draw what you remember. Then check it against the photograph to correct any errors, using a differently coloured pencil to highlight the differences.

- To understand an image in its entirety, it's also necessary to orchestrate the study of its composition. Every day, on a block of paper, doodle any situation that you've noted in the hours just before.
It could be a situation where people and things are moving, or a room, or anything else. It doesn't matter if the drawings

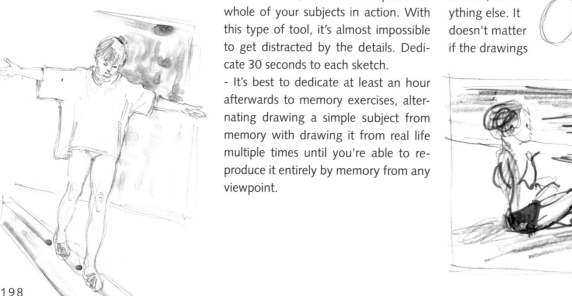

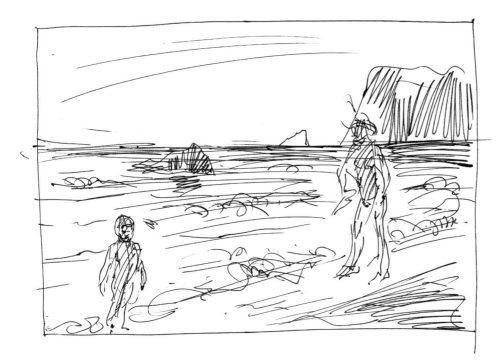

are "correct", they can even be entirely "wrong", but if you manage to practice like this every day, you'll realise that this exercise is extremely effective.

- Apply the same method to the representation of groups of figures in settings, to children and adults or children and animals drawn from life, from photographs or from paintings by the masters.

DRAWING FROM PICTURES AND VIDEOS; METHODS AND TECHNIQUES

- Make a black and white photocopy of a photograph or use a photo editing program to convert it to black/white. Examine them to find out what tones correspond to each colour and make use of a suitable grey scale.
Pay particular attention to the differences in tone between the foreground and the background to get the right depth.

- **TRACING:**

is an effective method for transferring a subject to a piece of drawing paper. First, trace the photograph on tracing paper or another type of transparent paper, then transfer it to drawing paper by using graphite paper. It is important to check and correct the drawing during every step, frequently comparing it with the original. If you want to transform a video to a set of images that tells a story, choose the most mean-

ingful frames and use them to create a copy using the method of your choice (gestural drawing, blind drawing or both). You can even print the still and trace it. Use any technique that meets your expressive intentions. It's always best to try more than one.

- **COPYING:** choose a photograph and copy it, trying one material at a time. This exercise helps you learn the differences between the various graphic mediums, including brush pens.
- Work simultaneously on two or more sheets of paper, employing different materials and methods with the same subject. Comparing the results is always very interesting and stimulating.

STUDYING LINES/MARKS, DUCTUS, AND BLIND AND MODELLED DRAWING.

Practice searching for your ductus, the sign that best represents you, testing out all possible variations using different techniques. Change your movements from slow or fast, light or intense pressure, continued or fragmented durations, single or multiple strokes, and a melodic or syncopated rhythm for the drawing.

become an effective tool, one which over time will transform and come instinctively.

SHADED DRAWING: choose an image that interests you or work directly from real life. Study the force lines of the subject's posture and movement and, starting from the centre, create the volumes

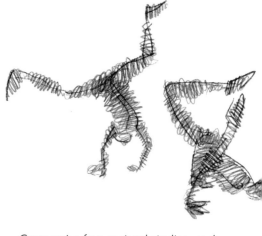

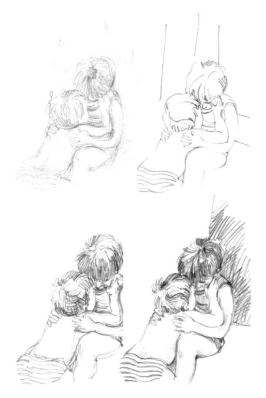

- Carry out a few gestural studies, each lasting 30 seconds, with a brush or graphite. Then overlap them with blind drawing, dedicating at least 5 minutes to each. Start with watered-down India ink and a fine point marker, then experiment with other combinations.

BLIND DRAWING: blind draw the external and internal edges of any subject from real life or from a photograph without overlooking complex details. Orient yourself on the page, not by sight, but by touch. Don't worry about respecting the structural logic of the subject. Set the timer and keep drawing, without looking, until it goes off, even when you feel like you've totally lost your orientation.

- Draw the external and internal edge of a subject without looking at the paper but, this time, when you loose your orientation look at the drawing and place your pencil in the correct place. Then start drawing again without checking your work. It's always best to keep this operation to a minimum. It takes a long time, but gradually blind drawing will

of the body. Remember to set the correct proportions from the beginning, as these criteria are different for children. Draw repeated dynamic positions such as when playing a game from real life, or from photographs or videos, drawing the force lines of various poses. Dedicate two or three minutes at most to identifying them, then take their measurements with the pencil and check that the proportions are right, correcting any mistakes. Then move on to creating the volumes.

You can use a grease pencil or lithographic pencil, as their soft texture and intensity of tone are well-suited to this type of drawing.

- Repeat this type of study, even without first drawing the force lines, but rather directly approaching the shaded drawing and trying out all the techniques and materials available.

- Overlap different types of readings, place a blind drawing over a gestural drawing, trying out different techniques.

PAINTING AND DRAWING TECHNIQUES, CHIAROSCURO AND COLOUR

- To practice line drawing and chiaroscuro, choose a simple subject or a black and white photograph and copy it, trying out every medium you have on hand, both those which have been suggested and other styles as well.

- Create a grey scale and copy the picture in black and white, or, better yet, a detail from it, harking back to the five tones you've identified. Draw by identifying the forms struck by light and those in shadow, partially closing your eyes

to help you recognise them. Once finished, compare the picture to the drawing from close up and correct any differences if you notice them. Also check how you've traced the outlines, which shouldn't be too noticeable, but rather blended with the contrasting tones.
- Start with vine charcoal, which is a soft, versatile material, and try all the other techniques as you go along. Once finished, check the model and the draw-

ing, mentally overlapping them, then correct any errors. For the proportions, a pencil used as a gauge will help you out. Remember to handle each subject and its surroundings at the same time, continuously comparing them.
- Try various types of marks both with dry mediums (pencils, chalk, pastels, conté crayon or charcoal, etc.) and water-based ones (India ink, watercolour pencils, watercolours, etc.) and seek out new combinations and fusions without being afraid of making mistakes, while using cheap paper as a base.

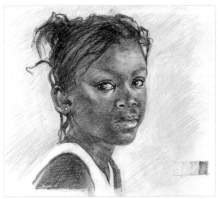

- Study chiaroscuro from real life, initially choosing a simple subject and lighting it with grazing light. I advise starting from a solid understanding of the more traditional chiaroscuro techniques: charcoal, graphite and vine charcoal.

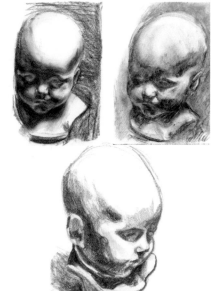

COLOUR TECHNIQUES

- Starting from photographs, experiment with all the basic painting materials. They are: acrylic, tempera, watercolour and oils.
It's always advisable to use black and

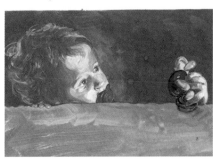

white images, then move on to colour once you've fully grasped the tones. It's also interesting to mix or overlap different mediums, remembering that, in general, fat-based mediums such as oil paints should be placed over those without fat, such as acrylics. In terms of choosing your colours, it's best to identify the dominant colour, the one which

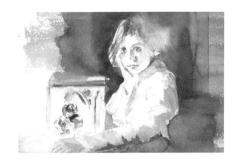

is the common denominator of the entire image, and introduce it partially to every element. The dominant colour and the atmosphere of an image are always determined by the type of light. For example, on a grey day it's easy to see how that tone participates in the composition of all the colours of a scene.

THE MASTERS, INSPIRATION AND IMAGINATION

- Identify the master, painter or illustrator, from the past or present, that you feel is closest to your expectations. Start copying his or her pieces, painting technique, image composition, the qualities of the characters, style and use of colour. Follow the example of Salvador Dalì, who was quite attentive

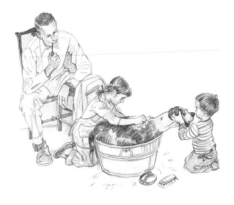

to Renaissance art, who encouraged: "Start by drawing and painting like the old masters, then do as you please. You'll always be respected."
- After having completed the copies, start interpreting the photos that you like, using the style and technique of that master, drawing inspiration from

his work freely and in a way that's personal to you.
- To enrich your "image library", be inspired by all visual arts, including film and comic strips.

RESEARCH AND IMAGINATION

- Concentrating your attention on the subject of children, among family pictures or those of yourself, identify those which inspire connections or the interpretations of situations or special settings that stimulate your imagination and let your imagination run wild to make the impossible, possible.

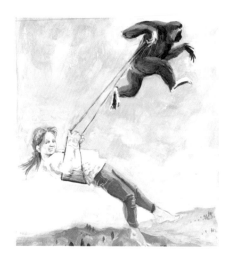

- Begin copying a drawing, painting or sculpture that you're drawn to or like in particular. Then, starting with that subject, gradually move away from it, following your own form and technique until you find a personal interpretation that satisfies you.

- Among the many pictures from a newspaper or book, choose the photo that for some reason, clear or mysterious, you are drawn to. From there, start imagining, without setting any limits, overlapping and pairing different images as if in a collage.
- Choose a subject or a picture from your childhood and use it as a departure point for a journey through images. You can draw on the photo itself or make enlarged photocopies to work on, using any medium or technique.

NOW WHAT DO I DO? THE SKETCHBOOK, TO NEVER TRAVEL ALONE

- Get a small-scale notebook or block notes for drawing with a hard cover, at most an A4, and slowly move within the space, capturing the subjects, human or otherwise, that surround you with quick, continuous lines, without lifting the pencil from the page. You can practice this exercise anywhere, in cities or out in nature, indoors or outdoors. Prepare a pencil case with just a few must-have materials.

- Create gestural designs and blind drawings of subjects captured rapidly, observing and drawing children, adults and the elderly from life, be they thin or fat, ugly or pretty, acting,

moving, etc., enriching your personal "archive" of types of people.

- Choose a film that you like and use a still from it to study the composition of each frame summarily. Use only chiaroscuro at first.

- Draw a subject by trying many methods and techniques. Take up the drawing a second time with other mediums or draw from memory.

- Every day, draw three pages in your notebook, dating them. It doesn't matter if you don't know what to draw. Simply look around and draw anything, or draw someone or something from the day before by memory. You can even let the pencil, pastels, or

brush meander about the page, with soft movements of the hand, without a specific purpose. Draw the outlines of the same subject very quickly and very slowly and with different materials. Dedicate at least 10 minutes a day to this exercise. Once they're up, stop the exercise. If you do so constantly, surely something will change in your way of seeing and drawing and, sooner or later, you'll realise it, pleasantly surprised.

- Stop to examine the changes which have happened in your drawing style and identify the drawing(s) that you like the most or which simply communicate a bit of emotion, no matter the reason why.

ACKNOWLEDGEMENTS

First and foremost, a heartfelt thank you to all the little boys and girls that, unknowingly or not, let themselves be portrayed. Thank you to the dads, mums, and grandparents for having shared a few of their precious moments with me, those which captured, in an instant, the emotions, episodes and expressions of their children.

Thanks to my current and former students, who allowed me to enrich this book with their work, and thank you to the friends who collaborated in various ways to support me in this undertaking. Thank you Fabio, my son and patient editor.

And finally, thanks to Hajar, a 5-year-old little girl, for dedicating the beautiful drawing which concludes our study with smiling optimism to me.

TABLE OF CONTENTS

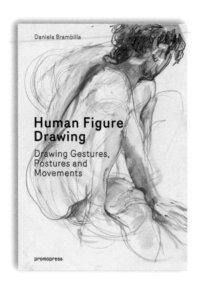

HUMAN FIGURE DRAWING
Drawing Gestures, Postures and Movements
Daniela Brambilla

978-84-15967-04-0

It sees drawing as an endless source of technical, compositional and formal inspiration that is essential for art, as well as a departure and arrival point in the artistic process, a vehicle to capture the essence of body language. Aimed at both those who want to learn to draw and those who are already proficient, and with hundreds of colour images, this volume offers a wealth of tips and advice for developing our creative endeavours.

DRAWING THE HUMAN HEAD
Anatomy, Expressions, Emotions and Feelings
Giovanni Colombo and Giuseppe Vigliotti

978-84-16851-02-7

Drawing the Human Head is an in-depth study of the infinite variety of emotions that the human face can express and of how these can be conveyed on paper. This book guides the reader through human emotion in the history of art and also analyses the methods required to reproduce it. With its clear and accessible texts, this book is an indispensable tool for students, who can also use it as a self-study manual.

BARCELONA-FIVE ROUTES FOR SKETCHING TRAVELLERS
Jordi Carreras, Jordina Bartolomé. Illustrations: Lapin

978-84-15967-91-0

Each of the five chapters offers brief illustrative texts, drawings and maps. Plenty of blank pages allow full freedom of graphic expression to the artist. The first four chapters propose sketching tours around different areas of the city. The last section suggests three routes outside the city: Costa Brava beaches; artistic and cosy Sitges and the capital of northern Catalonia, Girona, with its fresh patios and stepped streets.

PARIS JE T'AIME
The Sketching Lover's Companion
Lapin

978-84-16504-15-2

A fresh, well-observed, annotated, carnet de voyage about the "City of Lights" by French illustrator Lapin. A must-have art book for all Paris lovers and visitors with streak of creativity. Lapin already filled around 160 sketchbooks for the last 13 years. Besides capturing his life in his sketchbooks he also teaches art of "sketching" during workshops in universities, in art schools and participates exhibitions around Europe.

BARCELONA ORIGINAL
The Sketching Lover's Companion
Lapin

978-84-16504-12-1

Sometimes funny, sometimes elegant, always exquisitely drawn; this annotated travel journal, portrays French illustrator Lapin's adopted home city of Barcelona. Lapin is a French illustrator, an artist, a French urban sketcher based in Barcelona. Sketching is a way for him to record every second of his life and feel alive. Lapin has published several sketchbooks about Cuba, Japan, Istanbul, Barcelona and Carcassonne.

COLLAGE THERAPY
Cutting out Stress
Regeka Elizegi

978-84-16504-63-3

Collage Therapy is an introduction to collage techniques that will give free rein to your imagination and enhance your artistic expression. By trying out the immense variety of resources offered by collage—including cutting, pasting, painting, sewing and drawing—the book becomes a personal album that bears the reader's individual hallmarks.

THE RESOURCEFUL ARTIST
Exploring Collage and other Mixed Media Techniques
Victor Escandell

978-84-16504-62-6

Through the hands of artist and illustrator Victor Escandell, this book explores the infinite expressive possibilities offered by mixed media and provides the tools necessary to master this discipline. Each chapter offers a step-by-step explanation of a specific technique. The final chapter provides readers with a simple and practical guide to photographing their own works.

A WATERCOLOUR A DAY
365 Tips and Ideas for Improving your Skills and Creativity
Editor Oscar Asensio

978-84-16504-89-3

This book contains 365 tips and ideas on learning how to use watercolours and improving your drawing techniques. It discusses issues such as the materials needed for watercolours, the properties of colour, different colour combinations, and the different wet and dry techniques. Featuring many examples and illustrations, as well as clear and informative texts, this volume is an essential tool for anyone who enjoys painting with watercolours.

THE ART OF SKETCHING
400 Years of Travel Diaries
Pascale Argod

978-84-15967-76-7

This book illustrates the great scientific and journalistic adventures in history, from the Egyptian campaign to the war in Iraq. It also explores more intimate territories, capturing the essence of our world to preserve the remembrance. Between text and image, this stunning collection travels through the centuries revealing the most beautiful pages of a very human adventure.